painting my

a memoir of love, art, and transforma

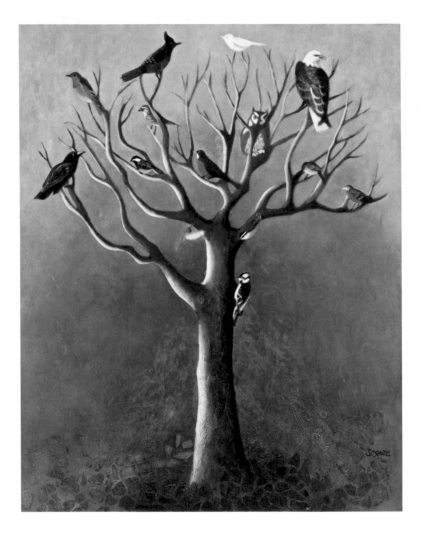

BIRDS

One day I saw three albino birds in our backyard. I ran to get my binoculars, but by the time I got back, they were gone. My neighbour, Mutang, saw them too and took photos of them. I had an idea of doing a tree painting and immediately decided to add the birds of our area, including the albino bird at the top. I have noticed that two ideas often coalesce to inspire a new painting.

I continued to play around with texture, and I think that element has added another dimension to this painting. It's one of my favourites.

ACRYLIC ON CANVAS, 60" X 44", 2007-08,
COLLECTION OF THE ARTIST

phyllis serota

painting my life

a memoir of love, art, and transformation

sononis
PRESS

Library and Archives Canada Cataloguing in Publication

Serota, Phyllis
 Painting my life : a memoir of love, art and transformation / Phyllis
Serota.

ISBN 978-1-55039-188-6

 1. Serota, Phyllis. 2. Painters--Canada--Biography. I. Title.

ND249.S453S47 2011 759.11 C2011-906340-9

Disclaimer: The events recounted in this book are based on my memories and
perspective. To protect the privacy of some of the people discussed, I have
altered several names, descriptions, locations and other details.

Sono Nis Press most gratefully acknowledges support for our publishing
program provided by the Government of Canada through the Canada Book
Fund and the Canada Council for the Arts, and by the Province of British
Columbia through the British Columbia Arts Council and the Book Publishing
Tax Credit, Ministry of Provincial Revenue.

Edited by Katherine Gordon and John Eerkes-Medrano
Copy edited by Stefania Alexandru
Proofread by Audrey McClellan
Cover and interior design by Annie Weeks

Published by
SONO NIS PRESS
Box 160
Winlaw, BC V0G 2J0
1-800-370-5228

books@sononis.com
www.sononis.com

Printed and bound in Canada by Houghton Boston Printing.

Canada Council Conseil des Arts
for the Arts du Canada

To my dear Annie,

without whom this book could not
have been written and this life could
never have been lived.

ACKNOWLEDGEMENTS

My children, Beth, Heidi, and Michael, who have had to put up with years and years of having a parent who was learning how to be a parent along with them. My grandchildren, Kyle, Sonja, Rosie, Megan, and Chelsea, for just being as wonderful and talented as they are.

My publisher, Diane Morriss, for her suggestion and encouragement to undertake this project and her generosity in supporting it. Katherine Gordon, John Eerkes-Medrano, Nikki Tate, Stefania Alexandru, and Audrey McClellan for their help in editing. Annie Weeks for her beautiful design of the book. This could not have happened without them.

Barry Herring, who generously came and took photos, both for the cover of this book and within it. Photographers Trevor Mills and Janet Dwyer for taking slides of my work over the years, and without whom I could never have amassed these images.

The memoir-writing group, where it all started: Debbie Yaffe, Dorothy Field, Charlotte Atlung Sutker, the late Jannit Rabinovitch (who had the idea), Susan Moger, Margo Farr, Nancy Issenman, and Jill Swartz.

The people who have supported my physical body throughout these years: Dr. Shannon Miller, Brian Lynn, Runa Fiander, and Bunny Sjogren, who I am forever indebted to.

My friends in Chicago, who continue to advise and encourage me: Lois Hauselman, Essie Landsman, Sondra Epstein and Lesley Ludwig.

The artist community here in Victoria who are my peers and my friends: Betty Meyers, Heather Keenan, Trish Shwart, Roberta Pyx Sutherland, and all the artists at Painters at Painters. I am so proud to have been asked to join that wonderful group. Especially Robert Amos, who nominated me and whose idea it was originally to do a book based on autobiographical imagery.

To the galleries: the AGGV, where I've been privileged to show my work in three one-woman shows; Mercurio Gallery, which has shown and supported my work; Polychrome Gallery, which has shown my work; Martin Batchelor Gallery, where I have had two very successful exhibitions; and all the other galleries that have encouraged me throughout my long career.

My studio group: Susan Corner, Betsy Tumasonis, Linda Lange, Linda Maasch, Karen Whyte, and Kath Farris. We all help each other and add so much pleasure and sharing to what is really solitary work.

My friends in Victoria, who have supported me in so many ways throughout the years by coming to my exhibits and buying my work. To all the people who have helped by talking to me about my paintings, being moved by the work, and following whatever I've done. I am so grateful!

CONTENTS

"There's only one thing I know to do," I said. "And that is to teach" . . .

"But Saar," she said, "Fokir can't write or read, and that's true of many of these children. What will you teach them?"

I hadn't given this matter any thought, but the answer came to me at once. I said, "Kusum, I'll teach them to dream."

—Amitav Ghosh, *The Hungry Tide*

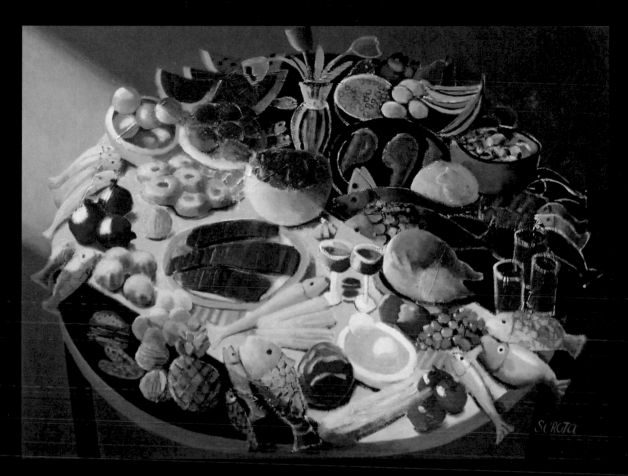

THE GOOD TABLE

THE GOOD TABLE

I saw this painting in my mind's eye. When these images come to me, they are gifts. I was thinking of including all of the foods we ate as children, a rich and varied assortment.

ACRYLIC ON CANVAS, 44" X 60", 2002, PRIVATE COLLECTION.

Should I start with a still life of food? The table sagging under the weight of bowls of tomato soup and crackers, big fat hamburgers made with garlic and onion and broiled in the oven, a fruit bowl overflowing with apples, oranges, bananas, peaches and grapes, rye bread with caraway seeds, veal chops fried in eggs and bread crumbs, mountains of french fries and fried onions, and fish, all kinds of fish— Lake Superior whitefish and fried perch, broiled and boiled and smoked fish. The rest of the table is filled with fish: they are hanging over the edges, big silver ones, little fried smelts, pieces of gefilte fish and very thin slices of lox, all piled up, clean and glistening in the light.

The still life is lit by an overhead light fixture, and the floor is made of big red and grey tiles. The walls are yellow. There is an old porcelain sink, the smell of coffee in a glass percolator perpetually simmering, and the noise of the apartment building. All of this is happening in a third-floor walk-up with big wooden back porches and smells of the neighbours' cooking, and their mostly muffled voices occasionally coming to us with a loud laugh or a baby's cry.

The people we see coming and going from the table are a little boy with golden hair and a slightly crooked smile, and a big girl of thirteen with dark hair and green eyes. There is another girl who wears glasses and is smaller and quieter than the big one. She is watching. There is a man wearing an undershirt and baggy pants who brings the fish home from his job in the fish market. The others try to avoid him if possible. And there is the woman. She wears glasses and an apron and always seems to be in the yellow kitchen, mostly bringing the plates to the table and then taking them away to wash in the big old sink. Sometimes she gets down on her hands and knees and scrubs the red and

grey floor tiles. She wears an expression of seeing more than this room, of being somewhere else, perhaps in a dream where this family would be cleaner and quieter and more like her imaginings of her friends' families. Yet she continues to bring the dishes to this table.

Her name is Sarah and she has tried all her life to do the right thing. She serves the fish on Tuesdays, Thursdays, Saturdays, and Sunday mornings. The other days she cooks the big hamburgers and french fries, the steaks and salads, and the chickens, which she buys alive from the chicken store and makes into soups and salads. She does all of this and she cleans the kitchen and the other rooms, she washes the windows and puts on lipstick and rouge, beautiful, beautiful good Sarah.

Maybe there is another table towards the back of the canvas. A restaurant table, where these people eat all the other foods they like, the foods that aren't necessarily kosher. Chop suey and big platters of barbecued steaks, bacon, the ham sandwiches that Sarah eats for lunch when they go downtown, thick corned beef sandwiches and ribs and hot fudge sundaes and apple pie with vanilla sauce.

Perhaps the painting shouldn't be a still life at all. Maybe it's a painting with movement—everything in flux. Because of their movement, the figures are indistinct. The golden-haired boy is grown now, and the big girl has moved away with her husband. The younger girl is still here; now she cooks the food for the family. She cooks the steaks and the broiled fish and the french fries and fried onions. Now the family eats scrambled eggs, frozen spinach with cream sauce. The younger girl likes to experiment with gravies and stews.

Where is Sarah? She has gone to work. Now she brings the fish home from her store—the Lake Superior whitefish, the perch, and the lake trout. The man is still here, and they are still afraid of him. He never cooks, but he gets really mad when the toast is burned or the steak is undercooked.

When company comes, Sarah cooks again. The table is filled with baked fish smothered in tomato soup; baked potatoes scooped out of their shells, whipped, and put back with butter and paprika; and coffee and coffee cakes. Sometimes Sarah bakes a chocolate cake, but not often. When it's a Jewish holiday, the table is always complete with all the traditional dishes, and on Passover even the dishes themselves are changed.

If I paint the indistinct figures at another time, it seems that the man is gone, and where is the little boy with the golden hair and the crooked smile? Now even Sarah is gone. Only the big girl with the dark hair and green eyes is still there at the table with the younger girl. But now the table is empty, except for the bones and the head of one large fish. They are pulling on this skeleton from either side of the table.

Much later, we see the same two women. The table is now very long—they sit far away from each other; they no longer pull at the skeleton that lies between them. They are finally quiet. It's almost dark.

FOOD IN OUR FAMILY

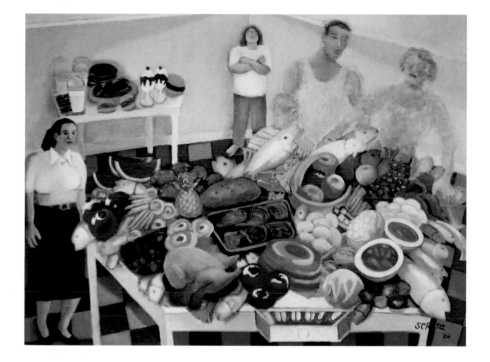

FOOD IN OUR FAMILY

This painting was inspired by writing about food in our family. In the forefront is our white metal kitchen table. It included a drawer for silverware and was the centre of our kitchen. The table standing at the back of this kitchen holds the foods we ate in restaurants. The ghostlike figures—my brother, my father, and my mother—have all passed away. Only my sister and I are left. Sondra stands at the left of the table. I look, and I watch; I am separate from my family, as I always was. Observing, listening, recording, preparing for my eventual role as the family's chronicler—a role I never anticipated.

ACRYLIC ON CANVAS, 44" X 60", 2003, COLLECTION OF DR. MARCEY SHAPIRO.

NEW PLUMS

This is the first time I used the device of the texture that was part of the tablecloth. A very special painting for me.

ACRYLIC ON CANVAS, APPROX. 24" X 36", 2005, COLLECTION OF PATRICK STEWART.

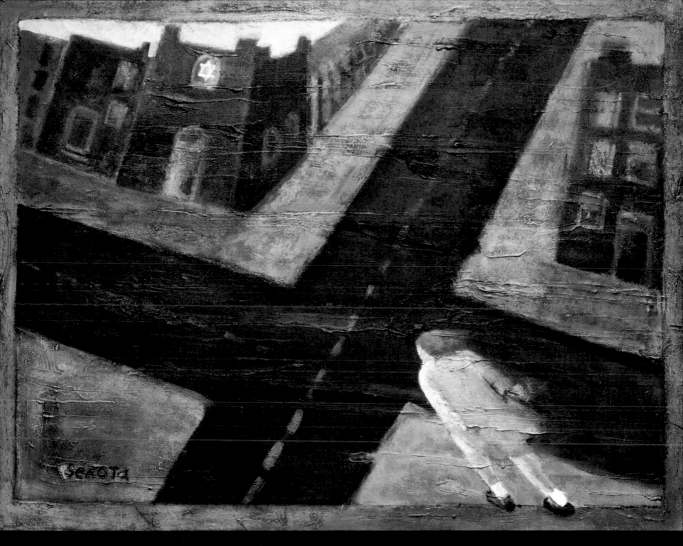

A POEM ABOUT MY CHILDHOOD

A POEM ABOUT MY CHILDHOOD

This is one of a series of autobiographical images I did in 2002.
I was using the device of a border to separate the image in time
from the present. All the paintings in the series make extensive
use of texture. I've always wondered why I remembered this
moment because nothing out of the ordinary was happening.
Why do we remember certain things? Perhaps I was fully
present in that moment; I had a strong sense of myself right
then, something that wasn't always true. My most vivid
memories of childhood are of the times when I was alone.

What makes a poem?

ACRYLIC ON CANVAS, 44" X 60", 2002, COLLECTION
OF THE ARTIST.

When I was eleven years old I lived on Keeler Avenue, on the west side of Chicago. All my friends lived not far away on Kildare Avenue then, so every day I walked a couple of blocks to see them. I passed Sam's, a small grocery store on the corner, walked in front of the old red synagogue on 13th Street—its weed-filled yard mouldering behind a wrought-iron fence—until I reached Kildare. On that corner, I stopped and listened if I heard the beautiful sounds of a violin: the neighbourhood prodigy, Sammy Magid, was practising. He later would become first violinist with the Chicago Symphony Orchestra. Every time I was walking, I was afraid I would meet up with a dog. All dogs terrified me, big or little, and if one happened to be on the street, I would hide in whatever hallway was handy and pray that the dog would soon go away.

Finally, I would get to my friend Lois's, or Marsha's parents' tiny grocery store, or Essie's apartment, or just hang out on Kildare with my friends. We could go on to Franklin Park, which was at the end of the street. In the summer we played volleyball or baseball, and in the winter, when they flooded the huge fields, we ice-skated on the bumpy, grass-laden ice.

Walking was the only time I got to be alone. There was no privacy in our house; we didn't yet know what boundaries were. My sister and I shared a room—small, hot in the summer and cold in the winter. My father ruled our two-bedroom apartment with an iron fist and his handy leather belt, and gave us no chance to contemplate life, to ask ourselves those important questions one needs to ask. Only on my walks was I alone.

The neighbourhood was primarily brick apartment buildings: two

WALKING IN CHICAGO

FRANKLIN PARK (THE DEEP POOL) HOMAGE TO DAVID HOCKNEY

We would go swimming in the summer at Franklin Park. There were two pools—the deeper one was circular and uniformly twelve feet deep.

These are all real people from my childhood including our gym teacher, Miss Wright, who is directing us from the far side of the pool. I also appropriated a swimmer from a David Hockney painting. That figure helped to bring this entire complicated painting together.

ACRYLIC ON CANVAS, 44" X 60", 2002, COLLECTION OF THE ARTIST.

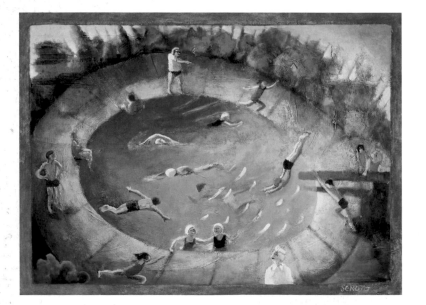

flats, four flats, and larger buildings with courtyards in the centre. There was one common flowering plant, called a four o'clock. It would bloom every day in the late afternoon. But most of the yards were dirt with a few weeds. No one planted flowers.

What there were was lots of people. All kinds of people, mostly Jewish and mainly families with young children. This was what is now known as a "high density" neighbourhood. The people were practically all working class, with a few professionals thrown in. We were all semi-poor, but it didn't feel that way.

One day, when I was eleven years old, walking on Kildare in front of the building where Beverly Mozak, my cousin Bobbie Golden, and Sue Bass lived, I asked myself the all-important question, "What will I be when I grow up?" I believe it was the first time I asked myself that. My answer was simply, "I guess I'll get married, have kids, and maybe . . . travel."

Well, I did do those things—but so much more happened to me, things I never could have anticipated, understood, or imagined. I got married, had kids, and travelled, but I also went to university and became an artist, supporting myself with my work for over thirty years. I moved to another country, Canada, in my early thirties. I left my husband and have lived with a woman now for thirty-eight years. Was I just so programmed that my imagination never learned to fly? Why were my wants, my needs, my ideas so limited, so constricted? Was it the times—the late 1940s, after the war? Or is it just how children are?

This is the story of how that girl became this woman who today walks on very different streets. These streets are filled with beautiful parks and flowers of every imaginable colour. There are snow-capped mountains visible from close by. Every day we walk our beautiful young dog down to a bay on the Pacific Ocean. How did all of this happen?

This is that story.

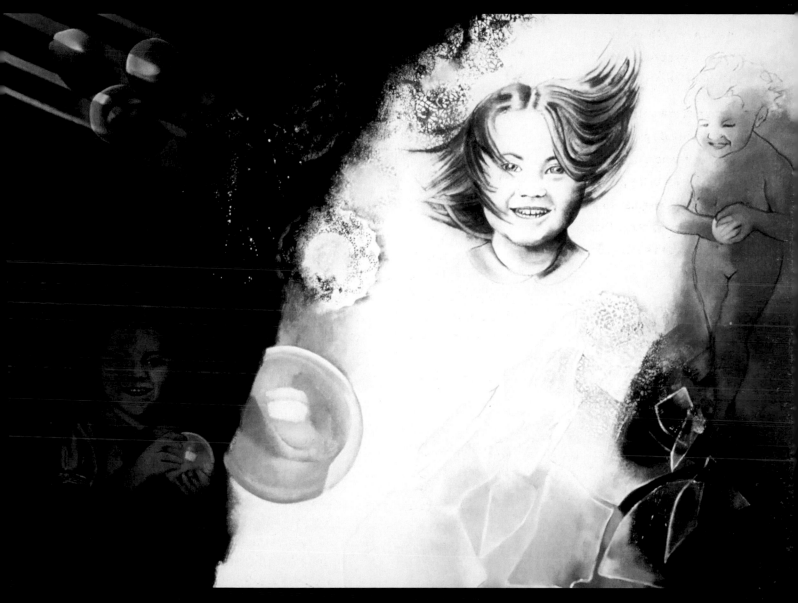

GLASS

GLASS

This is what I would call a virtuoso piece, showing all the things I could do at the time I painted it. This painting was done in an improvisational, intuitive way during the period when I discovered black gesso. I started the painting with a furious application of that material, using a doily as a stencil. I remembered a photograph taken of me at four years old with a glass ball and found that photograph, which is painted in the lower left-hand corner of the painting. Then I had a vision of a wild child, not the tame one holding the glass ball but perhaps one I could have been under other circumstances. She was done in black and white. Then the idea of broken glass came into my mind. I think the glass had to be broken in order for the wild child to actually emerge, but I had no broken glass. Soon after, however, a piece of glass serendipitously fell from my studio window onto the ground below. I photographed the broken glass and carefully painted it into the lower portion of the painting. All that remained was the drawing of my granddaughter Sonja, who was two years old at the time and in her "wild child" phase. I added the small still life in the upper left-hand corner because I had been working on still lifes.

I love the paintings I have done in this improvisational way because of the freedom I felt doing them. But I can only do them occasionally and then I have to go back to planning and having more control.

OIL, CHARCOAL, ACRYLIC ON CANVAS, 44" X 60", CIRCA 1993, PRIVATE COLLECTION.

What I have been told of my early years is sketchy. My mother had a difficult labour and the birth was slow, so the doctor had to pull me out using forceps. It is still hard for me to let go. I seemed to develop normally, except I didn't talk until I was two. My parents were very worried about that because my mother's sister had Down's syndrome and here I was, not yet talking. They always told the story of taking me to the doctor's office to tell him about this: while they were undressing me on the table, I looked up and saw a photo of a baby. I then said, "Baby." The doctor asked, "What are you expecting—that she'll have a philosophical discussion? She's fine!" Since then, it's been hard to shut me up.

All my early memories are connected with light. My first, very vague, memory is of seeing light in a back room of our first apartment. Later, a rectangle of light on the outside brick wall as I was leaving that building with someone. Perhaps it was the young German woman, Hilda, who took care of me. She left before we moved from our first apartment, and I never saw her again. When I asked my parents about her, all they would say was that she had a boyfriend named Ziggy, and that they would kiss for long periods of time. They would just have their lips together, which my parents thought was very odd. So I never heard much about Hilda's disappearance, and it's remained a mystery in my life.

My mother had a beauty shop, and Hilda had been hired to watch my sister and me. The story was that she took us to church, which, because we were Jewish, my parents were definitely upset about. She may have been fired because of that, or maybe because my mother gave up the beauty shop and stayed home with us until I was thirteen.

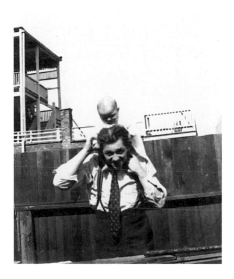

The first known photo of me, on my father's shoulders in 1938.

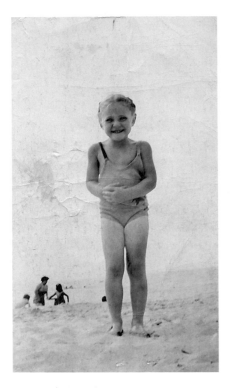

Here I am, about five years old, on the beach in Chicago.

And this memory: when I was four years old, I woke up with a severe stomach ache, and my mom carried me first to the pediatrician's office, then to the surgeon's, and finally to the emergency room. I remember small snapshots of movement and pain and, overriding all of this, my mother's worry. The problem was my appendix. I remember being on the operating table, where a large black balloon was put over my mouth and nose and I smelled a strange odour. The doctors told my parents that my appendix would have burst in another fifteen minutes and that I would have died.

I woke up in a big bed, not a crib like I had at home. I was in a beautiful new hospital in downtown Chicago. On the children's floor, all the walls between the rooms were made of glass. After a while I got to ride around in a wheelchair; there were toys, blocks, books, and even paints and places to stand when you wanted to paint. The colours had a deep, exciting smell. I loved paints. As soon as I could stand up, I used them.

The doctors and nurses were so kind to me, they told me they loved me. I had never experienced anything like this; at home they called me *mieskeit*, the ugly one. I was delighted and surprised to be loved and told that I was cute. On my last day in the hospital, the doctor brought me a red rose—my first flower. He was a famous surgeon, and other doctors still think my scar is a work of art.

This was in 1942, and the United States was deeply immersed in the Second World War. Many foods were in short supply, and when my parents came to pick me up and asked me for a kiss, I said, "No, I'm sorry, kisses are rationed." They drove me home in the car, laughing about this, and so happy that I was coming home. It was my first joke; my parents thought I was clever, and later they told the story to everyone.

When I got home, it was back to my crib. I felt so confined that I screamed and hollered that I'd had a big bed in the hospital and I hadn't fallen out. I yelled, "I'm too old for this baby bed!" My parents bought me a real twin bed after that. Actually, they bought my sister and me a whole new blond bedroom set. I had won!

So, this story had a happy ending: the *mieskeit* became the Cinderella. I had uncovered a new sense of myself that would remain with me. From pain and confusion my sense of humour had been born. My strongest sense of myself has always come from the outside world, not from my family.

I always loved school. On my way there, I skipped and sometimes sang to myself. I was considered "the smart one," and my sister, Sondra, "the pretty one." In grade one I sat in the first row, first seat, which was reserved for the smartest kid in the class. I clearly remember sitting there with my hands folded, waiting for the teacher to give us instructions, knowing that all of this was easy for me. I learned to read effortlessly and have never stopped reading. It remains one of my greatest pleasures and something that consistently relaxes me (my favourite place to read now is in the bathtub). I was "skipped" in grade two, and the school supposedly wanted to skip me a couple of times after that, but my parents said no. They thought it would be better for me to be with children closer to my own age. I never got into any trouble in school until I was older, when I would get checks on my report card for talking too much.

I hated taking baths and wanted to be dirty all the time, but once a week my mother would force me to have a bath and wash my hair. Then she would sit me down for the ordeal of combing it out. I would scream, cry, and try to bargain with both my parents, but they would pay no attention: "You're going to smell. What kind of girl are you? You're going to get lice. Sondra is always clean—she loves to get her hair brushed. Barbara Dubinsky"—my nemesis in the extended family—"always looks like a lady."

If you saw me as a girl of eleven, you would have seen a round-faced girl with smallish eyes and what was then called dishwater blonde hair and thick blue glasses. I was a stocky, short, strong, no-nonsense kind of kid, usually known as a tomboy. My family always told me that my father had wanted a boy when I was born. However, I did love to wear pants, and when I discovered Levi's I immediately went out and bought a pair. I remember being at the store and finding out how to measure the waist and the legs, and the distinct, precise smell of the Levi's and the way they sounded as I walked. I felt so grown up, so cool.

My friend Lois was the first person I truly loved (aside from my family, about whom I had more ambivalent feelings). Lois, who told me where babies came from, who was the reason I started walking over to Kildare Avenue in the first place, who led all of us with a gentle, adventurous hand. The person who, at ten, was already writing short stories, which really shocked me. I had no idea that a kid could do that. Lois

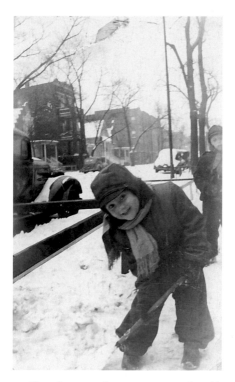

Clowning around: me on our street in cold Chicago, about 1944.

went to summer camp just before I did for the first time, and when she got back home I got up early, and because I didn't want to wake my parents, I went to the drugstore to call her on the telephone to see if she was back. Then I ran to meet her halfway between our apartments. We ran towards each other with open arms; I had missed her so much!

One day when I was ten years old, I went to my friend Sandy Klein's apartment. She and Lois met me at the door and said, "Today, we're going to smoke." I, of course, acquiesced. I was used to Lois suggesting things that would never have occurred to me. We went in and smoked Lucky Strikes—probably Lois's parents' brand—and from then on I was hooked. My friend and neighbour, Sondi, later told stories about me and my green-and-black-plaid lumber jacket, and a pack of Lucky Strikes in my pocket. Her mother always thought that Lois and I were bad influences on Sondi. She was probably right.

RETURN FROM CAMP CHI

Here, my friend Lois and I are running to greet each other the morning she returned from three weeks at camp. I had missed her so much! It still amazes me how open I was, how unafraid of loving.

OIL ON CANVAS, 20" X 20", CIRCA 1992, COLLECTION OF D. MURRAY AND D. YAFFE.

So, I had these two main friends at the time. Sondi, who lived two doors away, had been my first friend; I credit her with taking me to the Art Institute of Chicago and opening up that side of my life. We were co-editors of our school newspaper, *The Bryant Snoops*, and went all the way through Hebrew school together. And there was Lois—the bad influence, who was a wonderful athlete, creative and rebellious, and so much fun to be with. She and I would sometimes walk along, limping and pretending to be Catholic girls. (I'm not sure why we limped, or pretended to be Catholic, for that matter.) We would talk in what we thought were Irish accents and speak of "Father John" and "Sister Mary." We had so much fun. I would go downtown with Lois for her singing lessons and wait for her while she sang. I can still see and hear Lois singing "It's a Big Wide Wonderful World."

After skipping a half grade I was now in Lois's class, and we hung around together. I'd go over to her house and we would plan parties and run over to the park and make fires in the empty lot. Later we went to an "adults only" movie called *The Outlaw*. It starred Jane Russell and was about Billy the Kid and the woman who hid him even though he was a criminal, a bad man. The sexy part was when he was really sick, cold and shivering, and she said she would warm him up and took him into her bed. That's all we saw of them. That was what was called a restricted movie in the 1940s. When Lois and I came out of the movie into the sunshine, I said, "I feel funny." She said she did too. This was a piece of the sex puzzle: sex felt funny or strange, and the sensation was "down there." Later, Lois moved away from our neighbourhood to another part of Chicago, and my sister's friend said the word *lesbian*, explaining that it meant loving a girl rather than a boy. I became really afraid because I knew I loved Lois. The next year, when she came to visit, I didn't even welcome her. I was afraid of the sexual word, *lesbian*.

When I walked along I pretended to be OK, hiding the violence of our home, which was terrifying for Sondra, Bobby, and me, but none of us could talk about what went on behind our doors. It was our secret; no one outside the immediate family knew. We never said how afraid we were most of the time, how our childhood was not what others thought it was. We would all be marked by the violence, terror, and disrespect with which we lived. At seventy-three I'm still living with

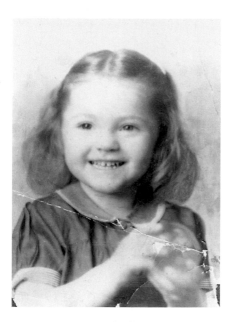

A posed photograph of me, taken in a studio, about 1944.

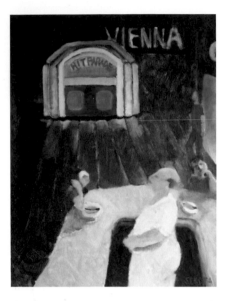

"COME ON–A MY HOUSE"

When I was eleven years old, I would walk down to Kildare Avenue. There was a deli there called Zimblers. They had a jukebox—the first I'd ever seen. One day, when I walked in, this song by Rosemary Clooney was playing. It was loud and thrilling. I'll never forget that moment and how much I loved that song.

OIL ON PAPER, APPROX. 30" X 20", 1979, PRIVATE COLLECTION.

that fear, yet I continue to put up the brave front of the strong, young girl being funny, still coping. The ties of the family are dark and enveloping, foggy and damp. They were right: blood is thicker than water, but water has always been good for me. I'm a natural swimmer.

When I was ten, a group of girls on my block got together for what we called The Dirty Club. We would talk about what we knew about sex. Did everyone do it? How did it feel? One of the girls, the only one of us who already had her period, had seen her parents making love. She described this in detail for us, and even showed us the position she had seen them in—missionary, of course. We all wished we would get our periods. I had seen a Disney film about the mechanics of this and was anxious to try it all out. The Dirty Club, dirty girl, dirty jokes—I thought dirty and sexual must be the same thing. Of course, I did not want to be considered dirty. After all, "Cleanliness is next to godliness," as my parents reminded me daily.

I was strong and a good athlete, usually second or third best in competitions with my friends. In high school, I became a very good softball pitcher. We played in leagues at Franklin Park. We had a wonderful gym teacher, Miss Wright, who ruled us with an iron fist but taught us about good sportsmanship and meeting our obligations. I also played volleyball, and in those days we would hit the ball twice: once as a set-up, and then again either over the net or to a teammate. Some of us could do wonderful set-ups on that first hit. I'm sorry the rules of volleyball changed to just hitting it once; I think that took all the poetry out of the game.

I had lots of other friends too, all of whom gave me great gifts. I consider myself very lucky always to have had very good fortune with friendship. When I was twelve, I hung out with a large group of girls in a club called The Beau Esprits. One day, one of our members told us that her brother was probably "screwing" his fiancée. I decided that I couldn't be friends with anyone who thought this was OK. Some of us had an impromptu meeting on the fire escape at our school to discuss this. It was summer, late afternoon, and the school was deserted. We decided that we would only be friends with each other. All of us— Essie and Sondi and Marsha and I—thought it was wrong to make love before marriage. That pact held for a long time.

I wore gym shoes, what they now call runners, and short socks.

I still dress in the same way, even though the outer edges of my life have drastically changed. I was always a rebel at home, and I did continue, from that early beginning, to smoke. My rebellions were always the source of my problems with my father. I wanted to do things my way, and still do. I still see myself as that sturdy little girl: funny, afraid, creative, a tiny bit brave, and finally alone.

LIGHT—FIRST MEMORY

This first memory really is about light. Hilda, the woman who watched over me, and I emerge from our apartment on Roosevelt Road in Chicago and see a block of light on the building behind me. I have no idea of the last time I saw Hilda, but I was very young. Maybe this was the last time.

OIL ON PAPER, APPROX. 30" X 22", CIRCA 1978, COLLECTION OF B. DIFIORE.

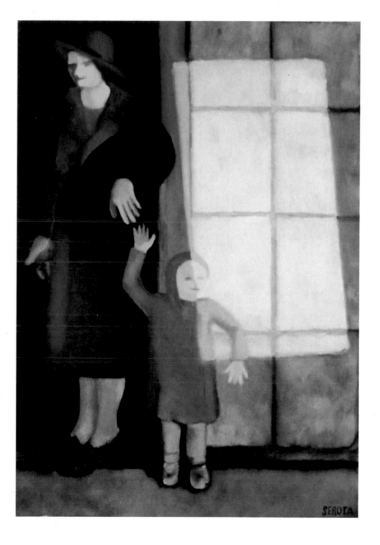

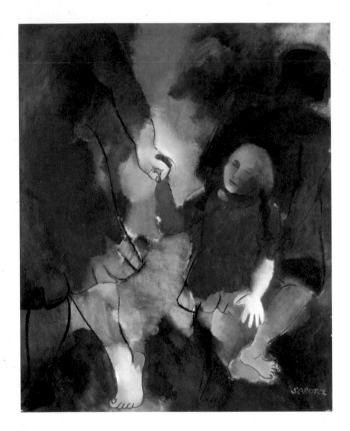

RED—FIRST MEMORY

About *Light* and *Red*

In the early 1990s, I experimented with working on a thin, translucent paper called vellum. I started out doing an abstract painting, one that had some red, grey, black, and pink spots. After I was happy with the colour composition, I came in with charcoal and did the line drawing. I didn't know what I was going to paint or what I was going to draw. I enjoy looking at these paintings, which collected together formed an exhibition titled On the Edge. However, it was a very tense way of working, and I soon retreated to having sketches and working from those or from other sources. There were many paintings in this series, all painted with oils on vellum.

The subject matter is basically the same as that in *Light—First Memory*, except that I added the figure of my mother taking me away from Hilda, who was now gone.

OIL ON VELLUM, APPROX. 36" X 30", CIRCA 1990, PRIVATE COLLECTION.

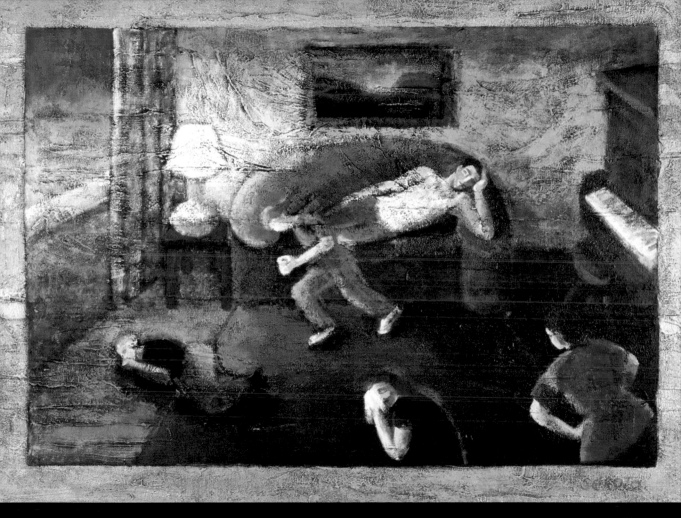

1220 S. KEELER

This painting again uses the device of a border to define the time that has gone by since the events depicted in it occurred. There we all are, the family in our living room at 1220 South Keeler: my father lying on the couch, my mother calling us to dinner (we had dinner together every night), my sister upset about something, my brother removed (as he could be), and me bringing my father a glass of water. Wherever my father was—even if he was standing beside the kitchen sink—he would yell to us to get him a glass of water. And did we run to do just that! We lived in fear of his temper.

There was one painting over the couch in our living room; I've taken my artist's prerogative and made it one of my own paintings.

ACRYLIC ON CANVAS, 44" X 60", 2002, COLLECTION OF
ERIC AGES AND RICHARD MOSSELMAN.

My family lived in the apartment building on Keeler Avenue from the time I was four, in 1942, until I was thirteen, in 1951. There were five of us: my mother, Sarah; my father, Sam; my older sister, Sondra; me, the middle child; and my younger brother, Bobby. The L-shaped building was made of light brown brick and had twelve apartments. A large brick marker, in the shape of two pillars that were four- to five-feet tall, served as the entranceway that led into the building's small courtyard.

Our apartment had five rooms—two bedrooms, a kitchen, a living room, and a bathroom—and was on the third floor. On my way up both the front and back stairs, I could hear what was happening in the other apartments and even smell the way each family's life differed. The Cohens, on the first floor, had a son who peed his bed, though he was older than I. On the back stairway, where they hung his sheets to dry, I could always smell urine. I'll always associate the Shipkins' apartment, which was directly beneath ours, with the smell of fried salmon patties. That was exotic to me because our family was in the fish business and ate only fresh fish.

Our kitchen had a red-and-grey-tile floor. From the window, you could see the building next door that butted up against ours. The walls in the kitchen were yellow, and there was a white metal table that had a drawer in it where we kept our silverware. On the Sabbath, my mother spread a white damask cloth on the table before she lit the Shabbos candles. It stayed on the table until Saturday night because "one could do no work on the Sabbath." When my cousin Paul slept over, we played under the table, and the white cloth was like a tent all around us. The kitchen was large compared with the rest of the

IN THE KITCHEN

This is the scene I have described in words many times: my father striking out at me in our kitchen, my mother's ineffectuality at restraining him. It almost looks like a dance. Was it?

OIL ON PAPER, APPROX. 22" X 30", CIRCA 1982, COLLECTION OF DR. MARCEY SHAPIRO.

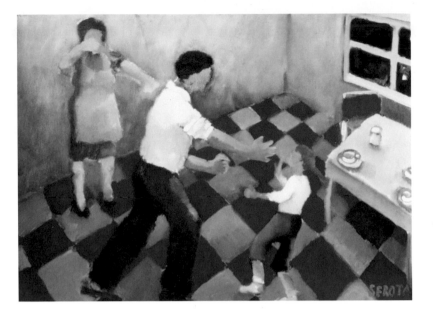

apartment, and you could walk out onto the back porch that we shared with our neighbours, Sidelle, Hy, and their son, Lesley. We kept odds and ends—ladders, tools, and rope—on the porch. However, the porch was as immaculate as the rest of our apartment. There was a screen door leading to the back porch that made a soft, creaking sound when it closed slowly. Sometimes, in the summer, my father would bring home "sweet corn." We would shuck it on the porch and then eat nothing else for supper—just corn, salt, pepper, and butter—a feast!

My mother washed the kitchen floor every day, down on her hands and knees, and she laid newspaper on it while it dried. She washed all the windows once a week, using a pail with vinegar water and rags, inside and out, winter and summer, for the ten years we lived there. She would sit on the window ledge of our apartment on the third floor, her body outside the window and her thick legs hanging down from the ledge inside.

So much of our life was centred in the kitchen: it was the heart of our home. All the dramas of my childhood, and there were many, were played out there. My father's legendary temper—Daddy striking out at us—always happened in the kitchen. My brother remembered my father hitting me with his belt, and me crawling under the porcelain

sink to get away from him. He reached under and got me again, according to Bobby, who laughed as he told me this: "He didn't fool around!" There was a running joke in our family that Daddy broke my glasses every Tuesday night. This is what passed for humour in our enraged, anguished family. Usually the fight started with a political discussion, often about racial issues—my father was a racist, and this upset me terribly. Whoever did not agree with Daddy would eventually get hit. I can still see my small blue glasses lying broken on the red-and-grey-tile floor.

Daddy talks about his day at work, and because he works in the wholesale fish market in Chicago, he works with black men. He tells us stories about them. Maybe they've had an argument and one of them has pulled a knife or a razor blade and "cut" the other one.

He says, "They're just animals, all of them, just animals, they're not human."

I say, "Daddy, they are human. I know some kids at school that are Negroes and they're just like us. We are all human!"

He says, "If you knew them, if you worked with them day after day for twenty years, then you could talk, but I've worked with them and they're animals. All they care about is sex and having a new car and cutting each other."

"They're not!" I say, and quick as a flash, Daddy has his belt off and I'm running, but he catches me, and before I know it I'm on the floor and he's hitting me with his belt. Curiously, while he's beating me, I feel nothing. Not the belt or my body hitting the floor or even my glasses falling.

But I'm screaming, and no one helps me. My mother yells, "Sam, stop!" but he continues. My glasses have broken. My sister and brother watch and are afraid to step in. They're just glad that Daddy isn't after them this time.

When he finally stops, I run to my bedroom and lie face down on my bed with its pink chenille bedspread and I cry: huge, wracking sobs full of shame and horror and futility and impotence. Shame at having a father who is ignorant. The same kind of shame I feel later when I learn about the Holocaust, the shame of being a human being and realizing the harm we do to each other.

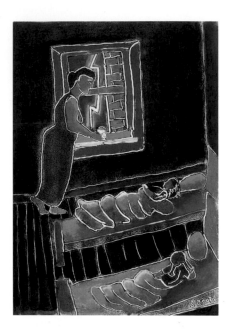

CATCH THE LIGHTNING

An example of a monotype. After the monotype ink is dry, I will often paint on it with acrylic paint.

ACRYLIC ON MONOTYPE, 17" X 12", 2004, COLLECTION OF THE ARTIST.

My sister and I shared the bedroom. Its single window faced north and, again, you could see the building next door against our only window. Summers in Chicago are unbearably hot, and whatever breeze did manage to get in would cool only my sister's bed. I would plead with her to change beds, but she never let me. Our furniture was a modern, blond pine set, with twin beds, a dresser, and a highboy. I would climb onto the highboy and enjoy jumping from it onto my bed. I did this over and over again. There was no rug, and the window had venetian blinds.

When it was a stormy night, my mother would pad in with her bare feet and her nightgown to put a glass of water on our windowsill, to "catch the lightning." I think it was something her mother had done, and I thought that everyone's mother in the old days had done this. But I have found only one other person who knew about this, and she was from Austria and was much older than I. People say "May your house be safe from tigers," and the joke is, have you ever seen any tigers in your house? Well, we never got hit by lightning.

When you came into our apartment, the first thing you saw was a beautiful French cedar chest that my mother got when they married. It opened from the top and had curved legs, inlaid colour panels, and a lovely woody smell. Once, when Sondra and I had our best friends sleep over, someone said the chest looked like a coffin. After that, we thought we saw monsters in the shadows.

A hallway connected all the rooms, and its floor was marbleized black-and-white linoleum. Directly opposite our bedroom, just a few steps away, was my parents' room. It had an old, very beautiful bedroom set made of warm brown cherry wood with inlaid coloured pieces, which my mother and father had also bought just after getting married. Their bedroom had a slightly holy feeling: quiet, clean, and somewhat dark. They had a white chenille bedspread and a blue carpet. The room was later crowded with the baby's crib; in our two-bedroom apartment, there wasn't anywhere else for little Bobby to sleep.

My father had a highboy for his things. Its top drawer was divided into three compartments. Although it was strictly forbidden that I open my father's drawers, even now I can remember their smell of cedar. Propped on top of the highboy was a photograph of an old man dressed in Chasidic clothes: my grandfather, Philip Serota. He had

spent his entire life as a scholar. I was named after him because he died two weeks before I was born.

Next to my parents' bedroom, in the hallway, was the radio—a large floor model that in the 1940s we all crowded around to listen to Joe Louis boxing and, later, to hear The Shadow on Sunday afternoons. Also in the hallway was a small table that held the telephone and the box that came with it, where we had to put in a nickel to make a call.

The bathroom was a small white room, its floor covered with white hexagonal ceramic tiles. The only room with a lock on the door, it was where I ran when I needed safety. Sometimes, when my mother was mad at me, I'd make a dash for it and I usually could get there before she did. She was neither as fast nor as scary as my father.

PHILIP SEROTA

My grandfather Philip died two weeks before I was born. I was named after him. This painting is based on a photograph my father had placed on his dresser. Painting this portrait was one of the best painting experiences I've ever had: I remember quite clearly painting the background. I was so grateful I had the opportunity and the skill to do this that I cried.

OIL ON CANVAS, 60" X 44", 1985,
PRIVATE COLLECTION.

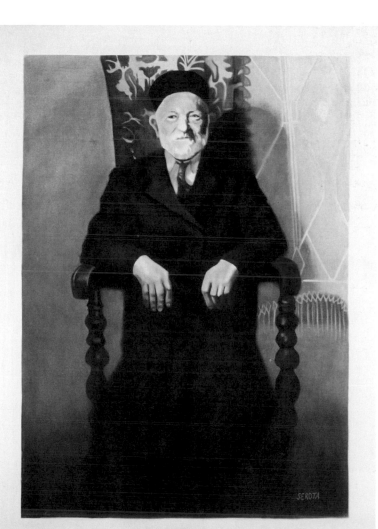

Mom washed all our clothes in the basement once a week, using a wringer washer. Then she carried them up to the third floor and hung them on the line with clothespins. The washline stretched from our back porch all the way across to the back part of the building. My mother was tireless.

The living room was the largest room in the apartment. There was a window that looked out to the front of the building, and a bank of three windows that overlooked the building next door. That building had an apple tree in its backyard—the only fruit tree I had ever seen. It had beautiful white flowers in the spring. In the late 1940s, my mother decided to redecorate the living room, and there were many conversations about colour. My parents finally decided on yellow green and maroon (which turn out to be opposites on the colour wheel). Most

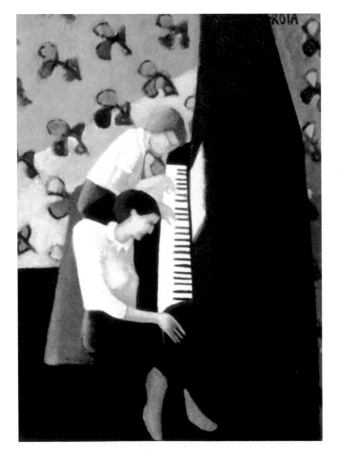

ME AND MISS ARANOWITZ

Once a week a piano teacher, Miss Aranowitz, came and gave me lessons. She was very tiny and had a big bone in her back. I had never met anyone else who was a hunchback. She was very precise and an extremely good teacher. I had been really excited about getting a piano and took to it with great enthusiasm. In this painting, I'm trying to recapture our living room wallpaper and where the piano was situated in the room. The other thing I remember about her coming was that once she said to me, "Would you please wash your hands," and I went and did that. My mother said to me, "Weren't you ashamed?" I hadn't been. This was probably during the time I had given up washing.

The next year I left Miss Aranowitz to take popular music, and it never held my interest. That was the end of my piano playing.

OIL ON CANVAS, APPROX. 24" X 18", CIRCA 1981,
PRIVATE COLLECTION.

things in the living room, including the drapes, carpet, wallpaper, and couch, were either recovered in these colours or replaced with new furniture. Of course, when television came in—again in the late '40s—we bought one: a round-screen Zenith. My parents had tried to wait until colour TV came out before buying one, but they couldn't resist.

On the living room wall, butting up against the hallway, was an upright piano we got from my Aunt Jenny. It was there because I played piano. My parents had asked Aunt Jenny for the piano because I desperately wanted it. For two years I took piano lessons from a tiny, hunchbacked woman named Miss Aranowitz. She was a classical teacher and really challenged me. After about a year, maybe two, there was a big recital at her apartment on a broad street overlooking a wide boulevard. I can still see myself playing the piano in a room totally surrounded by windows. I played well that day.

I later learned that she considered me gifted, but I left her class because my friend Sondi had told me that "popular" music was easier. So I took lessons from Sondi's teacher and got bored and gave it up. All I remember of that time was playing "Peg O' My Heart"—it was not very difficult or interesting.

In the living room, on the fireplace mantel, were two small sculptures: one of a *zaydie* (grandfather) and one of a *bubbie* (grandmother). The *zaydie* wore a long black gabardine and carried a book. The *bubbie* was equally old, stooped over, and wore a shawl. They were about eight inches tall. I don't know what happened to them. I wish I could see them again, and many times I've thought of painting them, but I never have. The only painting in our apartment was hung over the couch; it was predominantly brown, and of a bridge over a small creek. I often stared at that painting, never understanding how crucial paintings would become in my life.

All in all, the apartment was sunny. The living room faced south, and because it was on the third floor, with nothing above us, it was quieter than the lower floors. But we could never stamp on the floor or make too much noise because "there are people living downstairs!"

When I recall that apartment, where we lived for ten years, I feel it has been my only true home. I'm not sure if this is so because these

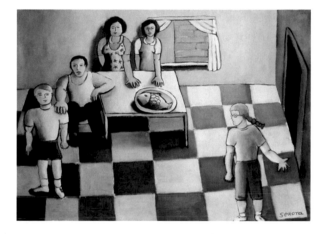

GREEN GIRL AT HOME

Another quintessential painting of me and my family—how I always felt at 1220 S. Keeler. Was I from another planet?

OIL ON PAPER, 22" X 30", 1987, PRIVATE COLLECTION.

years are pivotal in one's development, or because even though our family life was always difficult, I felt at home there.

The building has since burnt down, and the neighbourhood is now considered so dangerous that I literally cannot go home again. I can only see my true home in my mind's eye: my mother in her housedress, sitting outside washing windows; my small blue glasses lying broken on the red-and-grey-tile floor.

SHABBOS EVE

Another view of my family's favourite room—our kitchen at 1220 S. Keeler. A quiet painting of a rare quiet time.

OIL ON CANVAS, 33" X 45", 1995, COLLECTION OF MARNIE BUTLER.

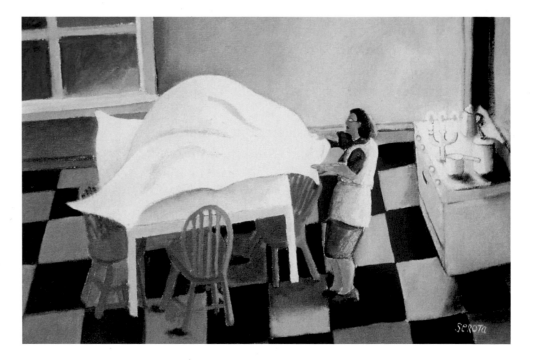

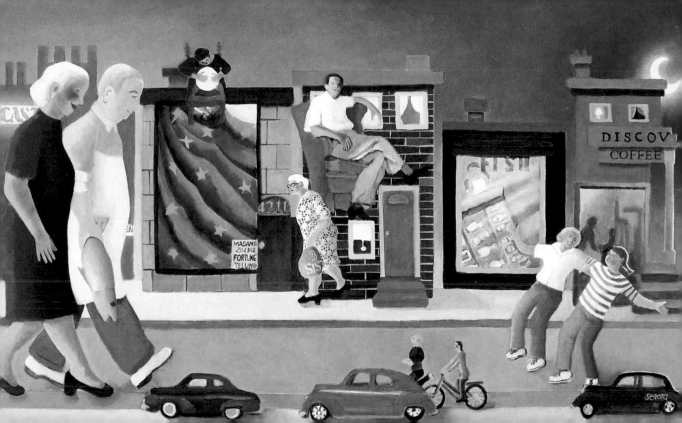

THE OLD WEST SIDE

This is a recent painting, done as a commission, and is a
composite view of Roosevelt Road, the shopping street where
Aunt Rosie and Uncle Jake had their store. Lois and I are
walking down the street, probably pretending to be Catholic.
It is a mystery to me now why this was funny!

ACRYLIC ON CANVAS, 36" X 60", 2010, PRIVATE COLLECTION.

Our apartment was only a small part of a vital, energetic community on Chicago's west side. Lawndale included many extended families, and I was called "Serota" because everyone in the neighbourhood knew I was part of the Serota family. They may not have known my first name, but if someone wanted to call me from down the street they would yell, "Hey, Serota!" I loved that feeling of people knowing that I belonged to my family. Probably one of the intrinsic aspects of being human is the need to belong to something. Even though my immediate family was difficult, I was happy to be part of our larger family, especially to have the connection with my wonderful aunts and uncles.

I remember the constant smell of the stockyards, all through every summer. On the hot Chicago summer nights, we would run around on the streets playing mad, frantic games—hide-and-seek, Red Rover—while that smell, that unforgettable smell, like burning flesh, permeated everything. I can see those nights as tinged with red, like a red film over everything, as though a huge fire was burning nearby, tinting our madness.

When we were eleven or twelve, my friends and I ran around in gangs of girls and could be seen eating pickles as we walked the streets. I remember eating pomegranates, putting my face into half a pomegranate and eating it as we walked or ran. Sometimes we would go and watch the big boys play baseball. We each had a crush on one of the "older boys": they would have been sixteen or seventeen. My cousin Arnie was one of them. Everyone knew that Arnie's mom and dad, my Aunt Rosie and Uncle Jake, owned the fish store, so they called him Fish.

In Chicago, as in many of the large cities in the United States, whole groups of people left their neighbourhoods in the 1950s. In the first half of that decade, in what had been a ninety per cent Jewish neighbourhood, all the white people left and African Americans moved in. I was a child at the time and don't know how our particular neighbourhood went through this change—what started it, how it all began. But I knew when I was young that over on the other side of a large street "those" people lived. Those people were foreign to us, and foreign to me as a child. I remember having fantasies about going over to their side, the other side of that street. There was a strange feeling, in my fantasies, of a totally different sense to a neighbourhood. The idea I had in these fantasies was a dreamlike space. I imagined people sitting on the steps, dark people, and everything moving very slowly, as it does in dreams. This was tinged with a fear of the unknown.

I knew very few African Americans, mainly women who worked as domestics. When I was in grade six, a black girl came to be in our class. It was very interesting for me to meet her. I don't remember her name, but I was fascinated that she was just like we were: just a kid, a shy kid. After a while, another two or three black kids joined our class. Again, I saw that they were human, nothing more, nothing less. Everything about them was just about the same as us, except for the dark colour of their skin.

In 1950, just before the changeover in the neighbourhood, my mother and my cousin Arnie decided to open a fish store in a totally different part of Chicago. I didn't want to leave our home: I could walk half a block down from our apartment building and visit with Aunt Rosie and Uncle Jake, or walk another block up in a different direction and be at Aunt Jenny's house. I belonged to a girls club with about twenty girls my age. I played ball at Franklin Park with two teams, a volleyball team and a baseball team. I'd gone to Hebrew school half a block from our place. But it was my parents' decision. During the next three years, everyone I knew moved away. The Jewish neighbourhood had been both working-class and middle-class, whereas the black people who moved in were much poorer.

While I was writing this memoir and describing the neighbourhood, my partner Annie and I decided to look at Google Earth. For people who aren't familiar with this, Google Earth is a way you can look

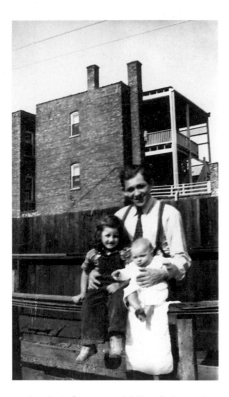

Sondra is four years old, I'm a baby, and our father seems happy. It's 1938, and you can see the backs of the apartment buildings.

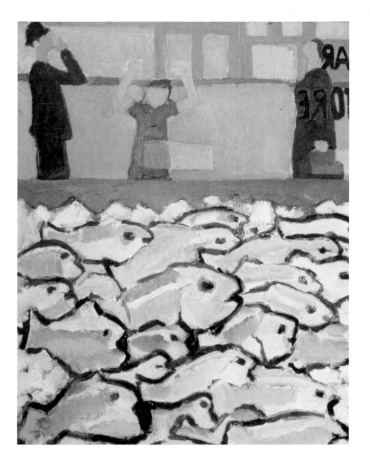

LOOKING IN THE FISH STORE

This is an early painting of me looking into the window of my Aunt Rosie and Uncle Jake's fish store. I was always looking at the fish. Now I see why. This was the preparation for doing countless paintings featuring fish of all kinds.

OIL ON PAPER, 30" X 22", CIRCA 1978, PRIVATE COLLECTION.

at a place as it is now. When you type in an address on your computer, Google Earth zooms around and settles down as close as possible to the location you've asked for. And you can see it! So we did this. We zoomed in, and there we were at the corner of Keeler and Roosevelt, half a block from our old apartment. Roosevelt was the big street that the stores were on. Aunt Rosie and Uncle Jake's fish store was there; Benny's Fruit Store, the Castle Baking Company where we bought rye bread every day—everything. The streetcars ran on Roosevelt Road. What I saw on Google Earth was the building at the corner, where Jastrom's Drugstore had been. This drugstore was a really important part of my childhood. We went there if we had something in our eye, if we had a stomach ache; whatever was bothering us, we went to see the druggist first, before going to the doctor. Jack Jastrom was a tall, kind,

I CAN'T GO HOME AGAIN

This is my street, Keeler Avenue, as it was. I painted the buildings as shells of what they once were because of the fires that decimated this neighbourhood in 1968. But when I look back at it, I look back on what it was like when I was a child.

These are some of the main characters that populated our street for me. From the right come my Uncle Jake (he's carrying a fish) and my Aunt Rosie. They're coming from their fish store around the corner. They are approaching a little boy peeing in the alley (the boys always peed on that wall, and I couldn't). Our building is two buildings over, 1220 S. Keeler.

There is a marker of sorts in front of our building, pillars on the path that lead to our doorway. We lived in one of twelve apartments that could be accessed there. Above the doorway stand my mother and father, dressed in their customary garb. As usual, Dad is mad at Mom about something, and she's cowering. Our apartment window is red. Two doors down lived my first friend, Sondi. There she stands, proud of herself. She was a good girl, wearing the bolero jacket I remember so well. Her mother, Margie, plays the piano.

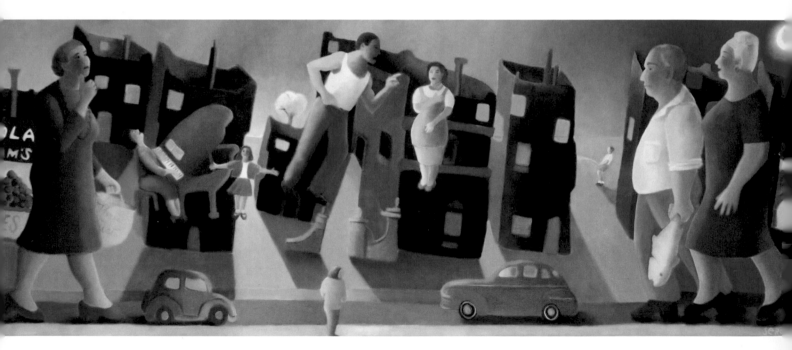

My Aunt Jenny is arriving from the other side of the painting, carrying a bag from the store where she worked, Three Sisters, where I had my very first job. At the very bottom of the painting is a small figure, me, trying in some way to go home again—my only real home, now gone.

Not only can I not return to that place, I can't return to that time. The cars look like they did then. The stores on each end of the canvas were important in my childhood: Jastrom's Drugstore on the right, and Sam's Grocery on the left. Sondi and I frequently used to steal bubblegum there. (This was before I was caught stealing at the drugstore.)

As far as style is concerned, I was interested in scale, working with big and little figures, cars, and buildings. I was not using traditional ideas of figures in the foreground being larger than those in the background, and so on. I wanted to see how much I could play with these ideas of size and shape. The sunset in this painting reminds me of the smell of the stockyards that permeated the summer nights on the west side of Chicago, the smell of burning flesh.

The hardest part of doing the painting was the cars. The gold car on the right was my father's, a 1948 Dodge.

OIL ON CANVAS, 38" X 98", CIRCA 1990, COLLECTION OF DIANE MORRISS.

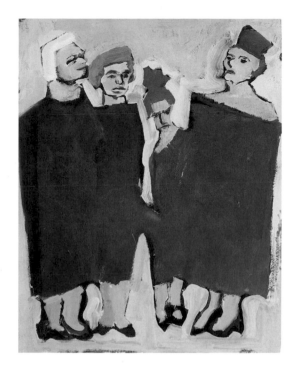

THE AUNTS

This is an important painting—the only one I would never sell. I did it circa 1977, and it was part of the first group show I was ever in, a women's show. I completed this painting very quickly. The image came into my mind after a phone call with my sister, Sondra. She said, "The aunts, their great stone faces," and I saw this image. This was one of the first times I had a clear image in my mind's eye. On the left is Aunt Rosie, next to her is Aunt Jenny, followed by (little) Aunt Fanny, and the great Aunt Molly is on the right. The painting has hung in my bedroom for all these years. I consider it a good-luck charm.

OIL ON PAPER, 25" X 19", 1977,
COLLECTION OF THE ARTIST. **37**

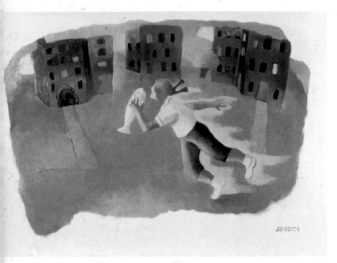

RUNNING WITH FISH

Once I saw a child running with a fish when we were travelling on the west coast of Vancouver Island, and I immediately visualized this painting. I certainly could have been a child running with a fish in those early days. Here I'm running on our street, Keeler Avenue.

I'm also playing with the idea of not going to the edge of the painting by using a free-form composition.

OIL ON PAPER, APPROX. 22" X 30", CIRCA 1987, COLLECTION OF DR. OLGA DUDEK.

soft-spoken, middle-aged man, someone I trusted. His drugstore had a counter where we could get milkshakes, malted milks, or ice-cream sundaes. It was a very clean, well-run business.

One day when I was eleven, trying to show off to one of my friends, I stole a roll of Butter Rums from Jastrom's. I quickly hid it in my pocket behind some baseball cards—I had a stack of them in my pocket. (We used to make "lagers" with these baseball cards, getting a stack of them together and taping them up in all directions with adhesive tape. We played a game with the lagers, in which we tossed them to try and land on a particular line on the sidewalk.) While I was standing outside the store after stealing the candy, waiting for my friends to join me, Jack came out and asked me, "Phyllis, did you take something?" I, of course, said, "No." So he went back into the store, and after a while I got tired of waiting for my friends to come out. I went back into the store, and Jack looked in my pocket and found the candy.

It turned out that my Aunt Jenny was also in the drugstore and saw all of this. She went and told my mother that I had been caught stealing, but both of them knew that if my father found out he would kill me, so they never told him. That was the end of my criminal career. I was terrified! I never stole anything again in my life. So you can see that this drugstore was a pivotal part of my childhood. When I saw it again on Google Earth, it all came rushing back to me.

The building that Jastrom's was located in is exactly the same as it was, but very run down, and there's a beauty supply company in the store now. Although the building, which goes down the block on Keeler, survives, the rest of that street has huge gaps where there is nothing but empty lots. In 1968, that fateful year when Martin Luther King Jr. was killed, my once-lively, wonderful old neighbourhood—in the frustration of the time, the utter hopelessness of that terrible time—was burnt down. Huge areas were devastated. They have never been rebuilt. The building we lived in, 1220 South Keeler, was burnt to the ground.

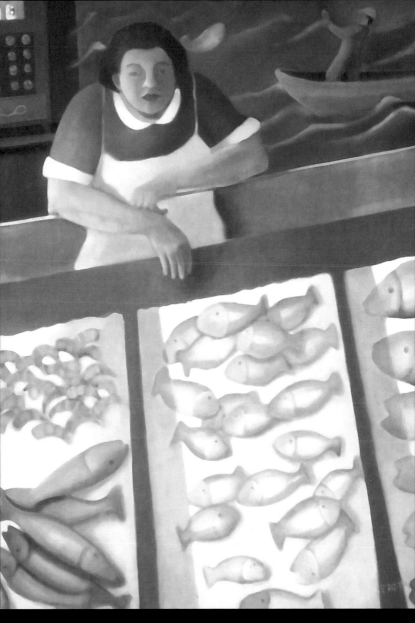

MOM (DREAMING)

MOM (DREAMING)

My mother was at home in the fish store. She was relaxed and loved talking to the customers. She and my father bought the Broadway Briar Fish Market in 1950. It had a mural on the back wall, shown here. For the first couple of years, my father kept working in the wholesale market, and my mother's partner was my cousin Arnie. His father, my Uncle Jake, would also help out after he and Rosie sold their store and moved out of the old neighbourhood.

This painting is part of the *Family Series*. I've subtitled it "Dreaming" because my mother always dreamed of a better life. In her dreams, my father would have been rich, he would have been helpful, and he would have given her a mink coat, like the ones her friends had. She wouldn't have had to work in the fish store again.

This painting resides in my niece's living room, where I sometimes visit and have conversations with my mother.

OIL ON CANVAS, 60" X 44", 1986, COLLECTION OF
DR. MARCEY SHAPIRO.

How can I describe my mother? Sarah was five feet three, had dark brown hair, and wore glasses all her life. Even when she grew old, her salt-and-pepper hair never turned white. In high school she had nearly won a beauty contest, but the judges found out that one of her shoulders was a half inch higher than the other and she was disqualified. Very small things, but my mother was really all about beauty.

If I could see Sarah at thirty-five years old, I would see a softly rounded, pleasant-looking woman with dark, wiry hair and glasses. She started smoking at about that age. It was her only rebellion, her only vice. My mother did everything right in her life, except for the smoking.

Her mother, Diana, had always been a hairdresser. My mother had to quit school when she was in grade ten and go to beauty college. It was the only way that Diana, who could not read or write English, could qualify for a business licence. Although my mother briefly worked as a hairdresser when I was a child, she rightfully always resented not being able to finish school.

Everyone always said she was beautiful. But she was also soft, afraid, clean, and hard-working. She had trouble trusting and never spoke to anyone about the problems in her life. She did not gossip and would not say anything bad about her friends or her children. If I was ever derogatory about either of my siblings, she would defend them. She worked very hard all her life, both when she was a housewife and later, when she owned the fish store. She was an indefatigable shopper, outlasting me at every age.

My mother as a bride, in 1931.

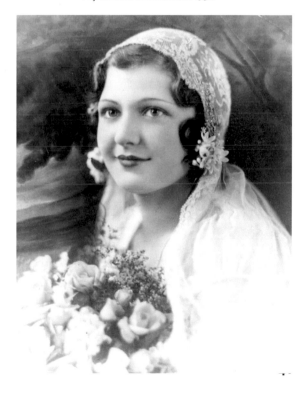

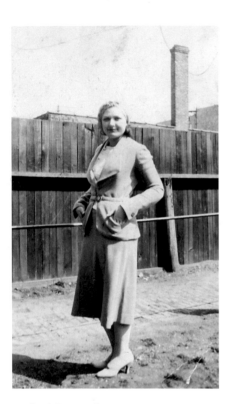

Sarah Serota, about 1935.

My mother would clean the entire apartment every day and then, after finishing, put on a clean housedress, her wedgies, and stockings that she rolled up on her thighs, and go out to shop. She put her lipstick on with her little finger and wore rouge and powder. Her legs were much heavier than the rest of her body, which was lovely and well proportioned. Mom would hardly ever shave her legs, and my sister and I teased her about that. She bit her nails and always talked about stopping; she even wore nail polish to stop her nail-biting, but never did. She was modest and soft-spoken, not at all brassy like some of her friends. Sarah was quiet, nervous, compliant, sweet, and dependable. She could tell a good story and, like all of the family, had a great sense of humour.

My mother and I had our best talks when she was in the bathtub. She was soft, rosy, and relaxed there and we talked easily, her voice low and melodic. I knew her body as well as I knew my own. I can still see it, feature by feature, there in that bathtub on Belmont Avenue, that new, sleek, fifties tub. I was so proud of her when I was a child. She was one of the youngest moms I knew, and she was just right: not too beautiful, quiet, bright, and very conventional.

She and my father had lifelong friends, but the people she was closest to were my father's family. Her mother had been married six times, and she was ashamed of that. She told me once that the defining thing about her childhood was that her parents had been divorced. She never could understand why I always questioned everything; she did not like to analyze her life, and certainly did not believe that "the unexamined life is not worth living." She felt that I looked into my feelings too often, but maybe that was because she didn't want to look at her own life too carefully: it was too late for change.

There was a lot of talk about shame in our family, and an often-quoted Yiddish expression, "a shonda for the neighbours," which means "something terrible for the neighbours to talk about"—which was always to be avoided. To my eyes, my father and mother had a horrible relationship; everything she did seemed to enrage him, and he frequently abused her verbally. Someone once told me that the reason she cleaned so much was that the atmosphere around my father was so threatening that she could only feel comfortable in a clean environment, bringing some order into the chaos. My parents once had

a terrible fight about her burning the toast, and I was shocked that grown-ups would fight about something so trivial. I told her countless times that I wanted her to leave him, but she never did. She was passive in everything. He led, she followed.

However, I thought she was just perfect and that Daddy, the one who did everything wrong, was the villain. She was the beautiful Sarah, after all, and if I had thought she wasn't everything she said she was, it probably would have scared the hell out of me. Mom represented the only safe place in a house that was always in an uproar. She was the stable one, and I loved her. Nevertheless, I later tried very hard to be different from my mother. She had the same experience with her mother, who had lived an interesting and varied life. Sarah thought her salvation lay in being conservative and careful, as opposed to leading the chaotic life Bubbie had led. Every other generation, eh?

My mother was always very cool, very removed with me. When I was young I thought it was because she was always so busy, doing all the cleaning, cooking, dishes, and laundry. Later, I realized that she may have suffered from a kind of depression: her natural inclination was towards order, quiet, and solitude, and here she was in this raucous, argumentative family with an abusive husband. I remember her holding me only once. When I was about six years old, she came into my little twin bed, lay down beside me, and held me for a while. She smelled so good and clean: oh, I was happy then. My mom, the best mom a kid could have.

She breastfed all three of her children for about six months each, even though hardly anyone she knew was nursing in 1944, when my brother was born. Sondra and I would lie in Mom's bed with her while she peacefully nursed Bobby, and both of us would dream of having our own babies and nursing them.

My mother was often afraid: in a way, she was defined by her worry. Once, on the way back from Miami on a train, we were crossing a very steep, narrow bridge over the Ohio River. Mom was so afraid that she wanted all the other passengers to get in the middle of the train. No one did. She was afraid of dogs, cats, mice, bugs, my father, her friends, what people would say, life, death, and, of course, the dementia that eventually claimed her.

Although Mom seemed to be a modern woman in her time, she

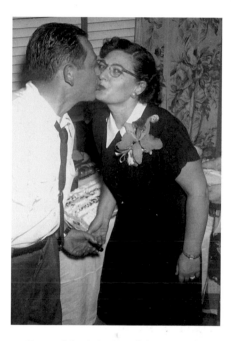

Sam and Sarah Serota celebrate their anniversary, in our new apartment, about 1952.

BEAUTIFUL SARAH

was very superstitious. When someone had cancer, she would not say that word. What she said was "poo, poo, poo," in a parody of spitting. If I said something nice about someone, she said, "Don't give a kenna-hora," which meant that the evil eye might hear you and take away the blessing.

All these years later, I long to hear Mom tell her stories. I long to touch her face, to keep her in my eyes, to hold that moment forever. I want it to be 1950, some day like a Tuesday, the fourteenth of September. I want to be able to experience the way the apartment smelled again, to see the lines of light streaming through the venetian blinds in the living room, the drapes pulled back. I want to sit on the piano stool and see her and all of it.

But she's not there, and, sadly, I'm not either. There are no venetian blinds, no piano. It's all gone now, and Sarah is gone, too.

THERE ARE JUST 3 CHARACTERS IN THE STORY

A painting of the main shopping street of my childhood— Roosevelt Road. This time my mother is in the car, my father standing outside, and I am coming along. This was part of a small series of memory paintings I did in 2001.

ACRYLIC ON CANVAS, APPROX. 30" X 40", 2001, COLLECTION OF PAM HUTCHISON AND SAMUEL GODFREY.

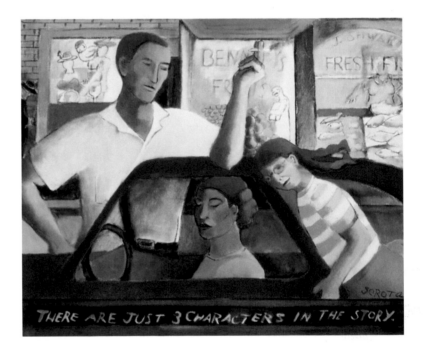

THERE ARE JUST 3 CHARACTERS IN THE STORY.

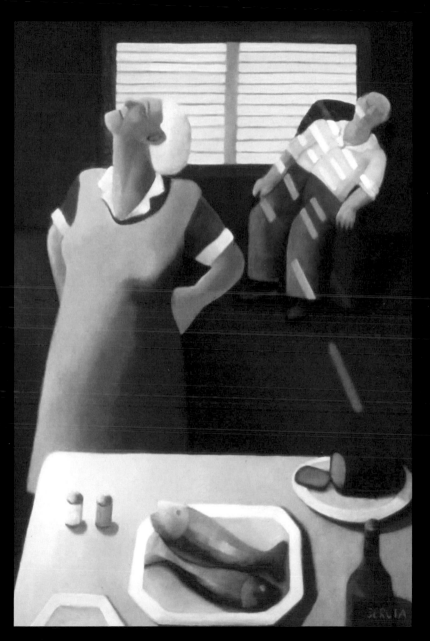

AUNT ROSIE AND UNCLE JAKE (PRAYER)

AUNT ROSIE AND UNCLE JAKE (PRAYER)

This is the first painting in the *Family Series*. I painted Aunt Rosie and Uncle Jake as they would be after a long day's work. They had a fish store and worked hard every day. I see them tired, but grateful, with the idea of prayer as gratitude. They have all that they need. The still life on the table is one of my favourites. The simple necessities of life: bread, salt, and fish, with a little wine thrown in for luck.

The other notable thing about this painting is the venetian blinds. We all had venetian blinds in the forties. I've always loved that distinctive light. Someone told me after seeing this painting that no matter what you do to block out the light, it still comes in.

OIL ON CANVAS, 60" X 44", 1984, COLLECTION OF
MRS. BEVERLY GORE (THEIR DAUGHTER).

You can see a white square more clearly when it is held up against a dark ground. I'm writing about my favourite aunt, Rosie, but will tell a bit about my other two aunts in order to observe her in sharper relief.

My father had three sisters, Rosie, Jenny, and Fanny. Aunt Jenny was the second-oldest sister, a great, funny storyteller and a warm, friendly person. She was a largish woman with ample breasts and worked downtown selling blouses in a women's clothing store. She would tell us wonderful stories of her adventures when we gathered together in the evenings, at either Aunt Rosie's, her house, or ours. It was Aunt Jenny who was the real card player, although we all played poker together. My love of stories and my understanding of humour are connected to her. I loved Aunt Jenny—although she would sometimes pinch my cheeks.

Her husband, Uncle Joe, was another story. I never really liked him, and was young when he passed away. I remember that Aunt Jenny was heartbroken and tried to throw herself on his grave (not an unusual event in our family). After that she was afraid to sleep alone in her apartment, and her son, Sheldon, went to live with her. She later married again, but I never knew that husband very well. I saw Aunt Jenny much later, after we had been gone from Chicago for years. She had acquired a beautiful, almost transparent, grace. Perhaps it was a sign that she was near death.

The other sister, Aunt Fanny, was another kind of person: small and thin. Fanny was married to Uncle Abe, a skinny little man, a pharmacist who owned a drugstore. They had more money than the rest of the family but were miserable together. They couldn't have a child and

eventually adopted a boy, Paul. Fanny was next to my father in age, just a couple of years older. She was smart, wickedly funny, rebellious, cynical, and very stylish. They used to say that when she was young, she couldn't afford much but would save her money and buy one skirt— an expensive, well-tailored one—and, if necessary, wash it every day. She was always immaculate, as they all were, but she had that added panache. She would take all the kids out of the synagogue to the ice-cream parlour on Yom Kippur, when we were supposed to be fasting. She told us not to tell anyone. I know where my constant rebelliousness started.

Years later, I heard a family secret about Aunt Fanny. When she was eighteen years old, she had met and eloped with a young man who wasn't Jewish. The family stepped in and annulled the brief marriage. They found Abe, the pharmacist, and quickly married her off to him. They lived a life of misery together, sometimes not talking for months at a time. I remember visiting their beautiful, large, ranch-style home (she had exquisite taste in houses, furniture, everything) and seeing the bed they slept in, a king-size bed. It was the first one I'd ever seen, and I could also see that these two very small people slept as far away from each other as possible. Finally, after forty years of marriage, they divorced. In her last years, I heard that she had resumed her relationship with the Italian husband her family had made her leave. I was happy for her!

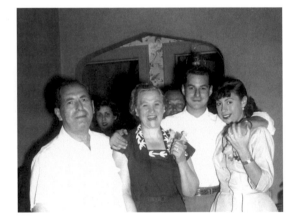

Uncle Jake, Aunt Rosie, my cousin Arnie,
and his wife Gloria, around 1950.

How to speak about my Aunt Rosie? She had so much joy, so much pride, especially in the children, that it burned out of her eyes. She lit up when she saw me. She was the only person in whom I ever saw that love. The others said I was a *mieskeit*, an ugly duckling. They pointed out my faults, and I had many; but she saw the purity, the essence.

Aunt Rosie was the person I felt safe with in this world. Actually, both Aunt Rosie and her husband, Uncle Jake. They loved me. My parents' relationship was volatile, and my father was a difficult and sometimes violent man, but Aunt Rosie and Uncle Jake were calm and stable. She was strong, proud, and honest; she had integrity and, like the rest of the family, a fierce temper—but she didn't scare me. She was my father's oldest sister; he was the baby of eight children. She had raised

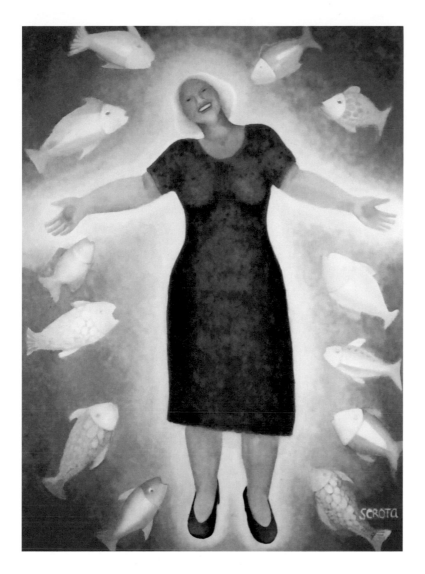

AUNT ROSIE'S GIFT

Aunt Rosie gave me the greatest gift.
She loved me unconditionally!

OIL ON CANVAS, 60" X 44", 1989,
COLLECTION OF MARY DENOYER.

him and so became a sort of grandmother to me. Their own mother had died when my father was just thirteen. When Aunt Rosie wailed and screamed at my father's funeral, my mother was angry, saying that Rosie took the attention away from her, but I understood that for Rosie it was like losing her own child.

My memories of her begin when she was at least forty-five, a tall woman, large breasted, whose hair eventually became all white. She had a vivid complexion and the Serota family underbite. She and Uncle

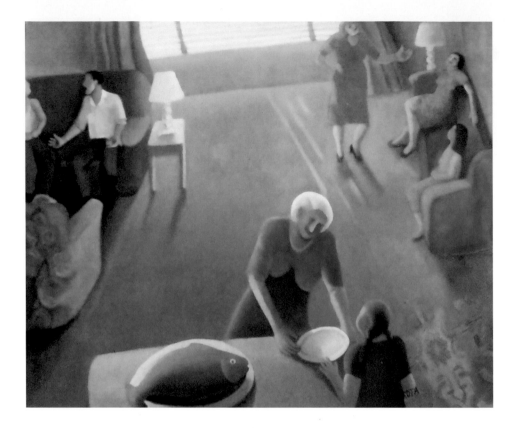

COMPANY

We would often go to my Aunt Rosie's after dinner or on the weekends, and the whole family would be there. In this painting, my father is on the left, talking about the fish business to Uncle Jake and Uncle Joe, and on the right Aunt Jenny is telling a story to Sondra and my mother. In the foreground is the important piece of this painting: Aunt Rosie is handing me an empty bowl, and of course there's the fish on the table. For years I wondered about that empty bowl, and finally I came up with an interpretation: she was giving me courage, the permission to be anything I wanted, because she would love me regardless. It was her gift.

I was experimenting with scale here—this painting is very large: five by six feet—and with pattern. I was trying to see if the pattern that I began on the carpet in the lower right-hand corner of the painting would be understood as the pattern for the entire carpet, and the same for the chair on the left, with another pattern. The venetian blinds and the light they tried to shut out appear again.

I love this painting.

OIL ON CANVAS, 5' X 6', 1986, COLLECTION OF PETER AND ERICA LADNER.

Jake lived around the corner from our apartment, on the nearby, busy shopping street. They had a fish store and lived in the back of it. The store was long and narrow, and at the end of it there was a small area, like a porch, where my uncle ground horseradish with a small machine. Behind that was their apartment. It was a very nice two-bedroom apartment, clean, no smell of fish. They had dark, heavy furniture with accents of rose reds and pinks.

Being the oldest woman in my father's family, Aunt Rosie ruled her seven brothers and sisters. Most of the family gatherings were at Rosie and Jake's home. She would often be angry with one or another of her brothers and could continue being mad for months. I can still see her with her chin held high, righteous!

Uncle Jake was the peacemaker, a very sweet man. He and Aunt Rosie had a long and happy marriage—fifty years. She called him "Mein Mann." She worked in the fish store with him every day of her life and still made time to cook gefilte fish every Friday night for the whole extended family. During the Depression, when no one had any money, many of the other aunts and uncles, including my family, came to live with Aunt Rosie and Uncle Jake. The joke in the family later was figuring out where all of them could have slept. No one remembered where Rosie and Jake's own two children, Beverly and Arnie, slept.

I respected her—we all did, even my father, who I knew wouldn't hurt me when Rosie was around. We went to her for advice, for medical opinions, for love. I would go to the fish store often and just hang around, enjoying the ambience, looking at the fish. I always wondered why I stared at the fish so often. Later I realized that I was storing up images for my paintings—I have painted fish many, many times. When I was there, my uncle would send me out to buy cigarettes for him: "A package of Philip Morris, please."

Altogether, Aunt Rosie was an inspiration to me; they both were. Uncle Jake was a kind, calm man. My father was the opposite, so to be in the company of someone male who was different from my father taught me that all men weren't the same. Thank God for that!

Aunt Rosie was the only woman in the family who read Hebrew; however, she never learned to read and write English. The women's area in our family synagogue was in a garage attached to the actual *shul* where the men were praying. The women would be talking and

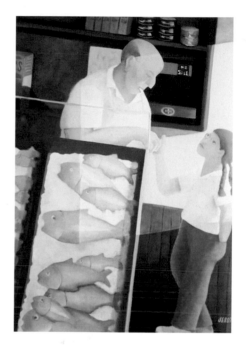

PACKAGE OF PHILIP MORRIS, PLEASE

My Uncle Jake would often send me out for cigarettes. Here he's asking me to go and get them for him. I felt so comfortable in their fish store, so safe.

OIL ON CANVAS, 60" X 44", 1985, COLLECTION OF ROSITA TOVELL.

laughing, not paying attention. Aunt Rosie would say, "Sha, be quiet!" and for a while things would calm down.

Later in her life, after we had all moved away from the west side and they had sold the fish store, Aunt Rosie finally got to relax. She could just cook, clean, laugh; she loved to laugh. She also loved to dance. At weddings, they all danced the Sherele together, an intricate square dance of sorts from Chodorkov, the *shtetl* (village) they were born in.

Aunt Rosie had severe diabetes all her life and had to inject herself with insulin every day. Also, because she once tasted the raw fish for gefilte fish, she got a tapeworm. She told us they had to tempt the worm out of her mouth with whisky. The worm came up and out, and that was the end of it.

Uncle Jake died a few years before Aunt Rosie, and then she moved into her daughter's, my cousin Beverly's, home for her last years. I heard later that when she was in her late seventies, she asked one of her grandsons to drive her around on his motorcycle.

When I heard the news of her death, I was attending a week-long encounter group on a small estate near a lake. I left the group immediately and spent the day alone, walking and sitting under a large tree, thinking about her. I'll always remember that day, my sadness and joy at having known her; my great luck in having had an Aunt Rosie.

Aunt Molly and Aunt Rosie dancing at a wedding, about 1955.

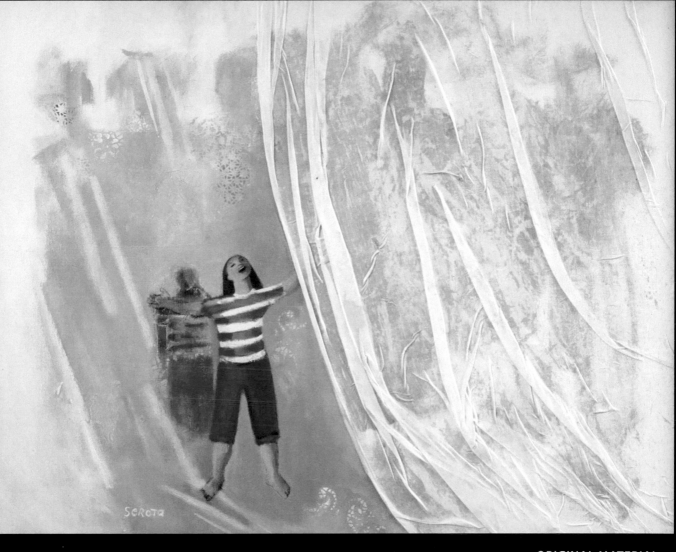

ORIGINAL MATERIAL

This is the first painting in which I used cloth. I vividly remember putting an old sheet down on the canvas and working with acrylic medium to sculpt it. I had already painted in the dark-silhouetted people who are showing through.

The painting represents my beginnings. I am nine or ten years old, wearing my favourite outfit. Behind me stands another, darker, more indistinct Phyllis. I've always loved doilies and have collected them throughout my life. All the elements that would prove to be a rich and fertile foundation for my art are here. My original material.

ACRYLIC ON CANVAS, 33" X 45", 1993, COLLECTION
OF MARGOT LODS.

When I was a child, there were perhaps twenty books in the unlikely setting of our working-class apartment on the west side of Chicago. My mother would occasionally read a *Reader's Digest* condensed book, and my father had some Jewish religious books, including an Old Testament and a prayer book that he *davened* (prayed) from twice a day. My parents also had a set of classic books that they'd won in a raffle at a local movie theatre. These books resided in a dark mahogany bookshelf in the living room. I never saw either of my parents open any of them.

They were bound in dark colours with gold lettering. Some of the titles I remember: *The Way of All Flesh*, *A Tale of Two Cities*, *The Last Days of Pompeii*—these I avoided, but the ones I did read have remained among the most important books of my childhood.

Jane Eyre was the one I loved most and read over and over, in the way that children do. Charlotte Brontë's Jane was such a strong, sweet character and had such a hard life. My life was difficult, but here was someone who had it even harder and yet managed to overcome her orphaned background and triumph over her many challenges. She was an inspiration to me. I still remember the poignancy of her early years in the orphanage and her fondness for her little friend who dies of tuberculosis. I can transport myself back to those days, reading comfortably, caught in that story. I was nine or ten years old at the time.

I'm stretching my memory right now to be able to see the bookcase where those books sat. I wish I could see it, as I wish I could revisit that apartment. Oh, how I wish that, just for one hour to breathe it, to taste it, to smell it. In Thornton Wilder's play *Our Town*, when the dead Emily asks for just that, she's granted only an ordinary day, because it

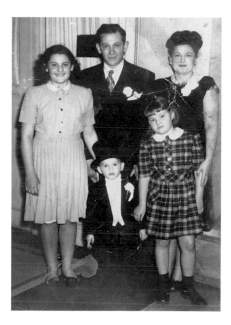

At a wedding, Sondra, Bobby, and I are in the front, with Dad and Mom behind us, about 1947. Bobby was the ring bearer and probably three years old. That would mean I was nine and my sister was thirteen. We looked good as a family, but there is a look on my face that belies that statement. I'm struck by that look.

55

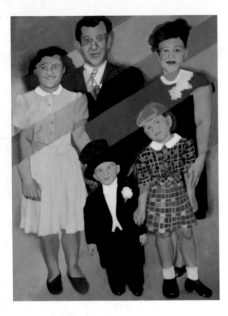

RING BEARER AND FAMILY

This painting is based on the photo on the previous page. I decided to paint it because we looked so good—like one big, happy family—and the reality was so much different. I put in the diagonals to illustrate that contrast.

When I painted this, my father had been dead for a long time. The family had been shattered by so many ruptures. That's what I was attempting to show: the reality, as opposed to the dream.

OIL ON CANVAS , 45" X 33", CIRCA 1995, COLLECTION OF TRISH SHWART AND BARRY HERRING.

would be too painful if it were something important like her wedding day. She says, "It goes so fast . . . Do any human beings ever realize life while they live it?"

The other books I read were *Black Beauty*, by Anna Sewell, and *Oliver Twist* and *Great Expectations*, by Charles Dickens. The original *Mary Poppins*, by P. L. Travers, was so much fun to read but then Walt Disney came in and ruined it. Louisa May Alcott's *Little Women* was one of my absolute loves—I reread that many times and always identified with Jo. She may be responsible for me being the way I am. And the great triumph of the imagination, Lewis Carroll's *Alice in Wonderland*, with its fabulous, bizarre illustrations by John Tenniel. We also had a set of *The Book of Knowledge*, a children's encyclopedia, that I loved to read. My favourite readings there were fables by Aesop and, in every book, chapters called "Things to Make and Things to Do." I loved those.

When I was ten years old, I started going to the Legler Library, a beautiful, elegant building a couple of streetcar rides away. It had large, airy rooms with huge, arched windows—the building took my breath away. The first time I went, I thought that when I got older and could enter the "adults" section I would immediately start to study astronomy. That seemed to me the most fascinating, expansive subject. For now, though, it was the children's collections I had to choose from, and I was happy with that and with the whole idea of libraries.

That happiness has continued to this day. I am a voracious reader, and at least ninety-five per cent of what I have read in all these years has come from the library. I'm also heartened by the fact that libraries have continued to grow and change with our times in such creative and egalitarian ways.

In the film *A Passage to India*, one of the characters asks another why he reads. He answers, "To know we're not alone in the world." What I experienced when I read was an escape from my everyday, sometimes brutal, life into another more magical and often more tender place. Reading still serves that purpose for me—escape and relaxation. The times I spend with books are some of my most creative times. The images suggested to me by someone else's words are precious and often indelible. Reading is one of my greatest joys.

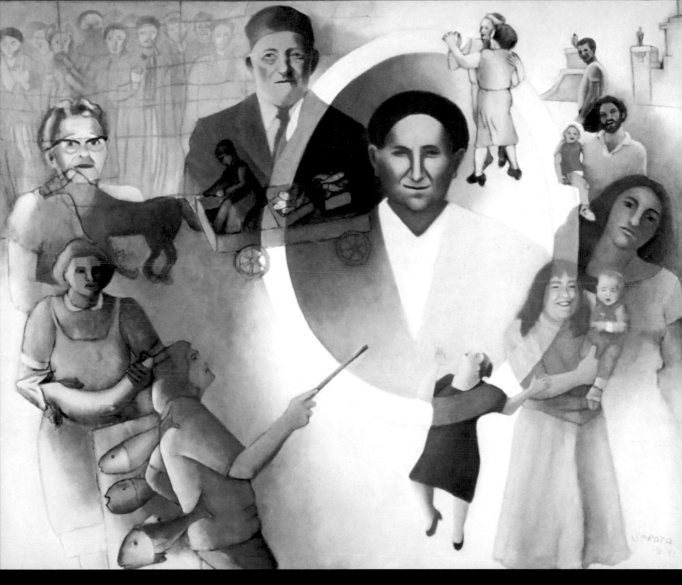

GENERATIONS

GENERATIONS

While I was having my studio in James Bay built, I started and finished this large painting, working slowly on it throughout that exciting time.

Here are my ancestors, my children, and my grandchildren, and I am painting it. My grandmother (Bubbie) is on the left, standing before a well-known concentration camp photo. Her family all died, either in the camps or in the Warsaw Ghetto. Beneath her is my mother holding a fish, and below her is me, painting as usual.

My grandfather Philip is up near the centre with his wife, Sonia, both beneath him driving a horse and wagon, and to his right. The only photo of her that exists is this oval one on her tombstone.

Over on the right-hand upper corner is my father with the famous pillars that guarded our building on Keeler Avenue. Below him, my son Michael is holding my grandson Kyle, Beth is under that, and below her is Heidi with my granddaughter Sonja. Some of my aunts dance towards the top of the oval, and Aunt Molly dances ecstatically at the bottom.

This painting hangs in our synagogue.

OIL ON CANVAS, 56" X 68", 1992-93, COLLECTION OF
CONGREGATION EMANU-EL.

SOME THINGS ABOUT MY BUBBIE

My clearest memory of my Bubbie (grandmother): she is standing in our kitchen, all four feet ten of her, smoking a cigarette that hangs out of the corner of her mouth. Her hair is bleached blonde, ornately piled high on her head. A tiny woman with an extremely big hairdo. The cigarette ash is about an inch long and, as always, is threatening to fall. My mother comes in and says, "Ma, the cigarette!"

Her history: Bubbie, born Diana Lampert, was one of sixteen children, the child of a scribe who wrote the letters of the Torah—they are all handwritten. She described her father as a holy man, one who wore a white satin robe and a tall white hat. Bubbie left Warsaw when she was fourteen years old and went to Paris, where she became a wig-maker. At eighteen, she immigrated to the United States and worked for the Metropolitan Opera in New York. There she met and married my grandfather, Harry, who was also a Polish immigrant.

They moved to a small steeltown in Indiana called East Chicago, on the outskirts of Chicago, where she started the first of her many beauty shops. She and my grandfather had four children. Abe was the oldest; Jenny was born next (she died of pneumonia at an early age), and my mother, Sarah, was born after Jenny. Their last child, Adeline, who was born when Bubbie was older, had Down's syndrome. Bubbie and my grandfather divorced when my mother was still a child. This was unheard of at the time, in the early 1920s.

My feelings about Adeline were always confused. As a child, I thought she was weird and didn't want to have much to do with her. When we visited the homes she lived in over the years, I thought they might decide that I was retarded too, which scared me. Later, after I

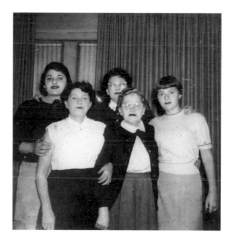

A visit to my Aunt Sheindel's house in East Chicago, Indiana, around 1954. Front row (l to r): Aunt Sheindel, my Bubbie, me (at about sixteen); behind: Sondra and my mother.

got married, I was terrified that I might have a child with Down's syndrome. Much, much later, after I moved to Canada, I met a young woman with Down's. Getting to know her was a revelation for me. She was so open hearted. I have been sorry ever since that I never really got to know Adeline. She died forty years ago.

Bubbie married and divorced another five times. She had friends of all kinds: gentile friends (which we never had) and friends of different ages, different races, and (who knows?) maybe even gay friends. She then moved to Arizona because of her severe arthritis.

Bubbie came back to Chicago in her early sixties. She now had senile dementia, so she came to live with us. She would watch television in the afternoons. If there happened to be Nazis in a film, or if a movie was about the Second World War, she would yell at the TV, "Hoodlums!" Once, during the war, Bubbie had been in a movie theatre, and in a newsreel saw one of her sisters being led into Auschwitz. She ran out of the theatre, screaming. One of her other sisters, my Aunt Sheindel, had also immigrated to the States, and one brother had escaped the Nazis. All her other thirteen siblings were murdered in Poland.

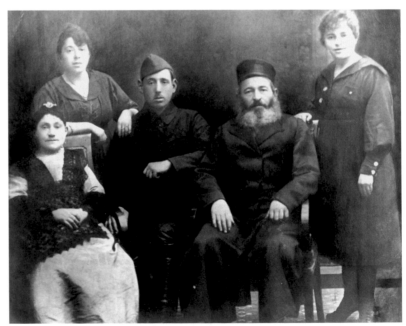

My maternal great-grandparents and their remaining children in Poland, after the others had grown up and left home, about 1915.

Bubbie spent the last years of her life in old people's homes. She became very angry and abusive and eventually did not recognize any of us. She died in her early seventies.

Her husband, my grandfather, Harry Goldberg (Grandpeppy), was a house painter. When he was a child, someone had thrown a stone into one of his eyes, and it looked all scrambled: the iris was all over his eye. A scholar, he spoke fifteen languages by the end of his life and sang in a huge choir that we once went to hear. I loved that. He was a member of the Workmen's Circle, a strongly socialist organization in the Jewish community. My father called him a communist. He died when I was twelve years old.

THE SEROTAS

My father's parents, Philip Serota and Sonia Dubinsky, came from Chodorkov, a village outside of Kiev, Ukraine. It is said of Philip, a scholar, that he never worked a day in his life. It was an honour in those days to have a rabbinic scholar in the family. His wife supported him first by selling fish and then by opening up a fish store in Chicago and running it. She is remembered as a wise woman who always worked very hard.

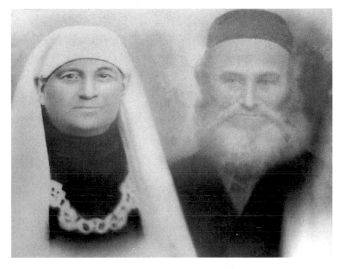

My paternal great-grandparents, in the late nineteenth century. They never emigrated from Ukraine.

They came to the United States in the early twentieth century. Two of their sons preceded them and sent money for them to come along with their six surviving children. My father, Sam, was born in Ukraine. His mother, Sonia, died at the age of fifty-six, when he was thirteen years old.

Philip died when my mother was nine months pregnant with me. When he died, the whole family sat *shiva*, and when you sit *shiva* you can't work. My very pregnant mother was the only one who could take care of Aunt Rosie and Uncle Jake's fish store. When I was born, two weeks after Philip died, I was named Phyllis after him.

My father always said that the name Serota came from Spain. When the Spanish Inquisition was happening, the Jews were expelled from Spain and some travelled east. We're not sure about that connection. But we found out that *serota* does mean "orphan" in Russian.

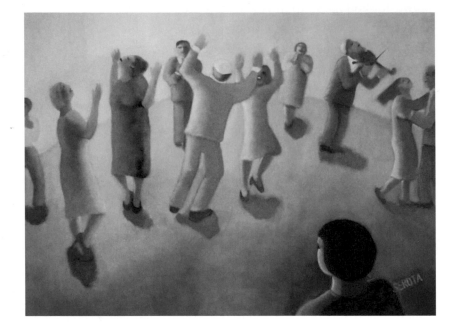

GOLDEN WEDDING

A very early memory of being at a family wedding on the west side. A moment that has stayed with me all these years. In this painting, my older self stands in front of the dancers, trying to see that moment even more clearly.

OIL ON CANVAS, 32" X 45", 1983, COLLECTION OF LOUIS AND CHARLOTTE SUTKER.

SIMCHAS TORAH

I wrote earlier about our family *shul* (synagogue) and about how the women were separated into another building from the men. This was true, except in my memory of Simchas Torah. (Simchas Torah is the celebration of God's gift of the Torah to the Jews.) On that night, all the children marched in the main synagogue together. I lead the children, Sondra behind me, and Bobby next. The others are relatives, and Aunt Rosie is at the left, looking over at us. Again, I'm using the border to show the time elapsed.

ACRYLIC ON CANVAS, 44" X 60", 2003, COLLECTION OF THE ARTIST.

We're outside the doorway to the cheder (Hebrew school), B'nai Reuven. Mr. Flyer is calling us to come in to our class. We all run away—Sondi and I run giggling into the girls' bathroom to hide from him. We stand on the toilets so he won't see our feet, but he yells at us to come and we follow him, breathing the smell of old books and sour old men who spend their days here studying. We file into the classroom, where there is a spittoon in the corner that Mr. Flyer uses, sometimes spitting clear across the room. There are papers and dirt all over the floor and an overflowing ashtray on his desk. He sometimes hits the bad kids because they talk back or don't pay attention. The desks are old, the books torn and yellowed, the windows grimy. We take a deep breath, ah, we're here again. We've made it to the upper class. Down the hall are the babies; they can't even read Hebrew!

We were Jews; everyone else was like a creature from another planet. Everyone I knew was Jewish. Jewish kids went to Hebrew school every day after school and learned how to read Hebrew. The gentiles were lucky; they didn't have to go. They went to church; we couldn't go there.

My friend Sondi and I went through Hebrew school together. We spent a lot of time hysterically giggling in Mr. Flyer's class, but we were both smart and could get by without paying too much attention. Mr. Flyer taught us Hebrew by translating it into Yiddish. We didn't know Hebrew and we didn't know Yiddish! Then we found out about a book that did that for us. It translated the Bible from Hebrew to Yiddish.

Judaism meant my family, mostly my aunts and uncles. They were

MR. FLYER

This is the first of three paintings I did of Mr. Flyer, our Hebrew school teacher at the B'nai Reuven synagogue. His was the more advanced class of two grades that we all attended. In those days, all the men wore fedoras, and because he was religious, Mr. Flyer would have had his head covered at all times. I always think of Mr. Flyer as he talked to us about Solomon's temple in Jerusalem and its wonders, which were all destroyed by the Babylonians in 586 BCE. He was not a good teacher in the way I have come to know good teaching, but he was passionate about the temple.

The children are mostly real people from my childhood, most notably in the lower centre foreground: Sondi is at the left and I am to the right of her (again wearing my striped T-shirt). Sondi and I giggled our way all through Hebrew school! A girl I didn't like and to whom I gave a hard time sits in front of me. I wish I could apologize to her, but I don't even know her last name.

OIL ON CANVAS, 36" X 28", 1993, COLLECTION OF DARYL JOLLY AND KERRY PADGIN.

religious, very observant. Our immediate family was less so, even though we kept kosher. As I grew older, Judaism meant that I could only go out with Jewish boys. Everyone dated Jews and got married to Jews . . . That was that. My father always said, "If you marry a gentile, he will eventually call you a dirty Jew!"

When I was twelve years old on Rosh Hashanah (the Jewish New Year), we lived near a boulevard where there were many beautiful, old synagogues. That day has stayed in my memory: we strolled from one *shul* to the other, we languished on the grass. The trees were turning, it was warm, and, of course, there was no school—we had all the time in the world. There was a spaciousness to that day, a golden spaciousness.

I have wonderful memories of Simchas Torah, a celebration of the day the Torah was given to the Jews. On that night, all of us children came to the small, family synagogue in our best clothes. We formed a line, and each of us held a Jewish flag with a pointed top. An apple was speared onto that, and a lit candle was placed on top of that. We all sang and marched around.

All the other times, the women and girls were in a garage attached to the men's *shul*. There was a window we looked through: we were the witnesses to religion while the men were actually worshipping. When I went to Israel years later and went to the Western Wall, women weren't allowed to stand in the same places as the men. Some of them pulled up folding chairs and climbed up to watch what the men were doing. I did that for a moment and then remembered our little family *shul*. I stepped off that chair and prayed for myself, no more a witness.

I had never heard anything about Israel, even about its existence, until I went to visit my Aunt Sheindel when I was ten years old. It was 1948, and she showed us pictures of this new state for Jews called Israel. My parents had never talked to any of us about this. Not until I was fourteen years old did I find out about the Holocaust (not a word that was in use then). I read a book that was terribly upsetting, written by a girl who had been in a cattle car going to Auschwitz. I went into the bathroom and sobbed. No one had ever mentioned any of this to me before. Did this mean it could happen again, and because I was Jewish, was I at risk?

I had grown up in a Jewish ghetto, and it wasn't until I was in my early thirties that I had any gentile friends. I was tired of only knowing

SHERELE

It took me fifty years to do this painting. I had the idea of painting it when I was still in Chicago but never did so until recently.

My father's family came from Ukraine. The Sherele was a complex Jewish folk dance. Not many of the younger people knew how to do it, and it was daunting for me to think about painting it. Everyone would form in a circle at weddings or bar mitzvahs as they danced. When I got serious about painting this, I started looking up dances that had eight people in them. I found something called the quadrille, an eighteenth-century dance, and used that for the form.

Reading from the bottom of this painting: Aunt Rosie is on the left; next to her is Aunt Jenny, then a cousin of mine, Abe Dubinsky, and his daughter Barbara. In the upper row, Aunt Molly, Aunt Fanny, and my father and mother.

ACRYLIC ON CANVAS, 44" X 60", 2009, COLLECTION OF LOIS
AND MARTY HAUSELMAN.

Jews; there was a big, wide world out there, with millions of people who weren't Jewish. Perhaps I could forget that in my religion men started the day by saying "Thank God I wasn't born a woman."

> *Don't be too Jewish—Don't use that Jewish way of talking—Don't say, Oy! Don't use your hands when you talk. Don't look too Jewish, get your nose fixed, get your hair straightened! On the one hand, you were only supposed to know and love and be Jewish, and on the other, it was not cool. Don't be too Jewish or you're not Jewish enough, which was it?*

I always said I was Jewish, but for a while it was a very minor part of my life. I opted for less is more. Being not Jewish was definitely better than being Jewish; being a WASP (white Anglo-Saxon Protestant) was best, especially a WASP with old money—these were the hidden messages. Jews changed their names from Goldberg to Gold, from Schwartz to Curtis. Someone with a very Jewish name, like Finklestein, was an object of laughter, the butt of jokes. When I worked as an employment counsellor in the year I married a Jewish boy, I had to change my name from my married name, which might have sounded Jewish, to Lee Raymond. Sometimes personnel people would say, "Don't send me any k– or n–": I had to ignore this, although it was painful, and say, "Of course not," or some such thing, but by the time I went back to work in 1968 that had changed—at least the Jewish part of it.

> *Verbs that have to do with being Jewish: shuckle, shlepp, drone, whine, shtupp, shnuggle, davon, kvetch.*

My aunts weren't ashamed of being Jewish; they gloried in it! They spoke Yiddish, they danced the Sherele at weddings, they cooked exclusively Jewish food, they kept kosher, their children married Jews, they lived in Jewish neighbourhoods. The first question about anyone was "Is she (or he) Jewish?" Since I always loved and respected my aunts, where did I pick up this yearning to be the other? I laughed at kids who were too Jewish, like the girl who came from a family that didn't even brush their teeth on Shabbos. I tortured her! I guess I got the message early—that was in grade five.

When someone in my family died, everyone would go to the funeral home to see the body. The service would end at our family cemetery, which was for all those who came from our village, Chodorkov: that meant the Serota and Dubinsky families. We walked around and visited all the graves, looking at the photographs on the tombstones and saying hello to my grandfather Philip and my grandmother Sonia and my Aunt Rosie's little girl, Edith, who died when she was twelve. Then we sat *shiva*, where we'd all gather at the family's home for a week, talk, cry and laugh, bring food, and all be together. It was a wonderful way for a life to end. The Jewish way.

At the heart of all of this was the mystery: what or who is God? Was God a man, who was everywhere . . . someone who had chosen us to be his people? We were taught to cover our eyes when we said the *Shema* (the holiest prayer) in the synagogue. I was never sure if I covered my eyes because God commanded me to or because it was a way to be alone with God—a private meeting, closed off from the eyes of others. Whatever the reason was, that's what I'm left with now. Not *close your eyes, don't look at other religions, don't take on gentile ways, close your eyes to everything but Judaism.* Not that, but *take a moment to probe the mystery, to come to an understanding of God—a separate time.*

There have been times that I've tried to leave Judaism behind. In 1969, when my husband and I immigrated to Canada, I had no concerns about whether there were Jews in Arbutus Bay or whether there was a synagogue on Vancouver Island. I didn't care if I could give my children a Jewish education, or if they could meet boys or girls who were Jewish, or whether they would marry Jews. None of these things were in any way important to me or to us. We threw everything away. We thought we could do it all new, but some of what we discarded shouldn't have been thrown out. I'm sorry about that now.

Daddy loved being Jewish. Our family followed. I wanted to be different. I had to take another path. Less is more, eh?

We're all in the hall, all the aunts, uncles, cousins, my mother, and my father. It is hot and muggy, and here is the groom and there is the flower girl. There is the smell of gardenias. Here comes the bride, and they are under the chupah. They are talking in Hebrew and drinking the kosher wine. The rabbi says some words, and then he puts

*the cloth on the floor and the groom stamps on it. The glass breaks
and we all clap. They kiss and we yell, "Mazel Tov!" Then we eat and
dance. It's great to be Jewish!*

THE SEDER

Everything in the kitchen was changed for the Seder, the Passover rit-
ual. The whole family would go down to our shed in the basement and
bring up the boxes of plates, pots, and silverware. Each year I looked
forward to seeing the *pesadiche* (Passover) dishes: the different sets of
plates, bowls, and cutlery, especially a little old saucepan that was dark
blue with white spots, and some very old-fashioned, transparent wine-
red bowls.

My mother cooked everything for the Seder meal: we had her won-
derful gefilte fish with strong, fresh horseradish (at the time, I couldn't
understand why anyone would eat this) to start, and then matzo ball
soup. We all liked our matzo balls hard and called them *kneidlach*.
Usually, I helped to put the Seder plate together: the symbolic roasted
bone, charoseth, parsley, and a hard-boiled egg that my mother burned
on the stove. Then we had either roast chicken or beef, and always
stewed prunes for dessert, because matzo (which we called "matzi") is
"binding."

After dinner, my brother, my father, and I raced through all the
songs—the object not being to sing beautifully or sweetly, but as fast
and as loud as we possibly could. As we sang, we cracked nuts with a
nutcracker and drank the sweet kosher wine.

My father read every word of the Haggadah, the book that tells the
story of the Exodus from Egypt and outlines the order of this Pass-
over ritual, in Hebrew. All of us tried to convince him that it could be
shorter, and if it were in English, we would understand it and be more
involved. But because he was a man and the leader, he made all the
religious decisions in our family. As a child, I asked the Four Questions
(which are the lead-in to the story of the Exodus), but only until my
brother was old enough to take over. By then, I was totally bored and
sometimes even drunk when it ended—I did like the taste of the sweet
kosher wine.

We kept our dishes changed and had no bread for the full week of
Passover, but everyone I knew did the same. Once my friends and I

went to a museum called the Historical Society during Passover. We all brought matzo sandwiches. I looked down from a window in the museum and saw the remains of our lunch: the waxed paper, the ends of the matzo, strewn around a statue of a horse and rider—an indelible image.

After I married, my husband George and I had Seders at our home. My father would not attend because I did not keep kosher. We still had matzo ball soup and roast chicken, but we read responsively in English and talked about slavery and freedom. George's extended family, about thirty people, had an annual Seder that George had the honour of leading. It was much more formal than my family Seders—a real dress-up affair at a hotel, much of it carried out in English.

During this time of my young adulthood, we still had one of our Seders with my mother and father. My father had acquired a beautiful illustrated Haggadah, which eventually wore small wine and food stains. He still read most of it in Hebrew. Being grown-ups, we all wanted to talk and smoke during the ritual, but my father would have none of that; he always ruled the table. However, we complained bitterly throughout. The only part I still enjoyed was the frantic, competitive singing my brother and I did, although Bobby read Hebrew much better than I.

In 1967, my father died, and with him, our family Seder. In 1969, I left Chicago (and Judaism) for British Columbia.

Ten years later, I decided I actually missed going to Seders. Some of my children were in town, and my partner Annie and I invited our Jewish and part-Jewish friends to join us at the Seder table. I led the service; mostly we read in English, with a few key parts in Hebrew. Everything was wonderful; that Seder night finally felt perfect—it fell somewhere between nostalgia and expectation. I took my father's role for the first part, reading and presiding over the table; for the second part, I took my mother's role: I prepared the entire meal, and it was delicious. I finally understood the unity that comes to us so rarely, the union of my parents within me. By the time we got to the singing, there was no one to compete with. With joy and gratitude, that night, for the first time, I sang alone.

THE SEDER

I did this painting in the late 1970s, very soon after my Seder. I appear at the head of the table; next to me and to my right is Annie; continuing counter-clockwise, beyond her, are Heidi and Doug; next, Jesse; then Susan at the top; on the right, her partner David, my son Michael, and Caroline, his girlfriend at the time.

We read from a book called the Haggadah, and at my Seder we all read pieces of it. It's very much about slavery and freedom. You eat particular ritual foods at certain times in the reading. Matzo is the flatbread eaten by the Israelites when they left Egypt, because they had no time to let the bread rise. At another time in the reading, you eat horseradish to stand for the bitterness of slavery. We go on with these ritual kinds of things to eat and drink, and the leader reads various parts in Hebrew.

This was a wonderful night for me: a real celebration of being Jewish.

OIL ON PAPER, 22" X 30", CIRCA 1980,
PRIVATE COLLECTION.

BEING JEWISH
ON THE WEST SIDE

THE BOSS COMES TO DINNER

My father worked in the wholesale fish market on Fulton Street for most of my childhood. His boss was Fred Wilner, a squat, powerful man of the 1940s, a time when many of these men smoked big fat cigars. Occasionally he and his wife, Sue, would grace our modest apartment with a visit.

Here we are all in the hallway, lined up to pay homage to the boss and his wife. Our little family is quaking in our boots. And there they stand, in all their glory,

especially Sue Wilner, who is younger than her husband, very glamorous, rich, blonde, and—most glamorous of all—gentile. This was one of the most exotic things of my childhood, because pretty much everyone I knew was Jewish.

We lived on the third floor of our building, and probably because of all the smoking that went on in those days, they were huffing and puffing by the time they arrived. We would try to be really careful about everything we said and did, because our father's job and our livelihood depended on this man. That's me in the pigtails, wearing red. Bobby is beside me, Sondra is on the other side, and my father is doing obeisance. My mother stands behind my father, wearing blue, as she often does in my paintings.

The black-and-white-tile floor is similar to the linoleum we had in our hallway. This painting always makes me laugh. I guess it's either that or cry.

OIL ON CANVAS, APPROX. 30" X 20", CIRCA 1995, COLLECTION OF DR. MARCEY SHAPIRO AND STAR WOODWARD.

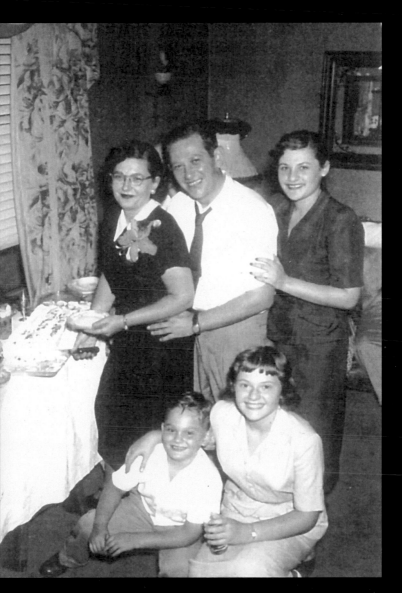

My parents' anniversary, circa 1952: Bobby and I are
in the front; Mom, Dad, and Sondra are standing.

SELF-PORTRAIT WITH MASKS

OIL ON WOOD, APPROX. 24" X 24", 1996,

PRIVATE COLLECTION.

TEEN YEARS

When I was thirteen years old, my mother bought a fish store on the north side of Chicago. Mom had been home with us for most of my childhood and had helped out occasionally at Aunt Rosie and Uncle Jake's fish store; now she would work full time. Soon afterwards, we were told that we were going to move. I was really upset about it. The apartment on Keeler Avenue was the only place I remembered living; all my friends and family lived nearby. I had just started at Marshall High School in our neighbourhood, which my parents and my sister had also attended. This new business was in a much more affluent neighbourhood, and that was going to change our lives in many ways. I was intimidated by the idea that the people in this new area were much richer than we were; after all, my parents just owned a fish store.

So, after my first year at Marshall, we moved to an apartment on Belmont Avenue, half a block from the new store. It was a beautiful, large apartment, painted in shades of grey, in a big older building. It had three bedrooms, two bathrooms, and even a large front porch. Since it was a block away from Lake Michigan, we were close to parks, marinas, and skyscrapers.

My first day at the new high school, which was called Senn High, was very scary. I asked a girl who lived in our building if she could take me on the streetcar that day. I also got in touch with my cousin Avie, who'd been going to Senn High for a few years. He was a couple of years older than I was and knew the school well. Avie met me after we got off the streetcar and showed me around. Looking back at that morning from this enormous distance of time, I see that on many levels I was taking good care of myself.

My yearbook photo when I graduated in 1955.

77

MASHED POTATOES
TO CASHMERE

With Dad and Mom at the
University of Illinois, about 1956.

So there I was at Senn High at fourteen—a difficult time of life for everyone. But I soon learned that I could go from knowing no one on the first day, and being terrified, to being invited into the best club in the school by the end of that year. Senn was an extremely social school, and clubs were very important. I belonged to a club called the Koalas. We all wore blue-and-white club jackets. The more important club, for me, was the Fidels, which included forty of the most popular girls in our class (this was a very large high school). One of my friends nominated me for membership in the Fidels, and I was invited to join. I was very, very thrilled about this. I wore the red Fidels jacket proudly. My father used to say, *"Veni, Vidi, Vici"*—I came, I saw, I conquered—which describes the way I felt. I had the sense after that year that I could make my way socially, and that sense has remained with me through all these years.

I did a lot of crazy things then, like necking with boys I didn't really know or even care about, and hanging around with girls who would have been considered fast. I didn't study much—I just coasted along—but I did all right on grades. I also realized that I had more than one side: I came into contact with the dark side of my personality by gaining the knowledge that I could and did use people for my own purposes. I got the feeling, because I became aware of this social-climbing side of myself, that my friends at Senn never really knew me. I didn't think they ever saw the free, humorous, looser side of me.

I met my future husband in an art class during my first year at Senn. This boy came in and I thought, "What a cute fat boy." He was immediately attentive to me, and he had the use of his brother's yellow convertible. This was in 1952, when few people had cars, much less yellow convertibles! George lived in a huge mansion overlooking the outer drive, the road along Lake Michigan. I naturally assumed he was rich. He would often drive me home from school, and sometimes he would want to stop at his house. He'd say, "Just wait here in the kitchen while I go to the bathroom," and leave me in the kitchen with his mother. I wouldn't know what to do. She was very cold to me and would keep working at whatever she was doing. She would never speak or, if she did, would do so very cursorily. I was so uncomfortable about this; I had never met anyone like her.

In some way, I have never left that kitchen table—I'm still fourteen,

not sure what to say to this skinny, haughty, older woman. I'm still reading a newspaper on that table covered with a yellow-and-brown oilcloth, waiting for George. (I spent a lot of my life waiting for George.) The people on the west side were open, friendly, and real, but here was a pretentious rich woman who probably thought I wasn't good enough for her cute little fat-boy son, or so I thought. I'm not sure I ever forgave her for that.

George and I went steady for four years. During those years, I spent a lot of time holding him off—all he wanted to do was have sex, and I wouldn't. After four years of dating I was still, technically, a virgin. It was the 1950s, and girls were supposed to wait for sex until they got married. I knew it was safe to be on the side of my parents, who definitely did not want to talk about sex, and that it was wrong to let boys do anything to me. Every time these boundaries could have been crossed, I would become agitated and remove myself. Eventually, though, George would cross all my boundaries.

For most of my teens, I had various jobs after school and on the weekends. I sold hosiery, typed, sold ladies wear, cashiered, and helped out at the fish store during the Jewish holidays. I worked downtown, at a large department store on the busiest corner in the world, selling hosiery. Every day that I worked there, I went up to the store's restaurant at lunchtime for its fabulous chicken pot pies. When I worked in the shoe store, there was a great deli nearby where I went for hot beef or hot turkey sandwiches, which, of course, came with mashed potatoes and gravy. I loved gravy—my mother never made it, so Sondra and I were always experimenting with recipes for gravy. As you can see, a lot of the charm of working had to do with going out for lunch. The other charm of it was the fact that I could buy cashmere sweaters—most of my money went to buying them, because at Senn High everyone knew how many cashmere sweaters one had.

After school, I was expected to straighten up the apartment and make dinner for the family. I can't figure out how I managed to do all of these things at the same time. But making dinner taught me how to cook, which has helped me throughout my life.

My major teenage rebellions all centred on smoking. I smoked all through this period and hid it from the family. On my way up the stairs of our apartment building, I would put my cigarettes behind a radiator

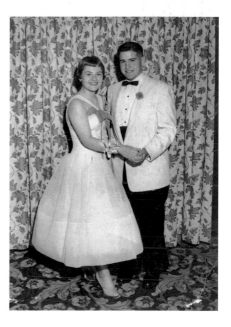

With George at the prom, 1955. The ribbon is what I called "periwinkle blue."

in the front hallway on the first-floor landing (we lived on the second floor). My parents both smoked and weren't able to smell it on me, so I got away with this for years.

COLLEGE DAYS

In my last year of high school, I decided I was going to get some decent grades so that I could get into a university. And I did both. I enrolled in the University of Illinois, which was the state school in Champaign–Urbana. This was a two- to three-hour train trip south of Chicago. Two of my friends and I rented a room in what was called an independent house, which meant that it was not a school dormitory or a sorority. I started out doing very well at university, but I didn't like living in the independent house. There was no kitchen, so we had to eat all our meals either in restaurants or in the fast-food hamburger place across the street. Occasionally I would have dinner at my friends' sorority house, and I clearly remember the lamb chops and wonderful fried noodles I ate then. So even though I didn't believe in sororities or fraternities, I decided to go through rush. I needed to be able to eat good food.

Sororities and fraternities in those days were divided by religion and/or race. Many of my friends, both from the west side and from Senn, were in a Jewish sorority called Iota Alpha Pi. I went through rush and got into that sorority. I spent the next year and a half at the Iota Alpha Pi house and made some wonderful, close, new friends. I did very well at school and was elected to be in the honour society after the first year.

My idea was to become a high school history teacher. I had been lucky enough to have had a good history teacher for my last year at Senn, and I didn't really know what else to do, so that's what I studied. I got really fascinated with the First World War and the lead-up to it. But I also used to watch two art students, sorority sisters of mine, while they were painting. Although I marvelled at the interesting things they were doing, the penny didn't drop. I didn't realize that that's where my heart—or my bliss, as they say—was.

George was down at the University of Illinois too, and he had pledged a Jewish fraternity. But he never made the grades, so he never activated. I should've realized then that it was hard for him to follow up, but that penny hadn't dropped either.

After about a year at university, George phoned me one night and said he was leaving school. He had gotten into some kind of trouble—he was supposed to be in the Reserve Officer Training Corps, a requirement for every young man at the University of Illinois, but never was. He was scared and had decided to leave school and go back to Chicago. His father was in the cookie business and had offered him a business to run, a sugar wafer factory. But George was only nineteen years old—he got bored, had very little that interested him, and started to push for us to get married. By then we'd been dating for four-and-a-half years, so I decided we could get engaged. He gave me a fairly large diamond ring, and I wore it proudly. I started going home to Chicago every weekend.

Everything changed when I made a new friend in the sorority who'd been dating a guy even longer than I'd been dating George. When I asked her if she was still a virgin, she said no. I took that as permission to go ahead, and the next weekend George and I finally did it. As soon as it was over, I told him, "Now we have to get married."

He was only too happy to comply. Having left school in mid-semester, he felt that getting married was more interesting than doing nothing. Maybe, in hindsight, he knew that if he had one woman, it would be easier to get others.

A JEWISH WEDDING

George and I planned our wedding for June 30, just three months after our decision to get married. My parents weren't happy about the timing, because they had just hosted my brother's very expensive bar mitzvah, with two hundred guests. But they were worried that I might get pregnant. My mother asked me if George and I had been, in her words, "fiddley daddling"—that was the extent of our sex talk. I replied that we had not, but I was afraid we might if we didn't get married soon. That was all she needed to know.

Because I was only nineteen years old, my parents made all the arrangements. People gave me bridal showers; I got many presents, some of which I couldn't even identify. All the preliminary events leading up to the wedding were as fancy as possible, and held in only the finest places. There was a great deal of trying to impress friends, family, and neighbours.

During the three months before the wedding, I was finishing my

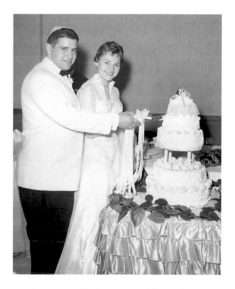

George and I slice our wedding cake.

second year at the University of Illinois. I'd been doing really well—achieving mostly A's and the occasional B. I was flying high and felt like I could do anything. I even thought about becoming a doctor—which, of course, would have thrilled my parents. Occasionally, after that fateful night and my even more fateful decision to get married, I wondered whether I had made a wise choice. But as I did so many times in my life, I soldiered on and ignored the misgivings that could have saved me so much grief. I thought I'd go back to school in Chicago after we married, but I made no definite plans. I didn't apply to any other school; I just let go. Getting married was too big a thing for me. I couldn't think about anything else. I simply coasted along.

The morning of the big day was bright, hot, and beautiful. I was having breakfast when I heard a horn beeping in front of our apartment building. I looked out the window and saw George standing in front of a brand-new white-and-pink Pontiac convertible. He yelled up at me that his father had just leased the car and we could take it on our honeymoon. I felt so privileged, lucky, and rich!

The wedding was held in the big hall of a synagogue. The rabbi, whom we had never met before, happened to be George Burns's brother. My bridesmaids were my oldest friends. We had planned as children to stand up for each other's weddings, but I was the only one to honour that promise. My sister was the matron of honour.

At the ceremony, I walked nervously, trembling visibly as I moved down the aisle. I'd borrowed a dress from my older cousin, Barbara, with whom I was usually compared unfavourably. Barbara was seen as beautiful and as someone who always did everything right; she was not a rebel like I was. But since the wedding happened as quickly as it did, she was kind enough to lend me her dress. It had a long train, and when I was halfway down the aisle it got stuck on a nail and I nearly fell. The other memorable moment occurred when the rabbi gave us the wine under the chupah. It was sweet kosher wine, and I loved how it tasted. We kissed, and I tasted it in George's mouth.

After the ceremony and the receiving line, we marched triumphantly into the dining room, where 250 of our closest friends and family awaited us. Music played as we entered, and I felt a flush of complete happiness. Buffet tables were laden with all kinds of Jewish and other foods—all of it, of course, kosher. We had dinner, posed for

pictures, and danced the hora and the jitterbug. George was a great dancer. Later, there was a sumptuous dessert buffet with every imaginable sweet thing and the obligatory wedding cake, a huge, many-tiered creation baked by my father's friend in the business.

I was the first one of my friends to get married. So what if my husband was overweight and couldn't be trusted? I always knew this: if we went on a ferris wheel, George would shake the seat when we got to the top, and I had a strong fear of heights. But I chose to ignore my early misgivings in the thrill of getting married. He did make me feel loved and wanted, at least sexually. And he had asked me to marry him: I wouldn't be an "old maid," the most awful fate my generation could imagine.

When it was time to leave the party, we got into our white-and-pink convertible and drove a couple of miles to the Edgewater Beach Hotel. We had both been drinking, but that didn't stop us. It was 1957, and the days of not drinking and driving were still far off. Once we were at the hotel, I thought we would make love, legally now for the first time. But George had other priorities. He counted our gifts of money. We had twenty-four hundred dollars to start our new life. When he had finished counting, he fell asleep. My wedding day was over.

WEDDING

This is a painting of George's and my wedding. In this painting I was trying to show how young we were: I was nineteen, and George was just twenty. Behind us are our "closest friends" and family, about 250 of them. I was terribly nervous that day—we were two children getting married, and everyone expected that we would know what we were doing. Obviously, we didn't.

OIL ON CANVAS, A SMALL PAINTING, PERHAPS 24" X 18", CIRCA 1985, PRIVATE COLLECTION.

THE WOMEN IN OUR FAMILY

These are the women in my
mother's family. I worked from
the photo on page 59 to do this
drawing/painting.

OIL AND CHARCOAL ON RICE
PAPER, 30" X 22", CIRCA 1995,
PRIVATE COLLECTION.

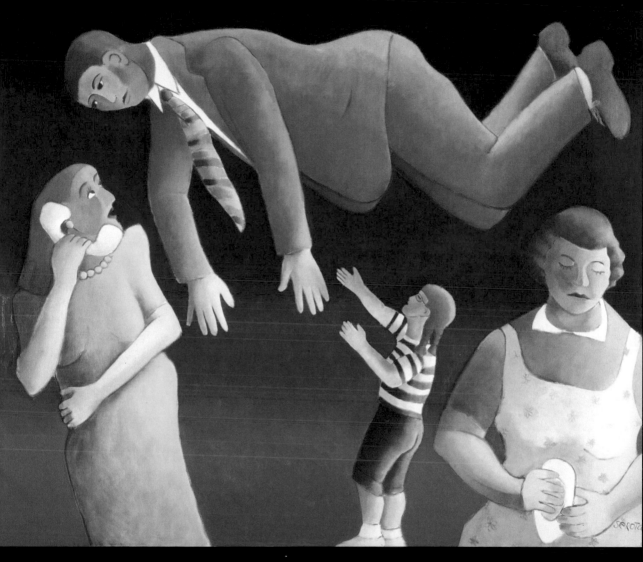

MOM'S DREAM

MOM'S DREAM (FORMERLY TITLED INOPPORTUNE ANNUNCIATION)

My mother was a dreamer—a bigger house, a mink coat, quiet children, maybe even a different husband, one who wore an orange suit? Who knows?

There she is, as usual, washing dishes.

OIL ON CANVAS, 56" X 68", 1995, PRIVATE COLLECTION.

Me: *I'm looking back at our kitchen on Keeler Avenue. It's the forties. I'm trying to see our dishes, our fleischige dishes. What colour were they? I can still see the silverware with its faintly military look, like a fork or knife capped with a freeform group of soldiers, the edges etched in black. But it's hard to see the dishes.*

My mother must have been so tired after everything that she did and did well. My father said, If you start something you must finish it. But she never said anything like that. She was a blank slate, taking on the coloration of whoever she was with—a sponge, a chameleon, so mild, so scared, so beautiful. Beautiful . . . it was all anyone ever said about her, and here I am, saying it again.

I'll let her speak.

Sarah: It's almost dinnertime. Sam wants his dinner on the table at four o'clock sharp on Sunday. Will I be able to make it? I'll be sorry if I can't.

Where are those kids? I always have to worry about them. You never know where they are from one minute to the next. Where's Sondra? She's never here when I need her. And that Phyllis, she's probably playing ball and hasn't washed herself for days. She should have been a boy. Bobby, at least he's always here, next door, playing with Leslie. Sidelle said she'd watch them. Sidelle's going to drive me crazy, always in and out of our apartment, you'd think she lived here and not next door. Then there was the time when she put the sweet potatoes in my oven because she didn't want to light hers. And the potatoes burst! They burned me so bad. There, my potatoes are done. Probably I should put the steaks in the oven. Sam wants them really well done. A little garlic salt? OK.

Maybe I'll have time to comb my hair and put on some rouge and lipstick. Oh no, there's Sam now. Is someone with him? Oh, it's just Jake. "Hi, maybe you'll have dinner with us?" "No, Rosie needs me, I just came to say hi." He comes over close to me. "Do you need anything, any money?" he whispers. "No, we're fine this week, thanks, Jake. How's Rosie?" He smiles and leaves. Now Sam and I are alone in the apartment. Where are those kids? He looks mad. What's wrong now? Always there's something aggravating him. What is it now? Ah, there're the kids.

Everything is ready. They all sit down and begin to eat. There is always a lot of food. Sam says, "We may not have money, but we always have enough to eat." But the kids grab for the food; they think they'll never get enough. They feel that they have to grab whatever food there is, and grab it as quickly as possible.

Sam eats fast, with his mouth full. We see all the stuff in his mouth, and sometimes when he's talking or yelling, some of what he's eating spits out. I wasn't brought up like this. Even though he calls my mother a whore, at least she knows how to eat properly. Sam controls himself when we have company, but when it's just the family, the table is like a battleground. Now he's talking about work in the fish market. He starts to get mad, and I try to stop him. It's OK this time; he stops. But he doesn't always.

Me, I don't really like this dinner. What I like to eat is a roll and butter, a cup of coffee. All this fried food, all this meat, it's too much for me. All of this is too much for me. Where's the calm, the quiet I long for? Where is the family I wanted, good kids who aren't so greedy, so rough—like Rose and Joe Cohen's kids? Joe's such a good husband. Why wasn't I lucky enough to have a husband who respects me? But I made my bed. This is what I'm stuck with.

Now they're torturing Sondra. She made the mistake of singing a few bars of "Go Down Moses." She's learning that song in school. They're making fun of her voice. Now she's sobbing and leaving the table. Phyllis and Bobby are enjoying hurting her and, of course, so is Sam. Sondra is so dramatic. Where did she get that from?

I'll ask Phyllis to clear the table. Sondra won't be back. Girls shouldn't sit at the table after dinner. They have to get up and start to clear. Phyllis always wants to just sit. She's just like "Mahsey," she never got

up from the table. "Will you help with the dishes, Phyllis?" I ask. She says, "No, I have to go out." Sam screams, "Did you hear your mother? She needs your help!" He starts to take off his belt. Phyllis dashes out of the kitchen into the bathroom. I run after her, but when I get there the door is already locked; she's too fast for me. Sam has his belt off. Bobby is still at the table. "Well," Sam says, "what do you want? Are you asking for it too?" "No," Bobby says quietly, like a sad little old man.

Sam says he's going to lie down. Phyllis finally comes out of the bathroom, smirking, and we do the dishes. Now I can lie down too. Finally.

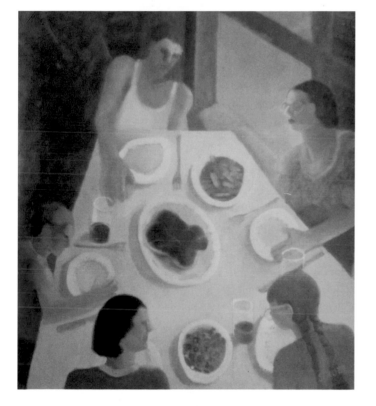

SUNDAY DINNER

This is the quintessential painting of my family. I did this painting in 1981, and I've always felt that it summed the whole thing up. I am the one in the lower right-hand corner with pigtails. My sister sits next to me, and my brother is over on the left. My father is at the top, the head of the table, and my mother is wearing blue, as always in my paintings. My beautiful mother. My beautiful, sad mother who worked so hard to put this dinner on the table, who always worked so hard.

We are having steak, french fries, some green (probably canned) vegetable, and, of course, red pop. There's blood on the steak, something my father hated—he wanted his meat well done. Would you fight with him?

I feel a great sadness looking at this painting, the pain of our family—my father's violence, his rage, and the secrecy of it. How ashamed we were.

OIL ON PAPER, APPROX. 55" X35", 1981, PRIVATE COLLECTION.

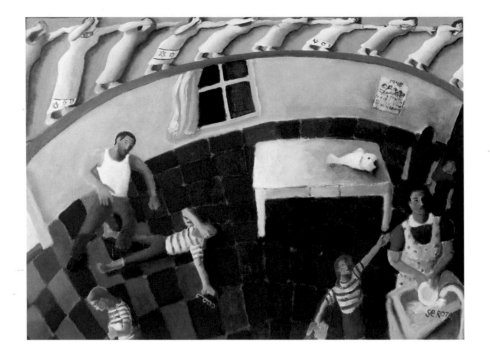

KITCHEN

Here I painted myself three times: reaching for my mother, on the floor after a
beating by my father, and walking out, finally! The scene is again our kitchen on
Keeler Avenue. The date on the wall calender is 1948. I would be ten years old.
The "frieze" at the top is of dancers, in this case wearing Jewish stars. I remember
thinking that this painting was about shame. The shame of having a violent father
after the violence that had been done to us, the Jewish people.

OIL ON CANVAS, 33" X 45", 1996, COLLECTION OF THE ARTIST.

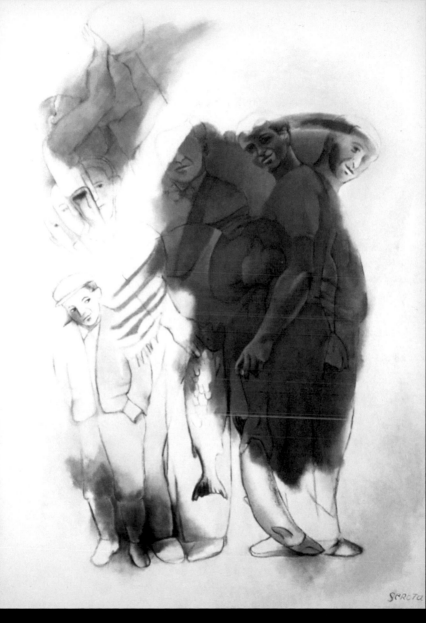

VALENTINE FOR MY FATHER

VALENTINE FOR MY FATHER

In the 1990s, I became fascinated with Marc Chagall's work and was obsessed with learning to separate colour and line. In other words, there is one composition in colour and another in line. This is a good example of working with that separation.

My father's life was that of an immigrant child coming into Chicago in the early twentieth century. He had emigrated from a small *shtetl* near Kiev, Ukraine. He was the youngest in a family of eight children and moved to what was considered a rough Chicago neighbourhood.

On the left of the painting is my father as a child; perhaps he looked like one of the kids Lewis Hine photographed at about the same time, kids who had to grow up too fast. My father told me lots of stories about friends of his who used to steal and did lots of other bad things—but, of course, in his stories, he didn't. He could have gone either way, but he had a strict father and a strong family. The red area shows my father at various times in his life—always working with fish, his wedding, how he looked as he eventually aged. The blue area is my father as a basketball star; he was a famous basketball player when he went to high school and was remembered for a long time after. My sister owns this painting now—it's one I'm proud of.

OIL ON CANVAS, 60" X 44", 1999, COLLECTION OF SONDRA SHAPIRO AND DR. MARCEY SHAPIRO.

If I were to paint a portrait of my father, Sam Serota, I would start with a dark underpainting to show the very dark parts of him. I would use black paint for all the parts we could not see (and that we never would) and blue for the Jewish parts that became more and more pronounced as he got older. The dark red parts would represent all the hurt he inflicted on his family, all the violence, all the heartbreak.

After painting these dark colours, I would paint the background before I continued on the main figure. That background would illustrate his arriving in the United States at age four, from the Ukraine. There would be images from the early Jewish neighbourhoods in Chicago: the pushcarts on the streets and an ever-present fish store.

Then I would begin to paint his body: a strong, beautiful, very masculine body, one that was good at sports. A handsome, dark-haired, not very tall man, who still somehow managed to be a wonderful basketball player. I would paint his skin, perhaps starting on his hands: skin that was a creamy, vulnerable colour, perhaps one of the reasons for his belligerent stance. His body never had any extra fat on it. He was neat and trim, even into his old age. He kept his hands meticulously clean to belie the fact of his life's work: the cleaning, cutting, and scraping of fish.

For his face, I would still use only dark, transparent colours. I would add soft colours for his cheeks, his thin mouth somewhat redder than the rest of his face, which was clean-shaven. He had small laugh lines, with their implicit sense of humour. For his hair, I would use burnt umber, a transparent, very dark, brown colour. His eyes were dark brown, intelligent eyes that really could see a fish, that understood what to buy if it was fresh, and how to prepare it; but eyes which were also somehow blocked, blunted.

What should I dress his beautiful body in? The clothes he wore to cut and scrape the fish? Or the suits, immaculate white shirts and ties in which he dressed up for weddings or the synagogue? Perhaps I'll start instead with the sleeveless undershirts that showed off his strong, muscular arms that could strike out and hurt so quickly.

If I were to paint such a portrait, could I paint those arms to show the other side of him? Could I reveal all his dimensions? Could I show in the painting how he laughed a lot? How he hated people of other races, especially blacks? Could I, with only a few hairs on the end of a stick and this thick coloured stuff called paint, reveal how thoroughly he terrorized three small children and his young, beautiful wife?

That is what I would want to show in my painting, how beautiful and terrible he was at the same time. How love and hate resided simultaneously in the same arms; how love can hurt us or lift us up. He sometimes carried me into the house when I fell asleep in the car. How strong and tender those arms felt then. I would also paint those arms.

REMEMBERING SAM

Can I see my father with clear, fresh eyes and tell about it? When I think of my father, I see a small boy who grew up in a tough neighbourhood. He was one of those kids who photographer Lewis Hine might have taken pictures of: a boy who played ball all through school and was a star on the Marshall High basketball team; a kid who lost his mother when he was thirteen years old. Soon after, when his father wanted to marry again, he left the house rather than live with this new woman.

Sam Serota was a very handsome guy, with a devilish quality and lots of lifelong friends. But he kept his wife and children in constant fear. He would hit out like a knife, like a black snake, and ask questions later. This was a man who left school and went to work in the wholesale fish market in Chicago because his family had always been in the fish business. He became a filleter, one of the best in the market. He was always very good with his hands. He had lightning reflexes, and we were terrified of them.

In my mind's eye, I can still see him coming towards me on the street, walking lightly and elegantly with an athlete's loose, graceful, loping walk. His dark brown hair came to a widow's peak, receding as he aged, but he never became bald. His face was oval, his lower lip

With Dad in front of a small shack we once rented in South Haven, Michigan. I was about four years old.

more prominent than the top one. He took great pride in his clothes, wearing white-on-white dress shirts, and always had a couple of suits that were in style. He took good care of his well-polished shoes, keeping the Florsheim shoeboxes in his closet with the shoe forms inside them. At work, he wore an apron over his clothes. My mother always manicured his nails, and after work, he would carefully wash his hands and apply scented hand cream so that he did not smell of fish.

When I see him in my reveries, he is laughing. He loved to laugh and dance and play cards. For a time when he was young, he gambled compulsively. He dreamt of being rich: dreams that never came true.

Quick to laugh and quick to anger, that was Sam Serota in a nutshell. Quick to anger but unable to sustain or tolerate it. His anger exploded, and he hit out or pulled out his belt to use on his small children when they challenged him or didn't show him respect. We ran away, or tried to, but he was fast and always got us. He wanted to be boss in his house, probably because he felt thwarted everywhere else. Strangely, he never hit my mother: for her, it was verbal abuse.

He was a man who, underneath it all, did not like women. He thought that they smelled. "Women are intrinsically dirty because they have their organs inside," he said. "Only men are clean, because everything is on the outside." He fell in love with my mother when he was twenty-

HANDSOME SAM

PORTUGUESE STILL LIFE

I saw these fish in a market in Lisbon. It was a wonderful arrangement of my favourite subject matter.

OIL ON CANVAS, 2000, 26" X 62", COLLECTION OF BONNIE MCMACKEN.

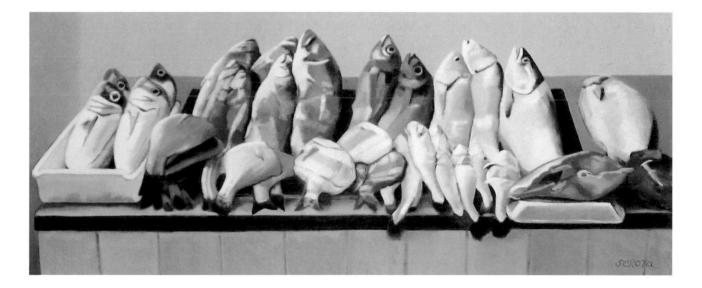

one and she was eighteen, and they eloped, but they were forced to have a Jewish wedding before my grandmother would let them sleep together. After they were married, he angrily told her never to initiate lovemaking, because only whores wanted sex; she had to wait until he wanted her.

He wanted a son, and only a son. He told me many times that he had wanted a boy instead of me, and when my brother, Bobby, finally was born, he had what he had always wanted. But he then proceeded to undermine my brother in any way he could, calling him lazy, stupid, and "like a girl" because he wasn't an athlete.

Sam had very little self-esteem. He always felt inferior to his friends because they had more money than he did. The fish store made a good, comfortable living for him and my mother, but she wanted more. All her friends, the women she went to high school with, were now rich. She wanted the things that they had, mink coats and trips to Las Vegas, and she started to torture my father about this. My last vision of him healthy, in Chicago, is in the fish store; all he wanted then was peace.

As my father aged, he calmed down a little and became resigned to his life. He looked for spiritual solace. He began to go to the synagogue more often, and I can still see him in his bedroom wearing his undershirt and the brown pants that he liked to relax in. He was laying tefillin (saying the Hebrew prayers with phylacteries) morning and evening. In my father's world, because I was now married, I belonged to another man and he no longer was a physical threat to me. But he still could be verbally abusive. He resented my rebellion against the family tradition of keeping a kosher home, and he never forgave me for that. He would eat at my sister's kosher home often, but hardly ever at our house.

CAR SONGS

Because Chicago is on the west side of Lake Michigan, and the east side of the lake has much warmer water for swimming, many people go over to Michigan for their summer holidays. Every year from the time I was eight to about twelve years old, we went to a cottage for a couple of weeks. Eventually we went for most of the summer. We stayed at inexpensive places that we often shared with other families. We packed up the car and pulled our pots and pans and luggage in a rickety old wooden rented trailer behind us. I called them popsicle-

stick trailers, because their sides reminded me of the small sculptures we made using popsicle sticks.

For the last few years, we drove all the way to South Haven, Michigan. We went down through Chicago and its outskirts, and then into Gary, Indiana, with its immense chimneys spouting fire out of their tops. After that, through miles and miles of young corn in Indiana. We were going around the bottom of Lake Michigan to end up in a place on the east side of the lake. We would drive for hours through the hot, humid, early summer in the Midwest.

It was so hot that my father was usually in his undershirt. I can still picture his strong, menacing arms. He would just come on the weekends, but he would have to drive us all back in the fall. It would be noisy. My whole family was in the car: Mom and Dad in the front seat, and the three of us kids in the back—probably fighting as much as anything else. And we would sing. When my mother sang, it was in her sweet, low, thick voice. She would usually sing "I Wonder What's Become of Sally." And she would sing "Always." My mother had a beautiful voice that quieted all of us, but she would only sing if she were coaxed.

Much more often, my father would sing his favourite songs, many sounding fairly military, songs like "Alexander's Ragtime Band," "Stouthearted Men," and eventually "The Pirate Song"—his favourite. It was a song about a pirate who had outsmarted his lady love, who had tried to get his money chest. All I remember of it is:

Ho, ho, ho, it seems so funny
You don't want me but you want my money.
I won't marry, marry, marry, I won't marry you.

And we would sing all kinds of songs together: "Oh Susanna," "I've Been Working on the Railroad," "I Dream of Jeannie," "Camptown Races."

It was a very long drive—something like seven hours. And I can't remember going to restaurants, so we must have taken picnic lunches, but we probably ate as we drove in the car. In those days, there were advertising signs that appeared alongside the road intermittently, Burma-Shave signs. They had continuous messages, for example: "drove too long / drivers using / what happened next / is not amusing /

Burma-Shave." We would recite these messages all together as soon as we noticed another one coming up.

One day, as we were driving along singing and reciting, my father suddenly asked my mother, "Where did you pack my shoes?" There was silence in the car, and then my mother said, "I didn't pack your shoes. Didn't you?" So my father started driving very fast, screaming at her about how stupid she was, how useless. He didn't let up, and the three of us were cowering in the back seat.

My mother was never very good at defending herself against him, so it went on and on, driving through Indiana. My father always had a cigarette hanging out of his mouth—Camels—and my mother, who started smoking in her early thirties, smoked Pall Malls. So there was all this smoke in the car and all this fear, all this pain. I don't think any of us ever forgot this day.

After a while, everything finally calmed down. At last, it was our turn to sing. My sister, my brother, and I sang a round: "Row, row, row your boat, gently down the stream / Merrily merrily merrily merrily, life is but a dream . . ."

CAR SONGS

ACRYLIC ON CANVAS, 12" X 36",

2011, COLLECTION OF THE ARTIST.

WAITING

WAITING

It seems that most of my life before moving to Canada was spent waiting. Here, I am waiting for George in the middle of the night. On many, many nights I was left to wonder if he had been in a car accident or was lying dead somewhere, only to have him wander in at two or three in the morning with hamburgers from White Palace or sweet potato pie.

OIL ON PAPER, 24" X 28", CIRCA 1978, PRIVATE COLLECTION.

After George and I were married, I enjoyed fixing up our first apartment. This was my first attempt at interior decorating. We laid white tile on all the floors and bought wrought-iron furniture. I hung fans on the walls because I wanted an airy, tropical look. The bedroom was so small that we had to get into the bed in order to get into the room. But it was ours.

At that time I had a job at an employment agency in downtown Chicago, but I didn't really like it. It was 1957, and there was a lot of overt racism. At work I often had to deal with potential clients using derogatory words for African Americans or saying mean things about Jews. This was very hard for me, and I was having a tough time with it.

Having a baby would get me out of the problems at work, as I would have to quit my job. I knew that my sister had had a great deal of trouble getting pregnant; despite undergoing fertility treatments, it had taken her five years to finally conceive. My mother had also had a lot of trouble getting pregnant at various times, so I was worried about whether or not it would work for me.

George and I had been married for four months. I now know I wasn't really ready to have a child. I was already in a difficult marriage with a husband whose company I enjoyed, but whom I did not really trust. I was ignorant of the realities of becoming a mother and just wanted to see if it could happen. How could I know what it would be like to have a child? I was nineteen years old and, as I can see now, very innocent. I stopped using birth control for a little while and, despite my anxiety, became pregnant immediately. I felt lucky about this and relieved. So I continued on—I did not miss work and looked forward to having a cute little baby to take care of. George and I were very active sexually,

and despite all of my trying to stop sex for so long before we married, I now enjoyed it tremendously.

I immediately started having morning sickness, waking up and not making it to the bathroom. My labour was extremely difficult and very long—forty-eight hours—in retrospect, an ominous sign that I wasn't ready to take on this enormous responsibility. The baby was in a posterior position; she was facing the wrong way and could not come out normally. Finally the doctors came to me and said they were going to do a Caesarean section. I had to give them written permission. I still wonder how I could have been expected to have the presence of mind to sign my married name. As it happens, I didn't. I signed "Phyllis Serota." It may well have been prescient.

I clearly remember the terrifying realization that there was no way out of this. The pain was intense. I didn't believe in taking drugs, because I knew that a lot of my friends had taken something called "twilight sleep," a fairly deep level of sedation, and the babies had come out drugged. Like so many things in my life that I have been totally against, I later thought better of it. At that time, however, I simply suffered through every excruciating moment.

The birth was an incredibly difficult experience. I went for three days with no food, lots of pain, and lots of fear, and for the first time in my life I experienced

Our kids—Beth, Mike, and Heidi—on the couch in Skokie, 1964.

"going off the deep end." I started seeing bugs and would try to hit them. I remember saying to someone, "That was a real one!" So I must have had an idea that some of these bugs I was trying to hit weren't real, but I continued to swat them anyway. This is how my wonderful daughter Beth came into the world. A difficult and painful beginning.

It was just the start, thankfully. Beth was seven pounds, had lots of black hair, and looked a lot like George's family, which I felt upset about after going through all of this pain. I thought that my baby should resemble me or, at least, my family. Nevertheless, I felt a lot of love for her, and there was an immediate easiness between us that continues to this day. She quickly grew into a beautiful, dark-haired charmer.

Things were very different with my second child, Heidi, who arrived just fourteen months later. The day we conceived Heidi, I had

gone down to the beach with Beth in her buggy, and I saw a newborn baby. I have always loved newborn babies: their tininess inspires strong emotions in me. That night, when George and I began to make love, I remember thinking, Maybe we'll have another baby. Sure enough, I got pregnant.

Immediately after I realized I was pregnant, I started spotting, and I called the doctor. He told me to get bed rest, which should make the spotting stop. I tried lying down for a few days. The bleeding did stop, but the rest of the pregnancy was still far from easy. George and I were fighting constantly. Neither of us had grown up knowing how to have an argument that was productive or constructive, so we were always at each other, fighting tooth and nail. Then George's father died. He was just fifty-three years old, and with his death, the business George had been running ended, and he had to find other work.

The pattern of our fighting, the war we were in, would continue for the rest of our marriage—another fifteen years. But it was at its worst when I was pregnant with Heidi and just after she was born. The night before she was born, we had a very, very bad fight. In the middle of it, George went across the street to my sister's apartment and brought back my mother. I sat there while George told my mother terrible things about me, including that my house was not clean. To my mother, the worst thing anyone could say about someone was that she kept a dirty house. I was humiliated. It was the night before I was scheduled to have my second Caesarean operation, and I was very nervous. As far as I could see in my addled state, George deliberately chose that time to hurt me more than he ever had previously.

The next morning, in the midst of all this trauma, my beautiful, brilliant daughter Heidi came into the world. She was named after George's dad, whose name was Harry. (In Judaism, one always names a child after someone who has passed away.) Heidi was a lovely, fair-skinned baby, a little one to go along with my adorable, dark-haired Bethy, who was still only a toddler. I didn't go through a long labour this time, and although I was upset at George, I was not feeling so crazy from the birth. Back then, it was a long recovery from a Caesarean section, and mothers stayed in the hospital for ten days. When I got home with Heidi, my temperature shot up to 104°F. I had a breast abscess, and the doctor advised me to stop nursing. I had a woman

Top, Beth, approximately three years old, and bottom, Heidi, approximately five.

Michael at about a year old.

lined up to come and stay with us so that I'd have some help after getting home. I was very sick for a while; I was lucky I had help in taking care of both children.

Here I was, twenty-one years old, with two little girls, feeling increasingly trapped in a very difficult marriage. Our fighting was so loud that we were forced to leave our apartment because of the complaints. We moved to Skokie, a suburb of Chicago, where we rented an apartment in a two-flat building. Some very nice young people lived beneath us, and we became friends, but soon afterwards the landlords moved in under us. The fighting had continued unabated, and the two girls were running around the apartment, as little kids will. The floors would squeak loudly when we went into the bedroom at night, and just walking in there and hearing that squeak scared me. I feared we were about to lose our home again, and we did. We were evicted for the noise again.

We then rented another apartment in Skokie, in a two-flat building next door to my sister and her family. It was great for the kids to play together all the time, and we also got to spend more time together. Sondra and I, after a rocky start as children, had become very close. When our children were first born, we walked together with the babies pretty much every day, down to the beach or to a wonderful Jewish restaurant called Ashkenazes.

My relationship with George continued to be difficult, but since both my sister and I had grown up in a very agitated, argumentative family, we didn't think it strange to see this happening in my marriage. My sister's son, Marc, was born while we lived there, so now we each had two children. Our lives were centred on the children, not on my troubled marriage.

Life also went on, as it did for middle-class, married women in those days: we went out occasionally, and visited mostly friends with kids. Both Sondra and I smoked: everyone did. We started attending art classes at the high school, played poker once a week, sat outside in the yard in summer with small rubber blow-up pools, and grew tomato plants.

When the birth control pill was introduced in the early 1960s, I immediately went on it. I have always said that I was the first one to take the pill after the trials in Puerto Rico were completed. Whether or

not that's true, it worked. I used birth control religiously (I was religious about some things). I did not yet want any more children, because life was enough to cope with as things stood. But then, despite everything, I began thinking about having another child. My doctor had told me that after I had my third child he would tie my tubes, which would guarantee that I wouldn't become pregnant again. I was looking forward to that, but I also truly wanted to have a boy; somehow I felt this would complete both me and the family.

In 1963, I got pregnant again. When I found out, during the third Caesarean, that the baby was a boy, I fainted—one of the few times in my life that's happened. In retrospect, I think I felt it was a justification for my life to have given birth to a son. Boys were so much more valued than girls, and until then I had always felt that I didn't measure up. To add to my joy, my baby boy was blond and really cute, and that boy, Michael, continues to be a very handsome man. All the same, I did have my tubes tied—something I've never regretted.

Around this time, George and I bought a nice brick bungalow on a quiet street in Skokie. Skokie was eighty-five per cent Jewish; I still hardly knew anyone who wasn't Jewish. I stayed at home with the kids while George worked as an insurance salesman, later moving up to a management job. I was living the life I had dreamt of as a young girl: getting married, having kids, and travelling. We went to Puerto Rico and New York City in the mid-1960s and took many other trips that George had won as a result of either his selling a lot of insurance or his employees doing well. My three children were beautiful, and I loved them. I was still only in my twenties, with much to look forward to.

But all was not perfect in Paradise. I was sleeping much of the time. I could barely pull myself awake, even after twelve hours of sleep. Various young women lived with us to take care of the children, so I could get away with this, but I knew it wasn't right. There I was, getting up at one o'clock in the afternoon, crawling out the back door to bring in the milk, ashamed that my neighbours might see me. In hindsight, it's easy to say that there was something very wrong in my life. I could say now that it was my marriage, or I could call it depression. I could say I wasn't cut out to stay home and take care of kids and live in the suburbs. Maybe it was all three of these things. Clearly, something wasn't working for me, but I had no idea what to do to change things.

Something is definitely wrong with me here. Skokie, about 1966.

BECOMING A MOTHER

FAMILY IN THE SUBURBS

Another quintessential painting of life for George, me, and our kids in Skokie. During that time in our lives, I always thought of George as holding me down.

OIL ON PAPER, 30" X 22", 1978, COLLECTION OF THE ARTIST.

In 1968, I went back to work. George was having financial problems and had decided to declare bankruptcy. I was totally opposed to his doing this and started looking for work, and things did improve for me after that. We still had a young woman taking care of the kids, so I could go to work. I resumed being an employment counsellor, and this time the racism was not as obvious. I had lots of new friends, many of them younger than me. George and I had also started smoking dope, an entertainment introduced to me by George, who had started a couple of years earlier. Life became fun! That was true for many people in those halcyon days. It was the sixties, after all. The fact that we were parents didn't seem to matter, compared with our common desire to enjoy ourselves and live life to the fullest.

Together we tried to turn on everyone we knew, including our neighbours and our closest friends in the suburbs. Although marijuana had become an important component of our relationship, the children were not yet aware of our drug use. Our lives, we felt, had come to a happier place. At the same time, I was painting more and had started having shows.

I was very good at my job as an employment counsellor and was earning more money than I had ever expected. The bankruptcy threat was gone. I bought lots of new clothes and was wearing makeup, which I would put on in the car, sometimes in the middle of traffic jams. I remember some harrowing trips on the expressway, balancing coffee cups and eye shadow, knowing that if I were to arrive late, I would not be able to make any money that day, as this was strictly a commission job.

George and I also had started going out together after work. We would head out to jazz and folk clubs, and to bars where people had started dancing on tables. I still remember the first time I heard "Twist and Shout." It was in a crowded, hot, storefront club, and everyone was dancing madly— including me. I still love that song!

SUNDAY AFTERNOON (FOUR O'CLOCK)

We've just made love and are getting up. George would often spend the
entire weekend in bed, which really annoyed me.

OIL ON CANVAS, APPROX. 20" X 24", CIRCA 1985, PRIVATE COLLECTION.

A rare visit with all three of my children, Victoria, 2007.

SHE FOUND OUT THERE WAS SUCH A THING AS SEX IN THE WORLD

SHE FOUND OUT (THERE WAS SUCH A THING AS SEX IN THE WORLD)

This is the moment George's infidelities became clear to me. Although I had heard his confession the night before, it took about twelve hours to finally hit me—on the stairwell between the nineteenth and twentieth floors of the building I worked in, in downtown Chicago.

OIL AND CHARCOAL ON CANVAS, 45" X 33", 1994, COLLECTION OF THE ARTIST.

In March of 1968, George confessed that he'd had many lovers throughout our eleven-year marriage. I'd often asked him whether he'd had another lover. He had worked nights for years and would sometimes get home long after midnight. I'd spent many hours waiting for him, and his excuses were either that he had fallen asleep on the road or he had to go out with someone who worked for him or God knows what. Finally, he told me the truth: from school friends of mine to women at work, from my sorority sisters to prostitutes, he had indeed had many lovers. All through our high school days, our time at the University of Illinois, our engagement, and afterwards, there had been other women. I was stunned. Purely and simply, he had lied from the beginning.

The next morning, I went to my job at the employment agency and telephoned my best friend, Lesley. We had been very close ever since college. She and her husband, David, were our constant companions. Lesley and I went everywhere together, painted together, played cards, and often sat up all night talking. That day, we were on the phone for three hours. She told me that she had always known about George's womanizing but had been afraid to tell me—people never told stories that might break up a marriage; marriage was sacred. I was amazed that I hadn't guessed but quickly realized that I had not wanted to know. I felt so stupid, so naive. I had been in denial for years.

When the phone call ended, I went upstairs to the bathroom. On the stairwell, between the nineteenth and twentieth floors of my office building, my world tilted and everything changed. I finally understood the significance of sex—how little I had understood of its power in the world and how men viewed sexuality differently from the way women did. That day, everything changed for me. I grew up.

The surprising thing about George's confession was that it rekindled my flagging sexual interest in him. I would never have guessed it. In the following months, he and I often met for lunch. I would take a cab from my job on Michigan Avenue to his La Salle Street insurance office and we would make love, quickly and passionately. I will always remember standing in the wind, waiting to catch a cab to get back to work, feeling really grown up and somehow dangerous for the first time in my life.

Before this, I had mostly followed all the prescribed paths for a woman growing up in the 1950s. I had met George in high school, we had gone to college together, and after he left school we got married. Our three children followed in fairly quick succession, as did a home in the suburbs. The one exception was taking a job. From then on, I was no longer dependent on George for money.

At least for the time being, I had forgiven George's dishonesty and betrayal. After the first passionate time, because George had obviously had other lovers and I had not, I started to want to have other sexual experiences too. He was strongly opposed, however, assuring me that his wayward times were over and that our new life together would be built on honesty and monogamy. That was also a lie, but how was I to know? My naiveté was still strong. And regardless of the other faults he had, when we weren't fighting, George was indisputably fun to be around (most of the time, anyway).

The first of many significant changes in my life occurred in that important year, 1968, when everything was changing for many of us. I met a young woman at work, Chris, who was tall and about ten years younger than I was. She had a cool command of the world that I didn't have. She had long, reddish hair and lots of freckles, and walked with a long stride. She was the first hippie I had ever met, and she personified the movement for me.

We started going out for lunch together occasionally, and George and I visited her apartment, which was in an older building. It had huge rooms, each one painted a different bright colour. I remember an orange room and a purple room. There wasn't much furniture—we sat on wooden doors set on top of bricks and smoked dope in a smelly

RISING FIGURE

This is a very important painting for me; I saw the image while in the synagogue in 1989. Work that comes from my mind's eye I consider to be a gift. I placed this painting here because maybe my spirit had already, as early as the late 1960s, begun to rise.

OIL ON CANVAS, 33" X 45", CIRCA 1989, PRIVATE COLLECTION.

old pipe. Every time we went there, I thought the police would rush in and arrest us. I felt more comfortable when she and her husband, Nils, would visit our house in the suburbs on weekends, and we could safely smoke dope or take mescaline there.

Nils was a gentle, very soft, quiet young man. He was of medium height, was well built, and had light brown hair and a large, droopy mustache. He and his family had come from Latvia when Nils was young, and he still had a slight accent. Chris had come from a wealthy family in Oak Park, an older, conservative suburb of Chicago. Her family had opposed her marriage to Nils because he was a foreigner, but Chris had rebelled.

Nils was an artist. His paintings were huge and dripping with paint. I had never seen paintings like his—they were angry and rough. The men had visible penises. I had been painting more and more since 1961, but Nils was the first artist I met who was working from his imagination and on this scale. He was selling his work to our bosses at the employment agency, and the paintings, enormous and shocking, hung there on the walls. Nils and I had many wonderful talks about art. I consider him responsible for my realization that I could work from my imagination and not just from reality.

As we listened to music and hung out, Chris and Nils were very relaxing to be with. They accepted people not according to how much money they had, or what schools they'd gone to, or what kind of job they held, but by how they behaved and thought. They talked about things I'd never thought much about: how homosexuality was OK, how the economic and political systems would eventually crash, how a lot of people were moving to Canada, and how we were a new generation who would change things. We could make the world a better place.

My kids really liked Chris and Nils, and our drug use didn't seem to affect them negatively—although I probably did not think much about that at the time. No one we knew was concerned about their children and drugs—it just was not an issue. On the night we did mescaline for my first time, the children were sleeping, but Beth woke up. She remembers me showing her a rose and extolling its beauty. I wanted to eat it and told her that, but I can't remember if I actually did eat the rose. Neither can she.

LETTING GO

In my case, changing times had some connections to letting go. I was holding myself so tightly for so long. I started to let go by going to work and doing all that I've just described.

ACRYLIC AND STRING ON CANVAS, 36" X 12", 2010-11, COLLECTION OF THE ARTIST.

RECITAL

RECITAL

Instead of portraying myself as a child painter, here I depict myself both as a musician and as a grown-up artist, calling forth many of the images I later used in my paintings, including Aunt Molly, Uncle Jake, and the mysterious smoking figure on the right edge. Who do you think that is?

OIL ON CANVAS, 44" X 60", 1987, COLLECTION OF DR. MARCEY SHAPIRO.

We made papier mâché bowls in second grade. Mine was a large round bowl, and I painted it purple and white. I loved it then, and I love it still. At home, I had a set of moulds, and in them I made little statues out of plaster of Paris. Then I painted the sculptures. I remember one set of Spanish dancers and bullfighters, and another of Chinese figures. I combed the dime stores for exotic colours and powders to decorate these small figures. I really enjoyed that! Now I realize that I was usually picked to do murals in the schoolrooms and other special art projects, but back then I never gave it much thought.

One day when I was in Hebrew school with my oldest friend, Sondi, she asked me if I wanted to go to classes at the Art Institute with her. "What's the Art Institute?" I asked—my family was definitely working class and had no connections with "art." Sondi told me it was a beautiful, huge building in downtown Chicago, down by the lake, where they had a wonderful collection of paintings by really famous artists. I asked my parents and they agreed, but the person I was most worried about asking was my Hebrew school teacher, Mr. Flyer. We were supposed to go to Sabbath services every Saturday, and these art classes were taught on Saturday mornings. Sondi and I told him we were going, and, surprise, surprise, he said yes.

So off we went on the streetcar the next week; we could take one streetcar all the way there. I signed up for a class in cartooning. I don't remember too much about the class itself, just drawing with India ink and pens with large nibs, but I do clearly remember the smell of oil paint in the basement where they held the classes. It got into my blood.

We ran around that basement to the rooms where the grown-ups were drawing from a nude model, and I peeked in. Very exciting and slightly dangerous.

We also went up to the galleries to see the paintings. At the tender age of ten, I got to stand in front of Renoirs, Picassos, and Toulouse-Lautrecs, and I have an indelibly clear memory of a small yellow-green painting done by Vincent Van Gogh. It had raised parts that seemed to be in a pattern where the paint had been thickly applied, and I marvelled at that. And the colour! The feeling of it, both calm and agitated. I stood there for a long time, while the life of the museum swirled around me. How did he do that, bring all of that emotion into a small rectangle of canvas and paint?

I took one other class there, one where we drew with pastels from life, which included going to the Field Museum and drawing some of the life-sized stuffed animals that had been placed in huge dioramas. I remember working on a painting of a giraffe, and the old woman teacher telling us about "negative areas." These, apparently, were the areas surrounding an object like the giraffe, and we were supposed to draw them rather than the giraffe itself. I had no idea what she was talking about at the time. Many years later, I finally did.

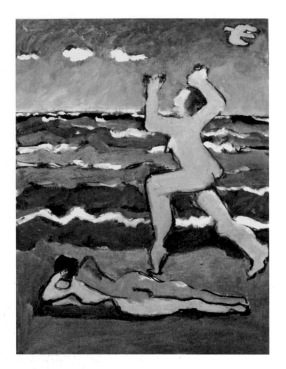

ON THE BEACH

A joyous moment in my life, when I felt alive, happy, and able to be alone. This was in the very first group exhibition I was part of—a women's show at a gallery in downtown Victoria.

OIL ON PAPER, APPROX. 28" X22", CIRCA 1977, PRIVATE COLLECTION.

When I was twenty-two, my sister, Sondra, my best friend, Lesley, and I decided to go to a night-school painting class at the local high school. This was when my two little girls, Beth and Heidi, were one and two years old. That class was taught by one of the best art teachers I ever had, Pete Carr. When I was painting, I noticed that everything else was gone from my mind. Gone were the difficulties with my husband and my family. Painting gave me a new kind of concentration.

Pete Carr was creative in his teaching, and his assignments really challenged us. He would read poetry to us and have us paint our visions of it. Or we would listen to music and interpret that. Mostly, he had an open mind, something I rarely encountered in those days—1959 to 60. He once had us paint while he read a Dylan Thomas poem to us. That time, we painted on huge pieces of cardboard using poster paints and commercial paintbrushes. I created what I thought was a horrible mess, with just red, white, yellow, and blue on unprimed cardboard.

Pete Carr loved it and asked if he could have it. I was shocked but said yes. I thought he was crazy.

The second teacher I had was Felix Patmagrian, a woman who gave classes in her home and later rented a storefront close to where we lived. She taught in the back of the store and used the front for painting exhibitions. I painted with Felix for a long time—eight or nine years. A bunch of us—Lesley, Sondra, my old friend Lois, and others originally from the west side—would go together and mostly paint still lifes. Felix would set up plastic flowers and wax fruit, the same dusty old peaches and apples, and we would all gather around and paint them in oils. We would buy stretchers (and not know how to make them square) and prepared canvas, and nail them together. And then paint, over and over, these very similar still lifes. Occasionally one of us would model or Felix would bring someone in to pose nude. I eventually painted there for two or three nights a week, leaving all of my problems behind. Towards the end of those years, I helped Felix teach.

Eventually, Felix asked me if I would have an exhibition in the front gallery. That was a big surprise. I had no idea that she thought I was doing well. So I had my first one-person show and sold eight paintings—enough to completely redo my girls' bedroom. The room was beautiful, but painting was still my hobby and not my profession, and it remained so for a long time.

After George and I met our hippie friends Chris and Nils, one evening we did a psychedelic drug together. At that time, Nils, who was a very good painter, talked to me about working more from an inner vision, rather than from reality. I didn't understand what he meant, but it did make me wonder, and that is always a good thing.

My kids in front of the Art Institute of Chicago, probably in 1988, because Beth's husband Matt is in the picture holding her. On the left is my son-in-law Doug; Heidi is lying under the lion, Mike is standing, and Matt is holding Beth.

YELLOW TULIPS

After my very first studio/home sale, I stood in front of some yellow tulips I bought for the occasion. The show had been a resounding success. I remember feeling so grateful and lucky, and painted that feeling.

Since then, I always have yellow tulips at my studio shows.

OIL ON CANVAS, 28" X 22", 1978, PRIVATE COLLECTION.

AUGUST, 1968

AUGUST, 1968

This painting depicts the moment that I have always said was the reason we left the United States: five or six policemen beating up a reporter on the hood of our car during the Democratic national convention, 1968. I've written elsewhere about this incident, but suffice it to say that we were terrified and got down on the floor.

The painting reminds me of Goya's *The Third of May*, which was done in 1814: the faceless attackers, their uniforms, their absolute knowledge of their right to beat up whomever—these are the people who do this kind of work.

To do this painting, I put on the music of that time and viewed photographs of the incident that had been taken at the scene and had appeared in the book *Rights in Conflict: The Chicago Police Riot*. There are five photographs of this incident, and this was the first time I realized that photographs don't tell the reality of a story. This story, which was so important to us, seemed mundane in the photographs. All the elements were there: the car, the police, the traffic light, the reporter. But what was missing was the emotion we felt that night. I determined to put that into my painting, and I hope I've succeeded.

OIL ON CANVAS, APPROX. 45" X 50", 1988, COLLECTION OF JEFF GREEN AND ROXANNE HELM.

In August 1968, the Democratic national convention was held in Chicago. The Republicans had already nominated Richard Nixon as their presidential candidate. Now, students from all over the country had come to Chicago to protest the Democrats' proposed nomination of Hubert Humphrey, who, like Nixon, was in favour of continuing the war in Vietnam.

The protestors were camping out in Lincoln Park without the benefit of tents. After work one day, George and I, my brother Bobby, and Mike and Sheila, a couple from England who we were hanging around with, visited Lincoln Park to see what was happening. It was a scene right out of my short, happy years at university, and I walked around enjoying this wonderful heady atmosphere. Near us, Allen Ginsberg was leading people in chanting *Om*. Small fires had been lit in garbage cans, and I remembered the idealism of my youth and my hopes for a new world.

But about an hour before midnight, we witnessed a huge line of helmeted police dressed in blue, silhouetted against the summer night sky. Using bullhorns, the cops warned everyone to get out of the park. When the crowd didn't move quickly enough, the police set off tear gas and rushed into the crowd, swinging their sticks and beating people.

We ran to our car and tried to leave but were almost immediately stopped at an intersection. A small sports car had stopped in front of us, and the three people in it were holding up a peace sign. All of a sudden, six policemen appeared, beating these young people on the head with their clubs. From behind our car, a man came towards them shouting, "Cut it out, you motherfuckers!" The police turned on him and started to beat him on the hood of our car. They kept hitting his

head, and the blows that missed him hit the front of our car. We were terrified and all got down on the floor!

Those few seconds changed my life. The man was bleeding from his head when the cops had finished with him, so we took him into our car and to the nearest hospital. He was a reporter; it turned out that nine reporters were attacked by the police that night. The couple from England, Mike and Sheila, said that it was "just like the Nazis." I was shocked at first and defended my childish notions about the police being our friends, but clearly that wasn't the case that night.

We tried to tell our suburban friends what had happened: the violence, the police attacking innocent people, tear-gassing and beating them, but they did not take it seriously. We were devastated by their denial, as well as angered and shocked at what we had witnessed. It had, after all, been widely reported and photographed.

Chris and Nils, however, did believe us. Not long before the protests, Chris had said to us: "There's a place in Canada that's warm, called Vancouver." I knew nothing about Canada except that all the cold weather we had in Chicago came from there, so how could it be warm? All the same, a couple of months after the convention, we were heading back into Skokie after a week spent fishing in Wisconsin, and I heard myself say to George: "Let's get out of here. I can't stand the materialism anymore. This street, with its McDonald's and other fast food restaurants, looks the same as every street everywhere. Maybe we should move to Canada. Chris said there's a place that's warm in Canada, called Vancouver. Let's go and take a look."

Police and demonstrators clash in Chicago on August 28, 1968, during the Democratic national convention. Photo: ©Les Sintay/ Bettman/CORBIS.

I now realize that it wasn't just the Democratic convention that inspired the idea. It was a very big thing for me to realize that the people I thought were there to protect me were attacking innocent people. When John F. Kennedy was killed, then Martin Luther King Jr., and then Bobby Kennedy, it was just too much for me: those deaths broke my heart. But I didn't know that then; I just knew that I wanted to leave Skokie and drop out.

It took us a couple of months, but eventually, at Christmas, we flew to Vancouver to take a look at that warm place in Canada, and we loved what we saw. After driving around, we decided to move as soon as possible. We thought we would move to Vancouver Island, to a

town called Lake Cowichan, a pristine, sparsely populated community situated beside a huge lake. We told each other: This is it, the place where we can drop out and just live. Turn on, tune in, drop out. That's how it was, remember?

Children are the real conservatives among us: they never want to move or change what they know. Our kids weren't happy about going, but George and I had made up our minds. We applied for landed immigrant status in Canada and went through all the red tape of moving to another country, a process that was both strange and difficult. But once I'd made up my mind to do this, I never looked back. I never have. Canada has been good for me in many ways, and continues to be.

It took us longer than we thought it would to sell the house in Skokie. While we were waiting for the legal work of the house sale to be completed, I got very impatient. Patience was never my strong suit—I take after my father in that respect—so when we signed the final papers at 4 p.m. on the day the sale was finalized, I couldn't wait until the next day to leave. We left our old life behind at 6 p.m., driving out of Skokie. I needed to get the hell out of there as quickly as possible. After stopping at our favourite ice-cream parlour for one last time, we were off. In October 1969, we set out with our three children in the back of a new green Chevy station wagon for our new country and new home.

The next day, we entered Canada at Fort Frances, Ontario. I was astonished to discover that we would receive a government allowance for the children every month. A family allowance—who would have thought? This Canada was some country!

It was a week-long trip out to the west coast. The kids, who were eleven, ten, and five, were cramped in the back of the car and often fighting, but still we picked up hitchhikers along the way. We hadn't brought any marijuana with us because of the potential for trouble at the border, but we knew that hitchhikers might have some. We would drive all day and sleep in hotels. We had some money from the sale of our house and stayed in good places and, as always, ate well.

When we arrived in Lake Cowichan, we couldn't get a place to rent, so we settled instead for a modern 1960s house built on a hill overlooking an inlet of the nearby ocean. It was in Arbutus Bay, a small, beautiful village that hugged the sea. People from all over the world

A photo of us in the car, from the official report to the National Commission on the Causes and Prevention of Violence, "Rights in Conflict—the Chicago Police Riot." Photo: ©Frank Haynes, Chicago's American. The caption in the book reads "Teenagers [we were not teenagers] in car watch, horrified."

had settled there recently. They had come for group encounters, for the new drug culture, for the music—for a lot of reasons, mostly having to do with escape. Our house was a beautifully designed three-bedroom, split-level home with an unobstructed view of the bay, much more posh than our simple home in Skokie. The village itself was another world. There was an old hotel and pub about a block from our house, and we soon became regulars there.

For the first time in my life, I'd moved away from all I knew to begin a new existence. Sometimes I would look across the bay to one of the Gulf Islands, which I thought was like looking at the other side of the mirror, and imagine that in Chicago my old self was still living in my old house, having my old life. I was disoriented, never having done anything so intuitive and bold. For a while I wondered about our decision, because we had arrived at the end of October, which in this part of the world is the rainy, dark time of the year. But my new life soon became much more vibrant than anything I could have imagined.

THE PROMISED LAND

A painting of our family's journey to Canada. Here we have arrived at a lake in the Rockies. I am so thrilled with the view that I make the kids get out of the car to experience it fully. George, clearly, was not as thrilled as I was about the land. I'm not sure this really happened, but it still seems correct.

OIL ON CANVAS, 4' X 5', 1997, PRIVATE COLLECTION.

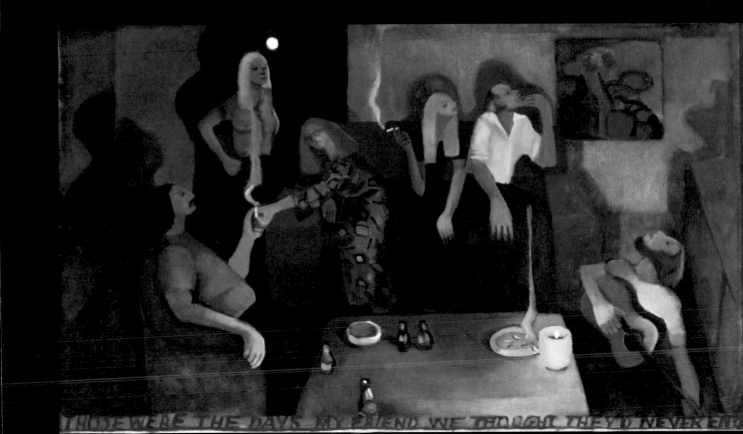

THOSE WERE THE DAYS. . .

"All my changes were there"—Neil Young

This painting of the Arbutus Bay days shows the main cast of characters of that important time of my life, the early 1970s. The three main characters are on the left side of the canvas: George is seated, Annie stands next to him, and I am the figure on the left of the couch.

The other two people on the couch are friends, and playing the guitar is a representative musician, one of many who were so much a part of those wonderful, stormy days. The setting is our living room in our first house in Arbutus Bay, lit as it often was by firelight and candlelight. So many things happened in that house—so many changes for all of us. We went to the pub, half a block down the road, at night, and when it closed, everyone would come back to our house. There was a party every night.

We did think those days would never end. When that song came out, we sang along lustily, never realizing that the end would come much sooner than we could have imagined. Soon after this, George and I sold this house.

I made this painting ten years after the scene depicted here had come to an end. I had seen a play at Victoria's Belfry Theatre about those days. The audience was mainly older people, who I felt would have had no understanding of what it was like to live through those times: how idealistic we had been, how open-hearted, and how convinced that the world really would change. I drove home feeling angry and then realized why I was so upset: I was holding those days sacred. I decided to look at them and really try to understand what had happened for me and for all of us then. Of course, my way of exploring those ideas was to paint them. Doing that made me realize that although there had been many good things about those days, they had not been perfect. I made many mistakes with my children and with drugs then that I've lived to regret.

One of the interesting things about this painting is that the director of the play ended up buying it. Things often do come full circle.

"Those were the days my friend, we thought they'd never end . . ."

OIL ON PAPER, APPROX. 30" X 55", 1982, PRIVATE COLLECTION.

At first our life in Arbutus Bay was quiet, building fires in our beautiful new fireplace every night, listening to music on the reel-to-reel tape deck we had splurged on before we left Chicago. But that got boring pretty fast. We met Jan and Ed, who lived across the road and whose son was enrolled with our son, Michael, in kindergarten. Both Jan and Ed were writers. After hearing our story of the Democratic convention and of leaving Chicago, they told us about the couple who owned the village's old hotel, the Arbutus Bay Inn.

Everyone we met said we had to meet the owners, and we soon did: they too lived across the road from us. We were impressed. One of them had started out as a Christian minister, but I guess he saw the light, quit that, and started groups that would help people, especially business people, understand the changes that were happening all over the world. The groups were also supposed to teach people to free themselves from the restrictive lives they had been leading. These "encounter groups" were happening everywhere. Nearby, in Lake Cowichan, was Fritz Perls's famous Gestalt Centre. Many people were living in communes, and it wasn't unusual for people to be involved in group marriages.

It seemed we had fallen into a hotbed of these new ideas, especially at the Arbutus Bay Inn. The encounter group was the group therapy of the late sixties and early seventies. A group of people would assemble in a room for usually a week to ten days. There would be a leader who was sometimes trained in psychology, but just as often was not. The objective of the exercise was to learn about our feelings—not our physical feelings, but anger, love, sibling rivalry, even hate.

By December 1969, George had started going to a men's group. I

Here I am in Arbutus Bay, cigarettes in hand, in 1971. I think this was a ball field.

went to my first women's group in March of the following year. Within six months, George and I were entrenched in "the scene" at the hotel and working for the owners. I was cooking there, and George was selling insurance. We also participated in the encounter groups to show the paying customers what they could expect after they "graduated" and to encourage them to acknowledge and talk about their feelings. The feelings could be sexual, and participants had a kind of permission to act on them, even if they were married to someone else. Jealousy, however, was not permitted: that wasn't cool.

In the three or more groups I participated in, we tried to break everyone down, to make each other cry. If you could manage it, the ideal thing was to cry early; if you didn't, the group would often torture you until you did. All of this was supposedly about helping each other. In some cases, I believe it did work. Ironically, jealousy was one of the most prevalent emotions we felt, because these groups encouraged us to make love with whomever we wanted. It didn't seem to matter whether the participants were married or not.

Revenge is a powerful force. I decided to call in my debts from George. I would begin my own sexual experiments; after all, George had been my first and only lover, and he owed me. One night, after smoking dope and drinking a fair bit at a big party, I started necking with a young man. I think he was a butcher's helper. George noticed this and immediately ran over and started choking the man. I was really upset, and my old feeling of being trapped returned. I had to get back at George, but at the time had no idea how.

I had never, since hearing the word *lesbian* when I was young, let myself entertain that possibility. Eventually, though, I met a woman who had been in sexual relationships with other women, and that made my transition relatively easy. Realizing that women were not as threatening to George as men had been, I started having women as lovers, and in time also had sexual contacts with other men. But there never was any other man who was significant to me.

Meanwhile, drugs continued to play a major role in our lives. By the end of the sixties, marijuana use was very common. With the drugs came a feeling of rebellion, of realizing the authorities didn't have all the answers. We could make our own lives and answer our own questions, which was a situation very different from the 1950s.

Beth, Heidi, and Michael on the porch of our second Arbutus Bay house.

Our motto, naturally, was Sex, Drugs, and Rock 'n' Roll. That's what we did. We experimented with drugs, and there was lots of experimentation with sex—all very exciting for a recent escapee from the suburbs. As far as rock 'n' roll was concerned, this was all played out within a wonderful soundtrack that included Bob Dylan, Cat Stevens, Leonard Cohen, Joni Mitchell, and James Taylor. My favourite song in the early times was "Me and Bobby McGee," first recorded by its composer, Kris Kristofferson, and later by Janis Joplin.

We soon started using other psychedelic drugs, mainly LSD, an extremely powerful drug. It scares me now to think that I took a drug like that. The scariest thing about it was that the high lasted for about eight hours, and you were pretty much out of control for at least two-thirds of that time. I "dropped acid" about eight times, always feeling terrified for the first few hours, constantly thinking, Am I peaking yet? Then I finally would get comfortable enough to realize it wasn't going to get any stronger. After about four hours, I actually enjoyed the trips and their accompanying insights into life.

What I experienced doing LSD and other drugs, such as psilocybin and mescaline, was something that took me a while to understand. I discovered a part of me that knew more than my conscious mind did. I've heard it referred to as the soul, but I'm not sure what to call it. I just knew that it was there. In my case, I saw something that appeared to resemble vegetable material, or straw, going by me quickly. After so many years, I'm not sure why I've interpreted it as this more sentient component, but I did, and that has stayed with me. Still, I can't recommend doing these drugs; in some ways, as Leonard Cohen says in "The Butcher," "It did me some good, did me some harm."

Our kids were having a wonderful time, too. They had friends whose parents were also doing a lot of experimentation, and the kids all hung out together in a fairly large group. They would camp out at one of the small coves, and were living a much freer life than they had in Skokie. We never imagined, though, that difficulties would arise from all of this freedom. The times were changing, we thought, and everything would work out.

Chris and Nils came to visit us a couple of times to see how we were getting along on Vancouver Island. Chris's statement had prompted our move here, and after their second visit she did not return to

SUNFLOWERS

One of only two paintings I did during the hippie years in Arbutus Bay. I was too busy living then, but soon got back to painting and haven't stopped since. I did this on my kitchen table in our second house.

OIL ON CANVAS, 36" X 24", 1972, COLLECTION OF BETH SCHOTT.

1971 REMEMBERED

A painting about friendship—the way it was in Arbutus Bay. These were some of our closest friends. I imagined all of us singing together, and the song is, my favourite, "Me and Bobby McGee."

OIL ON PAPER, 22" X 30", 1983, PRIVATE COLLECTION.

Chicago with Nils. She wanted to move to Canada, but he wasn't sure; in any case, their marriage seemed to be over. Attractive, smart, and tough, Chris settled into the Arbutus Bay scene and eventually became involved with the men in the area—men who had mostly grown up here and were very masculine, fishermen and hunters. In those days, it was considered cool to be as self-sufficient as possible; people who could survive in the bush were very attractive to all of us.

Chris eventually divorced Nils and settled in with a man named Wayne, a good friend of ours. Wayne was madly in love with Chris, and we were all very happy for them. We thought we would always be doing what we were doing, and that, as the song says, "those days would never end." One night, there was a dance at the Inn. We all went and had a marvellous time, and when we came out into the night it was snowing. We walked around in it, our eyes wide in wonder. It seemed miraculous to us; in some ways, it was the high point of our years in Arbutus Bay.

But the next day, a man who had moved from Detroit, a member of our "gang," said that it was over, that everything would slowly come to an end now. I was shocked and didn't believe him, but he was prophetic. Over the next year, the excitement of life in Arbutus Bay slowly dwindled: people left, went to other places, became addicted to stronger drugs, went back to school, or formed new partnerships and left, as I too would eventually do.

For Chris, the Detroit man's prophecy came true in the harshest of ways. One day she was on the Trans-Canada Highway near Arbutus Bay, waiting to make a left turn, when her car was rear-ended and pushed into oncoming traffic. She was badly hurt, and we thought she would die. Her memory was gone: she had complete amnesia.

Her parents flew out from Chicago to take care of their rebellious, lost child, now helpless again and completely at their mercy. They prevented her from seeing Wayne or taking any of her clothes, or anything that might cause her to remember her life in Arbutus Bay. They kept her away from all her friends. We might have brought her back to herself, but this was her parents' chance to reclaim her. Wayne frantically tried to see her, but failed. After a couple of weeks, Chris's parents took her home to Chicago. We never saw her again.

PAIRS

PAIRS

Just before Annie and I got together in the early 1970s, I had a dream in which I was in a cave, floating in water, and Annie was holding me. Just above my head in this painting, there is a representation of that dream. It felt very gentle, very soft, very loving.

This was the first time I ever painted pairs—that's PEARS. Annie is shown as strong and gentle, which she is, and a nurturing person—I must admit, I do need lots of nurturing.

OIL ON CANVAS, APPROX. 24" X 30", 1989, COLLECTION OF LORINDA ALIX.

At one of the men's encounter groups that George attended was a man named Joe Weeks, who lived on a boat with his wife, Annie. Joe invited us to go out with them for a trip. I had caught a glimpse of him at a movie theatre once and formed the impression that he was much older than he really was. Because of that, I imagined his wife, Annie, as a little old lady who liked knitting.

One night in January 1970, I went to the Arbutus Bay pub. There, sitting next to me at the table, was a lovely twenty-three-year-old woman with long blonde hair, wearing a white sweater. This was Annie. Annie was definitely not an old lady, and she certainly was not knitting. I don't think I said anything about my fantasy that night; I didn't want Annie to think that I had thought Joe was an old man.

We drank beer together. As I recall, draft beer was twenty cents a glass at the time, and we sat at round tables wrapped with fitted red terry cloth covers. Annie and I immediately started talking, and we were comfortable with each other. I liked her right away. I was surprised at how sophisticated she was, being so young and from a small town near Arbutus Bay. Since I was from Chicago, I thought that sophistication was the exclusive property of people from big cities.

But Annie knew a lot about books and current ideas. We talked about a book she was reading, and I felt I had finally made a real friend in this new, faraway place. After we talked for hours, she and Joe came to our house and stayed most of the night, still talking, listening to music, and getting stoned. Our mission in those days was to get everyone stoned. Annie had never smoked marijuana before, so we guided her through this experience. We had a regular lineup of music for the purpose that included the Beatles' *Sergeant Pepper's* album and the

Rotary Connection, a band that covered many of the new songs in a psychedelic way. The combination always worked.

The next morning I woke up feeling really happy. I had missed having a best woman friend around, and here she finally was in Arbutus Bay. It didn't matter that I was older than Annie was; all our new friends were younger.

The first time I'd had a lesbian relationship was not long after arriving in Arbutus Bay. I had fallen madly in love with a woman who was a bit older than I was, and a lot more experienced sexually, having had lovers of both sexes. I had never known anyone who had done that. It was intoxicating for me to imagine that the whole sexual world could now be open to me. I spent a lot of time with her before our affair started, and I knew about all her lovers, both male and female.

I had never before allowed myself to imagine making love to a woman. But now I did, and I liked the fantasy. I allowed myself to think about other women I had known well. We were reading books by Robert Rimmer about group marriage. Often the characters were bisexual. This was my time to experiment with everything, so I thought, Why not try women?

The woman I had the affair with was very secretive and didn't want anyone to know. That was difficult for me, because I felt proud of my new-found liberation. Homophobia in Arbutus Bay was still low-key, and I had no idea I could be ostracized for my choice. We were both, supposedly, in open marriages, so this should not have been an issue. We were part of a wonderful community that was supportive and non-judgmental, with a feeling of complete permission to love whomever we wanted. We all loved one another, and we were cool. I could make love to everyone, since I was now a bisexual.

Alas, that affair was doomed from the beginning. The woman I was in love with wasn't in love with me, and even though we occasionally made love, I couldn't communicate with her well enough to tell her how much she meant to me. Before I came to that realization, however, she and I planned a trip together to a deserted beach on the island. We would finally be all alone, with only our two smallest children for company. Donovan's "Catch the Wind" was a popular song then. It was a real hymn to longing, and every time I fantasized about the proposed beach trip, the song's lyrics would play in my head.

The trip was a complete fiasco. Our kids never stopped fighting, we ran out of food, we never made love, and we had a big fight on the last day. That was the end of our love affair.

The episode wasn't a complete loss, though. Because I'd had a woman lover, I felt that everyone was now available to me, including Annie. We had become very good friends and confidantes, and spent a lot of time together. It wasn't very serious in the beginning, just friends getting closer. I used to invite her to come over and have lunch or tea. She knew what I really meant and would get very nervous. She had never been with a woman. But sometimes she still would come.

Both of our husbands got along and were aware of our involvement. The four of us went to movies, drank in the pub, and, of course, got stoned. Annie and Joe had a beautiful, old, forty-two-foot, motorized wooden boat. They lived on the boat, so we would occasionally join them on it for a few days. Sometime in 1971, George decided to quit selling insurance and just work for the encounter groups. At the same time, he figured out that if we sold our beautiful sea-view house, we would be able to get along financially. So we did that. We sold our home, losing a bit of money in the process, and bought a much less expensive house a block above the ocean. The house was in pretty bad shape. It had been built as a summer cottage and was cold and drafty, but, as it happened, I didn't stay there for very long.

Our marriage had continued to deteriorate, despite its supposed openness, the fun of being stoned constantly, the drinking, and the music. It wasn't enough. I finally left George because of the increasing violence in our relationship. We were smoking dope, doing LSD and other psychedelics, and drinking in the pub every night. And after the pub closed, everyone would come back to our house.

I know now that when people drink and use drugs, their arguments can escalate in terrible ways. The violence continued to accelerate, and one day, after a particularly bad fight, George took my glasses away from me and locked me in the bathroom. Although I could barely see, I escaped. He was terrified that I was going to leave him, that he had lost control of me. He was right—I left him that day.

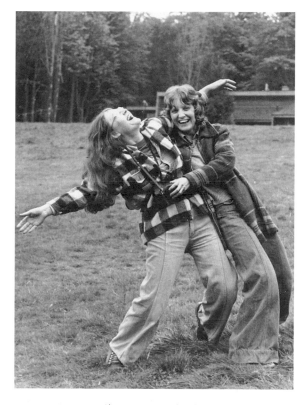

Clowning around with Annie at a women's camp on the Sunshine Coast, about 1975.

During our three-month separation, I lived around the corner from our house and across the street from the Inn. I had always been a pretty good cook, so I supported myself by cooking for the encounter groups. I saw the kids every day; they were very close by. George tried to get me to come back by promising major changes in our marriage, and in a weak moment, I decided to move back in. He and I were together again for another eight months. But the war continued.

Annie's marriage was also in trouble. She was often away doing fisheries patrols with her husband, but in 1972 she returned and told me she had left him. Our relationship began to get much more serious then. George and I were still having terrible arguments; after a fight was over, he would promise to leave the next time things got bad, to leave me with the kids. But when the fights began again—and they were coming fast and furious—he would not leave.

George would threaten to take me to court to get the children away from me. He said that if he told them I was a lesbian, the judge would rule in his favour. I was at my wits' end. I had always said that the worst thing anyone could do was leave their children. I felt that I couldn't stay and couldn't leave. I remember, after a particularly violent night, sleeping in a foetal position. I felt that I would die if I stayed, that I was already dying. The next morning, I did the unthinkable: I left George and my children. It was January 1973. He and I had been married for fifteen years. That same month, Annie and I moved into an apartment together.

Now that I was really committed, and despite my supposed sexual liberation, the word *lesbian* was still really scary for me to say or even think. The night Annie and I moved in together, we went shopping. At the grocery store, I saw a purple paperback book called *Lesbian Woman*, by Del Martin and Phyllis Lyon. I made Annie buy it—I was too scared to do so—while I hid behind the potato chip display. When we got home, we hid the book with our marijuana. That same night, however, we jumped on the bed in joy. I hadn't felt or done anything like that since I was a child. I'd always loved jumping on beds, and now I was able to jump again!

Annie and I were deliriously happy together. We remained friends with everyone we knew and experienced very little homophobia, at least that we were aware of. But I was anxious, all the same, about what

A photo of Annie taken in 1973 by her sister, Renske.

my family in Chicago would think. In a dream I had soon after we got together, I was flying around a large room and was so happy—until I caught a glimpse of a mirror beneath me, and saw myself in the mirror. I immediately crashed into it, coming down fast, and was suddenly on a street in Chicago, walking quickly and purposefully beside my mother and sister. They wore long black coats with fur collars. Along came my brother-in-law, Bob, who at that time had a history of being critical of me. He said to my mother and sister: "We'll have to take the children away from her!" I woke up feeling terribly upset, and have never forgotten the dream.

When my mother came to visit the next year, I had to tell her that I was a lesbian and that my kids had also gone through major changes. She was shocked by my hippie lifestyle, had no context for the lesbian part, and left a few days before she had planned to.

When I had left George the first time, the kids had usually come to visit every day. But now Annie and I were living ten kilometres away. Beth had left home already, at the age of fourteen—what was I thinking?—to move to a farm where a number of other teenagers were living. Later she met a young man in Lake Cowichan and moved in with him.

George stayed in the house with Heidi, who was now thirteen, and Michael, eight. Michael came to stay with Annie and me every weekend, and we would visit with Heidi. But finally, George resolved the situation by leaving without any warning. His only message to all of us was scrawled in lipstick on a wall: "I can no longer keep your promise!" I've never been sure what he was referring to; perhaps he thought he had promised me to take care of the kids. I don't know.

George disappeared eight months after I had left him, and in the meantime, Annie and I had moved to a small cottage in the country. There was a tiny bedroom for Michael, but I wasn't sure where Heidi could fit. There was no spare space in our small house. A close friend immediately offered to take Heidi to live with her family. They had fifteen acres on a beautiful lake, a big house, and a cottage with a swimming pool and tennis courts. Her children and mine were best friends. I felt it took the decision out of my hands.

I have regretted this ever since. It was very hard on Heidi to live in a place where she could not feel that she was in her own home. She

Annie and our dog Sadie, about 1987.
Sadie was with us for sixteen years.

always felt herself a guest and couldn't let down her guard. I'm not sure we will ever get over it: I was having a problem, and because someone made a suggestion that I felt could work out, I went along with it. I am always saying sorry afterwards—but it is often too late.

When Annie and I moved in together, our lifestyle changed. We no longer went to the pub every night, and I decided not to do psychedelic drugs again. Everything was in flux. She and I were part of a small group that eventually started the first Women's Centre in our town; women's liberation had hit even tiny towns in Canada by 1973. In time, I became very proud of being a lesbian. These were exciting, turbulent times; we were going to change everything, and we were idealistic enough to think that the world actually would be transformed: there would be peace at last, and we would be in the forefront.

All this time, my mother never told any of her friends about me. Most of them knew the truth after a while, because their children in Chicago were still my friends. But my mother was ashamed and always very nervous about people knowing anything "bad" about her or her family. For me, this was terribly upsetting, because it took years before I felt accepted by her. I have, to my knowledge, never suffered any major hardship because of my sexual orientation, except within my own family.

In 1983, Annie and I went to New York City and saw *Torch Song Trilogy*, a play about a gay man. Harvey Fierstein both wrote and acted in the play. Parts of it concern his relationship with his mother and her feelings about his sexuality. While watching the play, I started sobbing. It was a harsh reminder of my difficulties with my mother.

People sometimes ask me if I would have come out as a lesbian if my father had still been alive. I think I would not have—we were so scared of Dad.

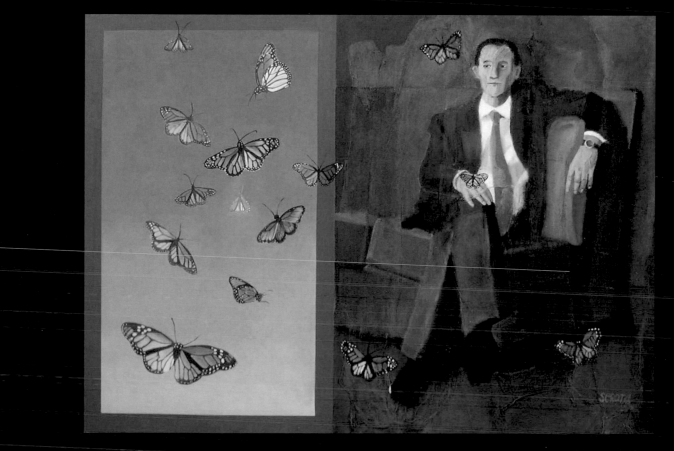

MONARCHS

MONARCHS

For this painting I put cheesecloth on the canvas and made a composition in texture with it. At that time, I had no idea where the painting would go, but I decided to paint a man wearing a suit. While I was painting him, he turned into my father. I thought it was interesting that the cheesecloth suggested a hidden quality, one that my father surely had. I then added the butterflies (very intensely realistic). The rest of the process I have talked about on pages 145 and 146. This painting hangs today in my living room.

ACRYLIC ON CANVAS, 44" X 60", 2005, COLLECTION OF THE ARTIST.

MY FATHER'S DEATH

In the 1960s, Sam's heart, which had always been flawed, started to fail. The joker became quieter now, even subdued. He'd suffered rheumatic fever as a child but hadn't known about it until he was a senior in high school, when he was a basketball star and was having health problems. The doctors discovered his early illness and told him he couldn't play basketball anymore. He was very upset and left school immediately, because he wouldn't be able to play college basketball. His heart deteriorated as he got older; he had always worked very hard and was extremely tense.

In 1965, when he was fifty-four years old, he went into heart failure. He was in the hospital for quite a long time, and everyone in the family went to visit him. All his brothers came, his sisters, and my immediate family. We all hung out there together. No matter how difficult he had been—and continued to be—he was my father. The fifth commandment had been drummed into us: "Honour thy father and mother." It never occurred to us to do anything else. We could get angry, rebel, talk about him behind his back, but he remained our father. We were very concerned about his health, and now he was weak.

To our great delight, open-heart surgery was approved as a surgical procedure. If Sam went to Houston, Texas, he could have a valve replacement. He agreed to do this and was one of the first people to successfully undergo this surgery. I was happy that he would have another chance at life: I'd always hoped things could be different—maybe they would be now.

Sam recovered well, played a lot of golf, which he had taken up not long before his heart problems, and was more relaxed and

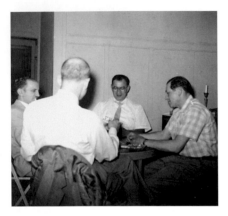

Men at play: my father (right) and
Joe Cohen (centre), around 1960.

happier than I had ever seen him. In my memories of him from that time, he is tanned and smiling, wonderful with his grandchildren. My kids remember him with great affection. When I talk about how difficult my childhood was with him, and how violent he was, they don't quite believe me. Their experience was very different. They remember him bringing them candy, playing with them, and being a wonderful, gentle grandfather.

We never did have the relationship I'd always yearned for. We never had a good heart-to-heart talk about the physical and verbal abuse he had subjected us to. When I was about eleven or twelve, he did take me to a couple of ball games at Wrigley Field, to see the Chicago Cubs play. We sat in the bleachers, and although I enjoyed that, it was difficult to talk to him. I only remember one time, when I was at the University of Illinois, that he and I spent a day together and went shopping. He was generous with money, as always, and bought me whatever I wanted, but he told me not to tell my mother what everything had cost. It was the same story when my mother took us shopping: she always told us not to tell Sam how much she had spent.

This halcyon time in our family lasted for two years. In 1967, Sam again started experiencing chest pain, and there were some signs of heart failure. This was not an easy thing for a man who was always so active to accept. He decided to go back to Houston and have the valve checked. My sister and her husband were living in Houston by then, and Dad went to stay with them while he was being checked over.

One day he went into a coma and they rushed him to the hospital. My mother and brother flew down to Houston, but I hesitated. It was hard for me, as it often is in times of crisis, to accept that this was really happening. My immediate response was: "He'll be okay. I'll just wait and see what happens." After a couple of days, however, I realized I'd better get down there. I knew I might not have the chance to see him again before he died.

When I arrived, he was very agitated, even though he was in a coma. Sometimes I'm sorry I saw him like that. I felt really badly that his life should end in this way. It was always such a struggle, and it seemed a shame that the end also had to be like that.

One night, the family was gathered at Sondra's house. My sister, my brother, and I had one of the best talks we'd ever had, a talk in which

we found out all kinds of details about each other's lives. Both Bobby and I confessed that we had started smoking marijuana that year, in 1967, a revelation that really bonded us. Sondra had a hard time with that; she felt she had lagged behind while we had moved into the next generation. We stayed up most of that night, talking. Very early the next morning, the hospital phoned and told us to get there as soon as possible.

We thought Dad would die quickly, but of course it took hours. At four in the afternoon, the chaplain finally came into the room where we were waiting. He said, "Mr. Serota has passed away." I gave out what I consider a primal scream and simultaneously thought, "Now it will never be okay."

When he died, Sam was fifty-six years old. In his dying, I thought, he had taken away any chance we had to reconcile our relationship and the enormous contradiction of love and terror that was Sam Serota. He never relented, never apologized. At his funeral, everyone said Sam Serota had been the greatest guy.

POSTSCRIPT: BUTTERFLIES

In 2004, I decided to spend three weeks alone to wean myself off two medications I had been taking for a while. I went to a small beachfront town about fifty kilometres north of Victoria. Towards the end of that time, I started doing a watercolour painting of a butterfly. Ever since my brother, Bobby, had died in 2000, I'd sensed a connection between butterflies and his spirit. During my "retreat" in

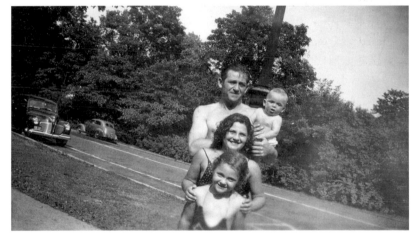

Dad holding Bobby, Sondra holding me, about 1944.

2004, I realized I couldn't really draw a butterfly, so I went to the local library to look at books on butterflies. I fell in love with all these creatures, their variations, and how beautiful they are.

At the same time, I was trying to work out whether I could forgive my father. I had been furious with him for more than sixty years. How long was I going to keep this up? They say that anger hurts the person who holds it more than the person one is angry with. But how does one forgive? What does it mean?

When I returned to Victoria, I talked about this with a group of women I meet with regularly and whom I respect greatly. One of them responded by telling a story about her father's generosity with his employees. It made me think about my father's generosity with his family. Every year on Christmas Eve, my father received a bonus. He would run out to the stores (which stayed open late for shoppers) and buy all of us presents with the money he had received. One year I got a bike; another year, ice skates. My father's birthday was on Christmas Day, but he bought us the gifts. I realized then just how much I had loved him. Maybe that is what forgiveness is all about—feeling and understanding the love that was there. Knowing that love and hate reside in the same person has been my hardest lesson.

I began a painting with monarch butterflies on one side and a male figure on the other. I started out using a photograph of a businessman. I wasn't sure what the point of the painting would be, except that I was aware of my love of the butterflies and their beauty. At first, I put cheesecloth over much of the right side, obscuring the image that eventually and quite inadvertently turned into quite a good portrait of my father.

When I realized that, I acknowledged that the painting would be about Sam Serota, and I kept working on it for months. I had a great deal of trouble resolving it. I was aware of the connections between butterflies and transformation. Finally, I moved some of the butterflies over to the right side of the canvas, one of them settling on my father's hand and touching him. With the addition of my love for the monarchs, the painting was finished.

It was not the portrait that I might have envisioned of the man I thought I knew as my father. But when I looked at the painting, I finally felt some sort of understanding: a completion of my sixty years of anger, and some sense of the love that lay beneath it.

Annie and I are in the centre, with our teacher, Ian Garrioch,
and other students behind us.

FOUR AUNTS

A very early painting of Aunt Rosie, Aunt Jenny, Aunt Fanny, and Aunt Molly. I did this after my first year at university. The caption on page 37 explains both of the aunt paintings.

OIL ON CANVAS, 68" X 52", 1975, PRIVATE COLLECTION.

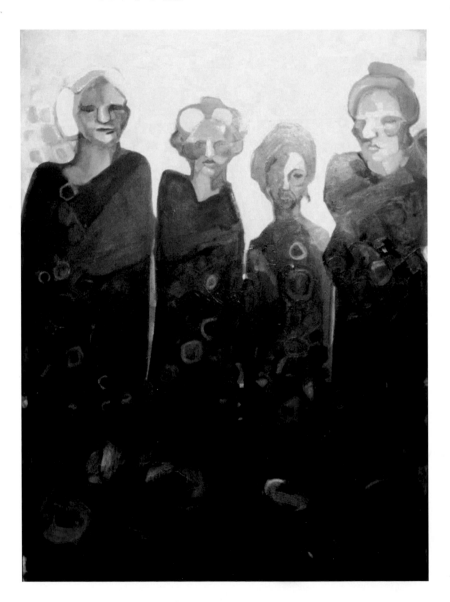

After moving to Canada, I started putting colours and shapes onto canvas, trying to envision what Nils might have meant when he suggested I paint from my unconscious. That soon progressed into images that connected me with what was really happening in my life and, for the first time, looking at that, rather than recreating another bowl of flowers on a lace tablecloth.

I had been earning my living as a cook since coming to Canada, and usually painting on the side. Eventually, however, a few close friends in Arbutus Bay asked me to teach them to paint. I set up still lifes in our living room, or one of us would model. This was my first real experience with teaching, and a year later I got a job teaching in an Activity Centre in the town of Lake Cowichan. I taught one or two days a week and enjoyed it. I kept trying to get my students to experiment, but most of them wanted to paint Cowichan Lake over and over again: one canvas for their mother-in-law, another for their daughter, and so on—it was an extremely conservative environment. However, it led me back to school, this time to study art. I wanted to learn how to teach my students to play, and even to dream.

As a result, Annie and I moved up the highway to Nanaimo to attend Malaspina College—a real art school. I loved studying art, and that year was very successful for me both in my own work and in how it was viewed. Everything worked: my drawing, painting, and sculpture. I was interested in the work, did innovative projects, and was awarded grants. We met wonderful new friends there and had close relationships with the teachers.

After attending Malaspina, I decided I wanted to teach art in a university. We moved down to Victoria so I could attend university there,

get a degree, and be on my way to a new career. My university plans changed, however, after experiencing the politics of academia. The teachers in the visual arts department were in a constant war. It was not for me. I decided to leave school after that year and went back to what I had been doing: cooking for a living, and painting.

Here I am, teaching art at the old Women's Centre near Arbutus Bay, around 1973.

This photo was taken by friends as they drove Annie and me
to the ferry to begin our five-month trip to Europe in 1976.

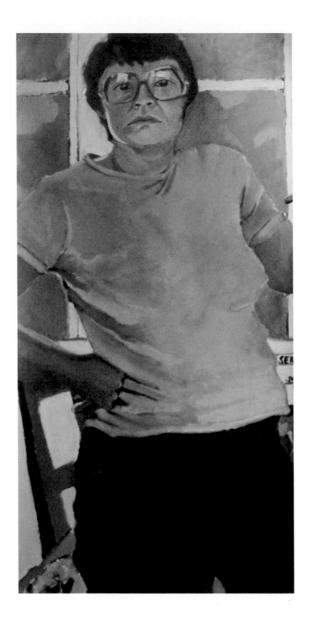

SELF-PORTRAIT, 70s

OIL ON PAPER, APPROX.
48" X 24", CIRCA 1979,
PRIVATE COLLECTION.

For Annie and me, the most wonderful thing about Victoria in 1975 was that we were part of a small but supportive lesbian community, including people who were among the first to buy my paintings. I had never before been part of a group of people who were as interesting, intelligent, political, and committed as these people. We felt strong in this milieu, powerful and alive. We had dinners together and participated in rallies, marches, and art shows. Every Friday night there were dances at the Women's Centre. I can still see us moving around to music, all the while putting wood on the stove, trying to keep warm in the drafty storefront on Pandora Street. In that way, our community was formed.

I got a job working in an old people's home, earning minimum wage while cooking for fifteen to twenty people. I had never had much experience with older people, and I enjoyed the work. I got to know some very interesting men and women. I put my heart and soul into cooking for them, trying to make the food as delicious and appetizing as possible. They had so little to look forward to that food had become the centre of their world.

Then I started to think about expanding their lives a bit. After seeing a movie about the pioneers of Canada, I wanted to bring this film to the home. Many of these people had lived through the early days here and really were pioneers. The owner of the home lived right next door, and I used to bring dinner to her every evening, so I thought this would be easy to do. But I was getting paid a ridiculously low salary and finally got up the courage to ask for a raise. The owner offered me an additional fifteen cents an hour but would not let me bring in the film that I knew was going to enrich the older people's lives. So, after

working there for eight months, I quit. It was not a complete loss: during the time I worked there, I did a lot of sketches of the old people. Some of them appear in these pages.

Just after I quit the job, I received a settlement on the land that George and I had owned in Arbutus Bay. After he'd left, George had asked a friend of his to rent our small, rather rundown place, and within a couple of years the house burned down. The tenant escaped unscathed, but all our furniture, and many of my keepsakes—my high school yearbook, a beautiful grey shawl my Aunt Rosie had crocheted for me, the fancy bedroom set I had brought from Skokie—burnt to the ground. There was some insurance on the house, which George and I ended up splitting, and with that money I was able to buy a small house in Victoria. Then we sold the land and got a sum of money that enabled Annie and me to take a long vacation.

We decided to take that wonderful opportunity to travel to Europe for five months. Heidi stayed with friends in Duncan, and Michael and Beth went to Mexico, where George was now living. The charter flight we booked left Vancouver in December 1976, and we returned in May 1977. I'd always dreamt of going to Europe, and during my first year at the University of Victoria I had taken a general art history course that had increased that desire. I was now determined to see every single painting that had ever been painted, every cathedral that had ever been built, and every sculpture in existence.

Some sketches from the old people's home. Top: Two views of Nana sleeping. Left: Her name was Daisy. Right: Ross had been an alcoholic and had dementia.

ROSS

GREEK FRIEZE

After returning from a trip to Europe in the early 1990s, I became fascinated
with dividing the canvas, using multi-imagery with vertical lines. On this painting,
I used a Greek pattern for the top and bottom and thought a lot about the kinds
of colours I had seen on buildings in Italy and Greece. Many of the images came
from photographs I had collected and from some of the more classical figures,
including the centre figure, which came from the Temple of Artemis at Corfu.

This painting was purchased by people who hosted a production of the play
Shirley Valentine in their kitchen and in their garden, overlooking the ocean. I
was invited to attend and was struck by the coincidence of the Greek-themed
painting and the Greek-themed play.

OIL ON UNSTRETCHED CANVAS, 50" X 120", 1993, COLLECTION OF
SHERRY AND WILLIAM BIRD.

After landing in London and driving around the southern part of England for two weeks, we flew to Amsterdam and bought a car. We drove all around Europe for the remaining time, visiting the Netherlands, Belgium, France, Spain, Italy, Greece, Austria, and Germany. At the end of the trip, we sold the car for the equivalent of $400—the same amount we had paid when we bought it.

We had some wonderful adventures and saw a lot of art, both of us being especially moved by the cathedrals. On the way, we met and connected with many other travellers, most of them on journeys at least as long as ours, and many of them on longer jaunts. Doris Lessing says that the late 1960s and early '70s were times of great generosity. I agree with that; people became instant friends, no matter what their language or age differences, or even their religious or racial differences. All through this trip we picked up hitchhikers and shared our marijuana (bought, of course, in Amsterdam) and anything else we had.

In January 1977, we met a couple from Boston, Ed and Caroline, who were staying at our hotel in Arles. We hit it off immediately. After getting to know each other better, we decided to travel together to Spain. Ed played the guitar and liked to smoke dope. Caroline, a more intellectual person, was a government worker. The four of us set off in our car along the bottom of France and into Spain, and spent a couple of weeks together. Then, sadly, we had to split up—they were continuing on to Morocco and eventually to Sicily, where Ed's family had come from, and we were staying in Europe.

In this book, I wanted to talk about yearning. It seems that on this trip—our fortunate, long-dreamed-of journey—our real yearning came to be about friendship, about meeting people with whom to share our wonderful experiences. We had that friendship with Ed and Caroline. We tried to meet up with them again in Palermo, Sicily, but by then their itinerary had changed. We have never been able to connect with them again.

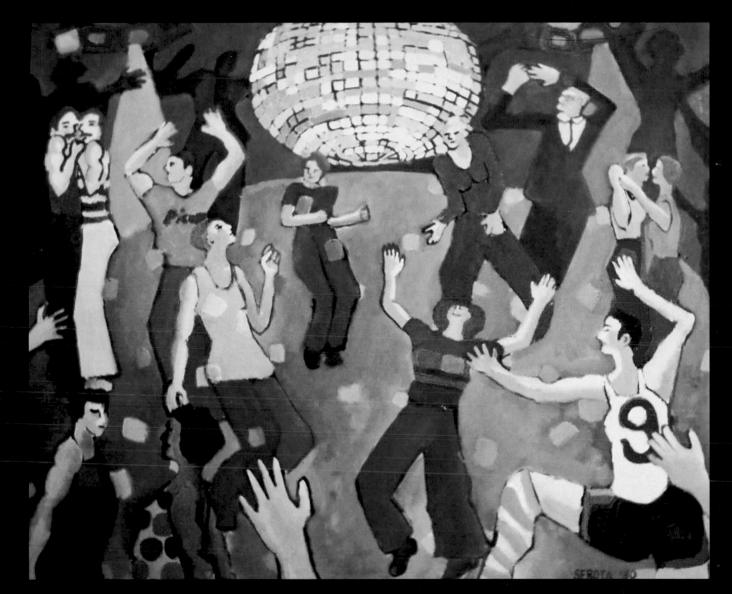

AT THE DISCO

AT THE DISCO

In the late 1970s, the disco became the destination of choice for the gay community. We went there, sometimes three times a week. In Victoria, it was called the Queen's Head and was, of course, the gay bar. Everything happened at the disco: people got together and people broke up. Some of us got stoned there, outside on the balcony, and I felt the usual paranoia. I did three paintings of the Queen's Head; this is the largest one.

Stylistically, I'm working with a few elements here: silver paint, the large mirrored ball, and scale. The disco ball is silver, and some of the spots in the painting are also silver. I was interested in depicting this unnatural light. I was also working with scale again—mixing it up, making some of the people much larger and some smaller than they would've been. A few of the people depicted are friends, and I think the figure in the foreground with the pink and black T-shirt is me, because I usually dance with my arms up. The figure over in the bottom right-hand corner is a woman I knew only slightly, who ended up getting married to her lesbian partner at our house during that time—my first lesbian wedding. One of the other disco paintings was stolen. In all these years I've had only two paintings stolen; that was one.

OIL ON CANVAS, 35" X 40", 1982, COLLECTION OF BRUCE STANLEY.

By the time we returned to Victoria, a new gay club, the Queen's Head, had opened. We started going there once a week and ended up going much more often. The Queen's Head was for gay men and lesbians, and we reconnected with some old friends and met some new ones there. It was still the 1970s, still the era of sex and drugs, but the music had definitely changed. It was all about dancing! Mostly I danced by myself, learning by doing it. I would raise my arms like my Aunt Molly and just let the music take me where it would.

I never waited for anyone to dance with me and actually preferred dancing alone. I would skirt the edges of the floor and take up as much room as was available. Later in the evening, the floor would get crowded and I would have to rein myself in. By then I was in the groove, feeling the music and luxuriating in the words—"I'm a star in New York, a star in L.A." After the club closed for the night, a bunch of us would head to Denny's. I can still see the restaurant's orange booths and tables, but have no memory of what I ate at that time of night. Then home to bed.

At the same time, I landed a job in a group home working with teenagers who had been in trouble. Teenagers are the most challenging age group for me, so I don't know what I was thinking. My friend Ginger and I worked there together on weekends. She was an actor and filmmaker, but not any better with kids than I was. When they acted up and Ginger and I couldn't control them, we would call the police. After two or three of these episodes, a cop took me off to the side. "You can't keep calling us," he said. "You're going to have to figure out how to handle them." Both Ginger and I quit soon afterwards. However, we could at least take pride in the fact that we had cooked really good food for them. Ginger, who came from Texas, made wonderful fried

chicken. I also took photographs of some of the girls, which I incorporated into a book I was working on in a photography class—*Photographs of Women*.

I was back at university then, thinking this might be a good time to return because the teacher I'd had so many problems with was taking a sabbatical. And then . . . Annie told me she wanted to split up. She said she needed time to be alone. I had thought we'd be together forever, and here it was just five years and she was going. I was devastated.

She soon left for a trip to the States. There were days when I could hardly get out of bed. I would stare at the phone, willing her to call, but she never did. It was the lowest time of my life.

I was living with my son, Michael, who had his room in the basement. He was fifteen years old and having a difficult time, doing things that were both illegal and dangerous. I tried to work with him to stop, but I was having a hard time dealing with it. One day, I woke up to find a young man in my bedroom! He was a friend of Michael's who knew there were drugs in the house, and he was searching for them. Very soon after that, Michael was arrested for dealing drugs and put under house arrest. So I was studying at the university and working as a cook, my son was under house arrest, and Annie had gone. I felt really low. It was a hard, hard time.

All through this time, I went to the Queen's Head and danced. My friends were supportive through this difficult three-year period, but the dancing was not as joyous as it had been. It was the kind of

My mother in Chicago with my teenaged children, about 1979.

dancing that one can't stop. Dancing and dancing and smoking dope and feeling weird and alone, rejected and unloved. I'm sure many of my feelings of paranoia had to do with marijuana smoking, but that certainly didn't stop me.

Now there was a new song at the disco: "I Will Survive." Once again I danced with my arms up, proudly singing and finally knowing the truth of that time. I will survive!

I was working at a children's hospital at the same time, and then the hospital asked me to relieve other workers who were taking their holidays. Generally I worked as a cook, but while I was relieving these people I did three or four other jobs for a few weeks each. I remember that I chose not to attend my university graduation ceremony; the day my degree came in the mail, I was learning the pot-washing job. I've always appreciated the irony of that.

I have survived ever since that low time, often thinking that I would eventually have to go back to work as a cook or even a pot washer, but I never have. I've completely supported myself as a painter, although sometimes that has meant I've sold a painting on the day the rent was due.

Eventually, all the fear I'd been living with led to renting out the house and, in 1981, moving to Annie's place while she was in Banff, taking a course in lighting design. Right after we split up, Annie had gone to California for a few months. When she returned, we started seeing each other occasionally, constantly reassessing our relationship and how to deal with it. Sometimes we saw each other once a week, sometimes more often, and there were times that we were happy again together. Altogether it was three years of hell—fighting, even physically. But I ended that. I had realized during Michael's house arrest that violence was never going to help me in my life. For a long time I had followed the path that had been set for me by my father and had, on occasion, been violent with my children. I had always said, "Not like my father," but I finally realized that this was like him and it had to end.

I remember asking Michael to do something for me one day, and he refused. I stood in the kitchen feeling the most intense anger, but I did not strike out. I just felt it, and I knew the time for violence in my life had ended.

A self-portrait I took when I began doing serious photography, about 1977.

SEROTA -AUG. 8

THE PAINTERS' DAY 1981

THE PAINTERS' DAY 1981

This is the painting I did of the event held in 1981, when many famous artists came to work in this beautiful setting. This painting was reproduced on the invitation for the show.

OIL ON PAPER, APPROX. 40" X 44", 1981, COLLECTION OF UNIVERSITY OF VICTORIA.

When did I know I was an artist? I have a strong memory of a moment when I was an art student, working in the painting studio at UVic. I thought, Who am I kidding? I can't be an artist. I'm a woman! A woman can't be an artist. Immediately after that I thought, I'll show those bastards. I'll be an artist. I can do it. I told no one about it, but that was an important turning point.

In 1978, Judy Chicago came to Vancouver and held a workshop for one hundred women artists. You had to say "I am an artist" to be able to attend. There was a lot of hesitation among the women painters I knew who wanted to go to the workshop. We all found it terribly difficult to say those words in the late 1970s; to call yourself an artist, you felt that you had to put in time, effort, and energy. We knew about the olden days, when one had to apprentice for years to an established artist, grind his (and it was always *his*) pigments, paint backgrounds, or do whatever he ordered you to do for years, and he would say, "You're an artist now," and would finally send you out on your own. To stand in front of all of these women and Judy Chicago, whose work *The Dinner Party* was travelling all over North America at the time, and say, "I am an artist"—how could I do that? Things in this regard seem to be different now. I notice that people who have just graduated from art school, or even an art course, have little or no hesitation in assuming the title.

Well, I did go to Vancouver, and even had dinner with Judy Chicago and some other artists the night before the workshop. And I did come out as an artist. I remember very little about the workshop, except meeting a photographer from Vancouver who talked about her hesitation on this question and was brave enough to cry in front of the hundred other artists. I later became friends with this woman. There's

Susan Nonen's family: one of the "families" photos I showed when I graduated from the University of Victoria in 1979.

nothing that endears someone to me as much as an ability to cry easily. And we all try so hard not to, eh?

Around the same time, I decided to go back to school. I had been doing some photography and learning about how to work in the darkroom. I took an intensive photography course for the summer. There I had the best teacher I'd ever had at university, Freddy Douglas. I ended up loving the class, and that summer I completed a book of black-and-white photographs.

I decided to re-enroll that fall and get my degree. I started out my final year by majoring in printmaking, being mainly interested in etching. However, there are so many steps in etching that I had trouble getting my mind to work in that methodical, almost chess-like way—and my personal life was in turmoil. So my adviser at school, Pat Martin Bates, kindly said that it was OK with her if I painted and did photography, and gave up etching until things settled down. I continued to paint at home and mostly concentrated on the photography.

What I also did then was go into art therapy. One day a week, I went to the basement of a large mental hospital and painted with a group. The materials were gloppy—acrylic base with colour added, and white house paint. We worked on paper, either newsprint or manila—very cheap, not at all precious. After painting, we talked about our work and what was happening in our lives. Eventually, I did therapy with the head of the art therapy school and worked with her privately for five years. The amazing thing about painting at the mental hospital was that the art produced there had more feeling, more energy than anything I'd seen at the university. Those paintings came from the heart, as opposed to the more intellectual work the university professors encouraged. Not surprisingly, I've always been drawn to paintings that come from emotions—those of Van Gogh, the expressionist painters, and so on.

I graduated in June 1979, at the age of forty-one, with a bachelor of fine arts degree. I was one of the first in my family to get a university degree. At the class's final graduating show, I chose to show my photographs and my paintings that I had done at home. The photography project I completed was a series of photographs of families. I was interested in giving visual form to the concept of family in the '70s, and to show how that concept had drastically changed over the years. The

other students spoke to me about these photographs but didn't know what to say about my paintings. There were teachers who would pontificate to the students, who then thought they knew what they were supposed to think. Since my figurative paintings didn't fit into any of these theories, it was difficult for them to know what they were supposed to say to me about them.

After graduating, I had the good fortune of starting to sell my paintings both privately and in small group shows, often centring on women's art. In 1981 there was a wonderful gallery in Victoria called Kyle's. All the best artists showed there. The owner, Paul Kyle, was a very stylish, handsome young man whose father had started an art school here. He had inherited a flawless eye. Every show at Kyle's did very well, but there was only one woman, Anne Popperwell, who exhibited there, along with about fifteen men—the cream of the crop, including well-known Vancouver artists Jack Shadbolt and Toni Onley. I was, of course, dying to show there! A friend of mine who collected my work encouraged me to show my work to Paul and also spoke to Paul about me.

So I brought in about a dozen paintings. I was working mainly on paper then—oil on paper, cheap cardboard kind of stuff—and didn't even prepare the paper properly, but the work, as I see it now, was fresh, brave, and creative. Paul loved it! He said he'd be happy to show my work. I'll never forget that day. When I left there, I actually kicked up my heels as I ran down the street. It was one of the happiest days of my life!

Very soon afterwards, Paul decided to have a "Painters' Day" at Michael Williams's beautiful home on the beach at Ten Mile Point, near Victoria. Williams was a consummate collector of art and a very wealthy man. His place encompassed acres of waterfront on a point jutting out into the ocean. All of the artists who had shown at Kyle's would go out there to paint, and later they would show the work that had come out of that day. As the new artist, I would get to meet the others and work alongside them. I was terrified. I ran into a fellow artist, Jim Gordaneer, in the supermarket just before the event. He is a wonderful teacher and long-time painter in the community. I confessed to him how nervous I was to be going to this "fancy" event. Jim said, "Don't worry, they're just artists." Ha!

Another of the "families": Heather Hestler and her children, 1979.

SELF-PORTRAIT, 1987

WATERCOLOUR ON PAPER, APPROX.
20" X 16", 1987, PRIVATE COLLECTION.

Well, although I was terrified, I got my paints, palette, and brushes together and drove out to Ten Mile Point. After a few minutes, a float-plane landed. It was piloted by Toni Onley, who got out of the plane and handed Paul Kyle a Renoir painting. I was incredibly impressed and even more terrified. Eventually, the other artists staked out places to paint. There were cameras from both the CBC national TV network and the local television stations. I was too scared to even start, so I decided to just draw. I walked around, drawing some of the artists close up and others in groups. I had a terrible time because of my fear of not being good enough to paint alongside all these stars of the art world.

The next evening, I had some people come over. When they arrived, we watched the coverage of the Painters' Day on TV. All of a sudden, I realized I was the only painter there who was doing figurative work. For years, I had looked at paintings of groups of artists; I especially remembered the painters in the Blue Rider group, and a painting of the surrealists done by Max Ernst. I decided then to do a painting of the Painters' Day: I already had done sketches of all the artists working in that beautiful space. I worked on a fairly large piece of paper for two days before calling Paul and telling him about the painting. He came right over and decided that it would be on the invitation to the show. It was one of the smartest decisions I've ever made as an artist, and the next year, when the show opened, people knew my name.

I had my first one-woman show at Kyle's Gallery in 1981. It was successful for me—I sold twelve paintings. Much of that work had connections with my Arbutus Bay days; it was good for me to look at a time in my life that I had held sacred for so long, to really examine what had been wonderful about it and what damage had been done. Since my time in art therapy, it had become easier for me to access my feelings and give them visual form.

In 1982, I was asked to be part of a group of artists that had joined together because they had similar ideas about art coming out into the streets. People were often reluctant to go into the galleries, we thought, because they were uncertain whether they were expected to buy a painting or unsure what the general protocol was. We also felt there was a lot of elitism in the galleries, so we went into an alley in downtown Victoria that had a large space to work and painted out in the open. It was a disparate group: men and women, and older, more

established artists as well as young, beginning ones. I felt flattered because I had been painting quietly on my own and didn't think that anyone, other than those in art therapy, knew anything about me.

We occupied Waddington Alley for a weekend, and since there was lots of space, we decided to work really big. I worked on a diptych (two paintings joined together) made from a pair of four-feet by eight-feet pieces of particle board. The weather was perfect for the paint-in, and afterwards we had a celebratory dinner. There was a wonderful feeling of camaraderie and mutual respect, all heady stuff for someone who had thought of herself as an unknown artist working in a basement. The Alley Art group did two more outdoor projects, both very ambitious, and later we held two large group shows that were called Bankart. Sadly, the group gradually fell apart after these shows. I've realized since then that there seems to be a life span to these groups, just as there is for everything else.

In 1984, I got an idea for a new show with two artists who I considered to be my peers. I had a vision of the three of us having a show together at the Art Gallery of Greater Victoria, the city's main public gallery. During this vision, I saw a painting that I would show in this fantasy exhibition. It was of my beloved Aunt Rosie and Uncle Jake, and was all done in reds (because of my Aunt Rosie's name, I often envisioned her in red). I saw another image, a bit more vague, of my Aunt Molly dancing. These images were large paintings. In preparation for doing them, I did a couple of small versions of Aunt Rosie and Uncle Jake, and also of Aunt Molly.

Because I really liked these small paintings—sketches, really—I felt confident about working in a large format. I started the big painting of Aunt Rosie and Uncle Jake, and it went very well all the way through. Then I started the painting of Aunt Molly, and after a rocky start, it also worked. It recalled times when Aunt Molly would get up at weddings, all by herself, while we waited for dinner to be served. She would dance ecstatically around the room in honour of her love for the family and for the act of dance itself. I have never known anyone with so much self-confidence as Aunt Molly. She was the queen of the family; she embodied everything we, as Jewish women, were supposed to be: She was a wonderful cook, kept a clean house, and had a very strong

Top: This photograph shows most of the artists who were part of Alley Art, at the celebration following our first project. They include Luis Merino, holding me in the centre, and many other artists who are friends and still painting: Helen Rogak, Bill Porteous, Lance Olsen, Luis Ituarte, Roberta Pyx Sutherland, Sandra Merino, and Betty Meyers. Andrew Leone, a dear friend of mine, is not in this picture, and the late Harry Schafer is also missing.

Bottom: Here I am working on an 8' x 8' painting in Waddington Alley—Alley Art's first project.

family. She baked great strudel and, when we ate at her home, would stand behind us to take our plates away as soon as we finished. The dishes would always be done immediately. She was a *bala busta* (great housekeeper and hostess).

Aunt Molly and I were never close, like my Aunt Rosie and Aunt Jenny and I, but I held her in great esteem. Even though she was my great-aunt, she was approximately the same age as my Aunt Rosie. I also painted her husband, my Uncle Maurice. He was the president of our small family synagogue. A very cool, removed kind of man, in his later years he became addicted to morphine after having been hospitalized and given morphine for pain. I clearly remember him wandering around at weddings and bar mitzvahs, not really there.

AUNT MOLLY

Aunt Molly dancing alone, part of the *Family Series*.

OIL ON CANVAS, 60" X 44", 1984, PRIVATE COLLECTION.

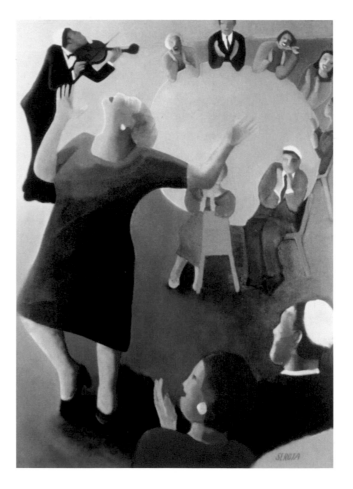

So I had these three paintings, each sixty inches by forty-four inches, and decided to show them to Greg Bellerby, the curator at the Art Gallery of Greater Victoria. He was very enthusiastic about them and immediately promised me a show for May 1986. This would be a one-woman show, more than I had dreamt of. For the next while all I worked on was the group of twelve paintings of my family. In a sense I was recreating scenes of my childhood, now that most of these people were gone and I had moved away.

Before I finished this series, I did another large series of paintings for Victoria's Open Space gallery, a huge artist-run space, in 1985. That was called *Esmeralda and the Fish* and was not autobiographical. I completed the *Esmeralda* series in five months: it consisted of six very large paintings.

At the same time I was to have the opening at the Art Gallery of Greater Victoria, I contracted to have a one-woman show at the Robert Vanderleelie Gallery, a prominent commercial gallery in Victoria. My idea was to have both shows running simultaneously. That exhibition consisted of thirty-five paintings of all sizes. The invitation featured *Company*, a very large pink painting of my family getting together after work at Aunt Rosie's house. To celebrate both of these shows happening simultaneously, the local arts newspaper, *Monday Magazine*, carried a long article about me and my work and put my photograph on the cover. I decided in that article to take the opportunity to come out publicly as a lesbian. Heady days!

A few days before the opening, I got my hair dyed, putting in a purple section on one side and a big orange swath in the front. It was the '80s! A friend of mine had made a dress for me; it was mauve silk and looked really great with my new hair colours. The opening of the show at the Art Gallery was a huge success: tons of people, everyone extremely enthusiastic. I had hung the show with some of the gallery staff, and it looked fabulous. I sold one of the large paintings that night, and eventually sold ten of those twelve paintings. The *Family Series* remains one of my proudest achievements. It was also shown in Vancouver and in Edmonton, Alberta. The show at Robert Vanderleelie's was also successful and did well financially. I was riding very high in 1986!

All through this time of public success, I was teaching eight-week

In our old living room, with the painting of Aunt Rosie and Uncle Jake before it was sold. I loved having them there with me.

WHEN DID I KNOW I WAS AN ARTIST?

One of the shows I had in our home and studio between 1993 and 2005. This show was in 2000. That room, with its high ceiling, was part of my beautiful studio.

painting classes in Chinatown. I taught once or twice a year, and usually had about twelve students. For more than ten years, I started one of these classes every February, because my car insurance was due then. I did all the organizing—renting the studio, scrounging easels, and making coffee (which I referred to as my "real job"). I alternated my teaching with asking my students to paint from reality and from imagination.

In 1988, I had a very large show at Open Space gallery. That show featured twelve oversized paintings on unstretched canvas, with an average size of eight or nine feet tall and four or five feet wide. It was called *Rope Climbers* and later showed in both Seattle and Portland, Oregon.

In 1992, Annie and I added a beautiful two-storey painting studio onto our old 1908 house. The studio where I painted was on the main floor, and I could see into it through the glass kitchen doors. It was a

EURYDICE

In 1990, I did a series of eight paintings on the myth of Orpheus and Eurydice, and while showing them to people, I would often tell the story. Finally, the publisher 123 Studio asked me to write the story and proposed to publish the eight paintings with my story. I wrote it for young people, as an introduction to Greek mythology. This is the painting of Eurydice, who is killed by a snake early in the story. Orpheus goes into the underworld to try to bring her back to the world of the living.

OIL ON CANVAS, 60" X 44", 1988, PRIVATE COLLECTION.

large space, with lots of windows and the most fabulous light. I had now discovered north light. Upstairs was the storage area with sky-lights. It was everything I'd ever dreamed of.

Because we had built the new studio, I started having annual shows, and continued that for thirteen years. I would hang the whole house, and the studio both upstairs and down. People went through the racks of my paintings upstairs, where I had organized groups of paintings at sale prices. We always held the show on Valentine's Day and served Valentine's cookies and coffee. Annie helped me with the invitations and the hanging, and eventually, to take the pressure off, she wrote the sales slips for me. We started out doing the show for two days and ended up doing it for just one day. It became the mainstay of my income for those years.

I seem to have done most things for myself in this life (with a little help from my friends). I both organized and taught my own painting classes, and later, having the annual exhibits in our house and studio also worked well. Some people have better luck doing things for themselves, not having to rely on others. That's how it has been for me. But always, in the back of my mind, I thought I was going to have to go back to work as a cook. Surprisingly, I never have.

I did two sculptures for *Rope Climbers*, with plaster of Paris bandage. George Segal worked in this way, as did many other artists. This sculpture is called *Yellow Man*. Most people at the well-attended opening asked me who modelled for the *Yellow Man's* penis. Open Space gallery, Victoria, BC, 1988.

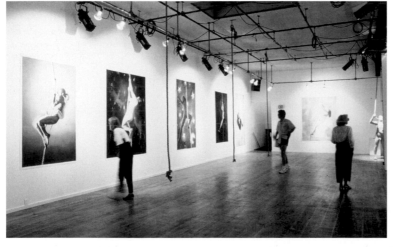

The *Rope Climbers* exhibition at the Open Space gallery in 1988. People would climb on the ropes while viewing the paintings. Open Space gallery, Victoria, BC, 1988.

ONE LIFE

The full title of the painting is *To understand one life you have to swallow a world*.—Salman Rushdie. This is the last painting in the *Rope Climbers* series, which showed at Victoria's Open Space gallery in 1988 and travelled after that.

OIL AND PASTEL ON UNSTRETCHED CANVAS, 103" X 53", 1988, COLLECTION OF LOUIS AND CHARLOTTE SUTKER.

PARABLE

I completed this painting soon after Bobby's death. In some ways, it seems to be about both that and his life.

I'd always wanted to work on this shape of canvas, so Doug, my son-in-law, an accomplished carpenter, said he would build it, stretch it, and frame it—all difficult things for me to do on this shape of canvas. All I had to do was paint it! I was still switching back and forth between oils and acrylics: the flying figure at the top and the clouds are in oils; the rest of the painting is in acrylics. The "parable" is your own—whatever the imagery and the title bring up for you as the viewer. That is always true of art: it's not really about what the artist was thinking, but about what it means to the viewer.

OIL AND ACRYLIC ON CANVAS, 74" X 44" (AT THE TOP), CIRCA 2001, COLLECTION OF THE ARTIST.

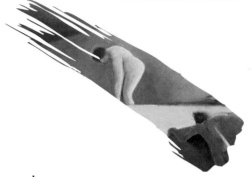

The night before my father died, my brother and I began a deep and powerful relationship. I'd always dreamed of having a real brother, someone I could confide in. We began to have phone conversations, two or three times a week, long talks about everything—God, family, love and fear, all the implications of our lives. I had never had a close relationship with any man, and I treasured this new-found connection with Bobby. The relationship between my husband, George, and me was just not on that level, and never had been. Bobby had been with us during the nightmare of the Democratic national convention, and we were very close when George and I decided to leave Chicago and move to British Columbia.

Bobby came up to Canada to visit a couple of times. The first time he visited we went to Long Beach, on the west coast of Vancouver Island. When I go there now, I always picture that weekend—we were so inexperienced; we didn't understand tides and had parked on the sand and were sleeping in our station wagon. In the middle of the night, we woke up with the waves lapping at our tires. We had to move fast; the car was about to be carried off. That spot at Long Beach remains my most spiritual place on the island. There are so many memories there.

In 1970, I went to Chicago with my friend Linda Willoughby, because my mother was getting remarried. Linda, Bobby, and I saw *Hair* in Chicago that week, and what a wonderful treat that was. I have so many happy memories of my brother throughout that tumultuous time. But as wonderful as our relationship was for a while, it ended. Bobby and I had a falling out at a difficult time in both our lives. It occurred when Annie and I were on the verge of splitting up. I went to Chicago and stayed with Bobby and his wife, Susan. We had a big fight,

Sondra and Bobby in a motor court at the
Wisconsin Dells, about 1949.

and it was years before we came back together. Sad, all that wasted time, in a connection that now seems tragically short.

Soon after George and I moved to Canada, Bobby married Susan. That was great for him. They were so much in love, and that continued throughout their marriage. They had three children, Scott, Larry, and Deborah. Later, in the 1990s, Bobby was operated on for cancer of the colon. After that surgery, he had a change of attitude towards me. When Annie and I came to visit in 1998 for Deborah's bat mitzvah, we checked into a motel in their neighbourhood. It was evening; we were very tired and thought we would just see everyone the next day. But after a while someone knocked on our door, and there were Bobby, Susan, Deborah, and Scott, now a talented singer-songwriter. They came in, and we had a wonderful visit—Scott played some music, and we all sang. We felt so welcomed, and even got a phone call from the front desk warning us that we were making too much noise! After that wonderful time in Chicago, Annie and I flew to Israel and had a great trip. When we returned, Bobby told us that the cancer had moved to his liver.

My brother was sick with cancer for more than two years. He continued to be hopeful even after the cancer metastasized. A stent was put into his liver, and that seemed to work for a while; then it failed and another stent was placed. All this time, Bobby was undergoing every kind of therapy imaginable: chemotherapy, meditation, dietary, massage, and radiation. The treatment wasn't too debilitating at first, and he and Susan were able to take several vacations. Bobby was also reassessing his relationship with Judaism, which had always been essential to him. Now he went to many other synagogues to pray, always in his quest for healing.

Bobby eventually travelled to Tucson, Arizona, where his intensive therapy continued. My daughter Heidi and I decided to go and see him there because we didn't know how much longer he was going to last. At about this time the TV show *The Sopranos* was a big hit. Bobby loved the show and was obsessed about seeing it while he was in Tucson. On the day we arrived, the TV cable had been attached, and Bobby was very excited. I had never seen *The Sopranos* but I'd heard lots about it, and the last night we were together we watched it. This episode was all about Tony Soprano's sister Janice coming from Seattle to visit. All

kinds of terrifically gory things happened that Tony took care of in his role as godfather in the Mafia, which, of course, meant a lot of blood and death. At the end of the show, when Tony drove Janice to the bus to return to Seattle, he said, "Well, I think we had a pretty good visit." Bobby and I laughed, and then hugged and said good night. Then I added, as sister to brother, "I think we had a pretty good visit!" That was the last time I saw Bobby.

We continued to have long phone calls, and it was very hard to hear him. I would go way up into the attic, because if someone was mowing their lawn or a helicopter came by, Bobby's voice would be inaudible. We took the opportunity to apologize to each other for the hurts we might have inflicted, and I am really happy about that. Towards the end, I felt so much love and sadness in talking to him.

We knew how sick he was because the hospice had been called in. We were waiting for news of his death, and I was afraid to be away from the phone. One day, our phones went out. There was no storm, nothing happening in any other way—just the phones going out. We waited for hours, and finally I called my niece, Marcey. She said that everyone had been trying to phone me but couldn't get through, and that Bobby had in fact died while the phones were out. This is one of those mysterious things that happen in life. There's no explanation for this: it was almost as if Bobby had stopped all communication when he died, and in a metaphoric way, that is what happened. Our communication was over. He'd had a hard death; he wouldn't lie down and kept walking around. He had been on lots of medication.

We went to Chicago for the funeral. Tons of people were present at the funeral home and then at the cemetery. We shovelled the dirt into his grave after his coffin had been lowered into it. I had never done that before. So much feeling came up, so much anger at his death. Working so hard, shovelling the clay-like soil of Chicago, helped me to feel all of that.

For one week following a funeral, a Jewish family sits *shiva*—they stay in the house, and friends and neighbours bring food in. For Bobby, every night, people gathered to say the prayers for the dead and to talk and laugh and cry together. There was lots of sadness about his death: he was only fifty-six years old. (My father had also died at fifty-six.) What also happened at the *shiva* was that a change began in our

Sondra (left), Bobby, and me at Bobby's bar mitzvah, three months before my hastily conceived marriage to George.

always-contentious family. Now we started to realize how small our family had become and how much we loved each other. Everything changed then, and that has continued to this day—another gift that Bobby gave all of us.

One other gift I must mention: a few months after he died, I found that a blue butterfly had flown into my painting studio. I carefully removed it and later realized that no butterfly, much less a very rare one, had ever come in there. I thought, in a way, that Bobby had come to visit. Years later, when I remembered this event and tried to paint that butterfly, it led me to make the painting *Monarchs*, which I have written about earlier in this book. That painting, and all the butterflies in it, led me to realize that I needed to finally forgive my father. Bobby always was the peacemaker.

My brother, Bobby, in his prime in 1987. The painting on the wall is one I had done as a gift for my mother. It is called *Mom in the Fish Store*.

MOM IN THE FISH STORE (ON THE WALL)

We dream of things that we think will make us happy, but playing out our lives—the real stretching that happens for us—is often the result of working in a fish store, or having to sell a painting right away to pay the rent, or the thousand other things that we resent but that eventually do give our lives meaning. Years later, as a gift for my mother, I made a small painting of her in the fish store. I put a lot of love into the painting, more love than I ever had before. I had earlier learned that if you want to communicate an emotion in a painting, you must hold that feeling while painting it.

I did it in very soft colours, but she didn't like it.

She was now married to a man who was a furrier, who had more money and more prestige than my father. My mother didn't want to be reminded of her former life as a seller of fish. My brother and sister-in-law rescued the painting from her, and it hangs in their dining room to this day.

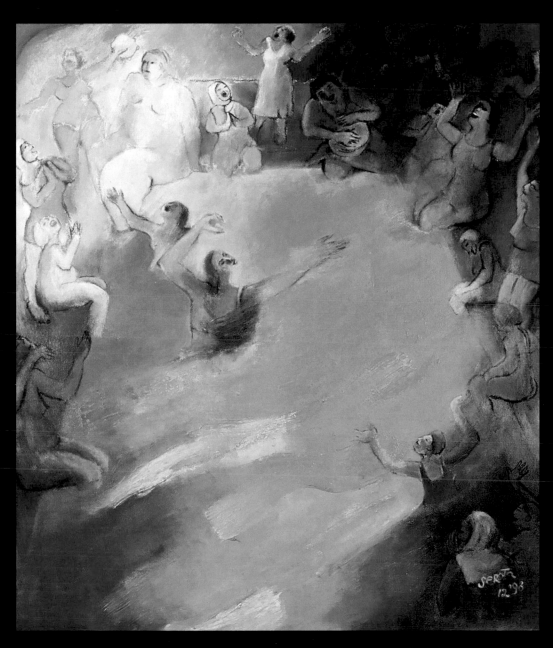

AT THE BATHS, "HAMAT GADAR"

AT THE BATHS, "HAMAT GADAR"

In 1998, Annie and I made our long-anticipated trip to Israel. We spent two weeks in Jerusalem and had a wonderful time visiting the Old City, including the Wall and the Dome of the Rock, and going into the desert. After two weeks, we set off for the Sea of Galilee, called Kinneret in Israel. Arriving that evening at sundown, we ran into the lake, into the most beautiful water, the same temperature as the air—unforgettable! On one of our last days in that area, we went to a waterpark, a spa—a huge place where all kinds of people, Israelis, Palestinians, were taking the waters, together.

After being there for a couple of hours, I noticed a building that had a women's sign on the doorway. There was another pool inside it, and within it some of the women were nude; others wore bathing suits. Eventually a woman walked in with a drum. She started playing, and the women started singing. Then everyone was dancing—the most amazing experience! I left after about forty-five minutes of this, and it continued. Towards the end of my visit, I just looked at the pool and memorized: looking carefully at the women and the building, and absorbing the feelings of joy and community so that I'd be able to reproduce them in my work. The women in the upper right-hand corner were the instigators of the dance, the musicians. I'm dancing just below them, wearing the blue bathing suit, and Annie sits at the edge of the pool.

All the line was drawn with chalk pastels. This was before I felt confident doing line with a brush. On a formal level, in this painting I was working with the ideas of separating form and colour that I had learned from Chagall. I have read that he developed this idea from working with theatre lights. Coincidentally, Annie was a theatre lighting designer for years.

ACRYLIC AND PASTEL ON CANVAS, 60" X 44", 1998, COLLECTION OF ERIN CALDWELL.

After I graduated from the University of Victoria and finished working at the children's hospital, Annie and I were still separated. It had been three years since we'd split up, and things were getting better for us. We started to talk about living together again. Perhaps because I was finally happy living alone and she was equally happy with her situation, we could think about getting back together. Life is full of paradoxes.

We thought that if we could find a rental house that was really fabulous, perhaps on Victoria's waterfront, we would do it. On the first day we started looking, there it was—a waterfront house, on the ocean, in a neighbourhood I had never lived in—so Annie, Sadie the dog, and I had a look at it. To our great surprise, the owner, a policeman, said we could have it. The house had a beautiful living room overlooking an inlet, and there was a window seat all along a large window. It also had a lovely garden and a basement room large enough for my studio. Annie had started her own graphic design business downtown that year with another woman, and it was going well. That was it—we moved back in together!

A friend of ours rented another apartment in the basement of the house. The odd thing about all of this was that we were still dope smokers, and the landlord was a policeman. He would show up unannounced at any time of day. Often, we had just smoked a joint, and there he would be. Eventually, we worked out strategies to avoid detection if he came at an inopportune time. The scenarios involved spraying room deodorants or gently steering our visitor in directions that would lead him away from the pungent smell of marijuana. We had some very funny times, but luckily it worked out fine. Annie and I were

IN THE BATHROOM

This is part of a small series I did of rooms in a house. I used very dark charcoal and white pastel for the figures, and coloured chalk pastels for the furniture or, in this case, the floor and the bathroom fixtures. I wanted to include one of these painting/drawings in the book, because they're among my favourite works.

CHARCOAL, PASTEL ON PAPER, APPROX. 30" X 20", CIRCA 1991, PRIVATE COLLECTION.

back together, I was painting, my paintings were selling, and I was proud of the work I was doing.

The problem with the place was that it was on a small road that ended at an inlet—there was nowhere to walk. At the other end of our small street was a major arterial road. It was full of gas stations, a McDonald's, and strip malls, and as a result had tons of traffic: it was not a relaxing walkway. The good part was that if we got hungry at night, we could get in the car and drive down our little road onto the "Indianapolis Speedway" to the McDonald's. We'd dash in, get hot fudge sundaes, drive for two minutes, and there we were: as they say in Canada, "Bob's your uncle." But I liked to have longer walks, and I missed not being able to do that. Though the view was beautiful, we ended up living in this house for just one year.

Then we got an apartment on a prestigious old street lined with beautiful plum trees. When the trees blossomed in spring, the street was filled with soft pink flowers. There are many such streets in Victoria—it's a feast for the eyes in the spring. The apartment was in an old, converted mansion with large rooms and wainscoting on the walls: it was very elegant. We had sold our first house, and I wanted to buy another, so we started looking. I've always had good luck with real estate, and, as you know, earning a living as an artist is a tenuous thing. I wanted a house that would be both a good place to live and a good investment. We now realized the wisdom of being careful about location. Our first house had been a cute place, but the neighbourhood had been disadvantageous for Michael.

James Bay, the oldest neighbourhood in Victoria, is the community we decided to live in. It's the area behind the provincial legislative buildings, and the place where Emily Carr, Victoria's most famous artist, was born in 1871, lived for most of her life, and died in 1945. My first job, at the old people's home, had been in James Bay, and I felt even then that I walked there in Emily's footsteps. Once, while sitting on the rocks at the beach, I was reading her journals, *Hundreds and Thousands*, and enjoying the few paintings interspersed in the book. Suddenly I realized I was sitting in exactly the same spot Emily had sat when she painted the work I was looking at.

This was important for me, because my sense of a woman's ability to be an artist had been tenuous. And Emily had been so talented

and interesting—as a painter, as a writer, and as a personality. One of the women who lived in the old people's home where I'd worked had known her. Emily had a monkey and many dogs over the years, and she used to walk down the street with the monkey in a baby carriage: she was a bizarre character in conservative old Victoria. The old woman told me she had been invited to Emily's for tea, but, "mind you, the cups were never too clean."

Annie and I ended up buying a 1908 house in James Bay for a very good price. It had two apartments we could rent out, which would help with the mortgage payments. So now we were landladies for the first time. I was painting, Annie was doing graphic arts and lighting design for theatres and dance companies, and it was working out.

Although my career and my relationship with Annie were going well, there were problems with my children. Our years in Arbutus Bay had been hard for them. I had been living as a belated teenager, and they had suffered for this. I have many regrets about that time and have apologized to them many times. I can't go back to those days and change things, but sometimes I wish I could.

George and I had moved to Canada when our daughter Beth was eleven years old. This was probably the end of childhood for her. She always wanted to be older, and before long she began to go out with boys. Drugs were in all our lives then, and I'm sorry to say that I turned her on to marijuana when she was thirteen—the follies of the early '70s! Beth left school at fifteen and eventually started living with a boy in Lake Cowichan. She never lived at home again. In any event, home had changed; I'd left George by then and was living with Annie, and I never thought about how all of this was affecting the children. It was finally my time—my time to start living, and I did it with a vengeance! Someone said, "When prisoners break out of jail, they never do it gracefully." And none of this was graceful on my part.

Eventually Beth went to join George, who was then settled in San Luis Obispo, California. Beth met a sweet young man, Matthew, in the early 1980s, and he asked her to marry him. Matt was very bright, but with a fatal flaw—alcoholism. His mother had been an alcoholic and had eight children, most of whom had inherited the disease. Nevertheless, Beth and Matt married, and Beth soon started attending Alcoholics Anonymous meetings. Matt would try to go on the wagon but

A photograph I took of Kyle and Megan in my hotel room in Lake Tahoe, about 2001. I love this photo!

never really did. The marriage started to fail, and Beth got angrier and angrier. One night, after Matt had been drinking, they had a terrible fight. Beth said she wished he would die, and Matt went to bed. He had sleep apnea, which was always worse when he drank. This time, he began by snoring loudly and then he was quiet; he had stopped breathing. Beth phoned for an ambulance, and Matt was rushed to the hospital. She called me from the emergency room, yelling into the phone that she thought he was dead. They were trying to revive him, but she didn't think they could. Finally they told her he had passed away. He was twenty-nine years old. It was the worst phone call I have ever had.

The next morning I flew down to help Beth. Together we planned Matt's funeral, which was beautiful. All my children and George were there. Soon after, I made a painting of Matthew for Beth. He was a great fisherman and had gone fishing the day he died. In my painting, he walks underwater, surrounded by fish. Matt was with the fishes now.

After Matt's death, Beth moved to San Antonio, where George was then living. There followed a period of about ten years in which she lived with a cowboy for a long while and then one guy after another, all of whom were addicts of some kind. She had told me for years that she could do crystal meth (occasionally) or heroin (rarely) and never get addicted. "I'm not an addictive person," she said. "I know you get nervous about these drugs, but I can handle them once in a while."

Finally, she bought a house and went into a business, hoping eventually to be able to own her own bar. The business was at the point of being a paying proposition, and then . . . Beth was addicted. Crystal meth caught her. Within a few months, Beth had lost her house, her business, even her car. For the next year, we didn't have much communication. I was terribly afraid for her, especially in the middle of the night. Near the end of that terrible time, Annie and I went down to see her and were shocked to see how she was living—in a trailer park, a cluster of crumbling old trailers in a dry, rutted field.

Finally, Beth started to get clean, having longer and longer periods between being stoned, and then she did get off the drug. She went to a few Narcotics Anonymous meetings, but it was a major accomplishment to be able to quit crystal meth without going to rehab. After that, there was a period of time when she could not find work. There were weeks of not even having any food, when her sister Heidi and I

Mike with his three children in 2007: Chelsea (being held, as a two-year-old), Megan, and Kyle.

were sending her money. Eventually, Beth found a waitressing job at a restaurant and worked there for a couple of years, leaving after working as a trainer. She now has a job with a related restaurant and has worked for this chain for several years. She consistently wins every contest in the company, selling more food and getting the best tips—she's very good at her work.

After Beth moved to Texas, Bruce, the cowboy she lived with, was (supposedly) cleaning his gun. It went off and shot right into the centre of my painting of Matthew. The painting now had a big hole in it and lots of smaller damaged areas. I brought it to my studio to repair it—a huge job, basically a repainting of the entire portrait. It took me a couple of years to complete. The restored painting now hangs in Beth's living room. I think it has helped her to face and deal with her guilt and grief about Matthew.

In 1988, my son, Michael, and his wife, Tracy, had my first grandchild, Kyle—a beautiful baby, born in San Antonio, where Michael and Tracy lived, probably because George had settled there earlier. I first saw Kyle when he was three months old. I was a proud fifty-year-old grandmother and asked that they call me Bubbie. I love that name. I had never liked the name Phyllis, but Bubbie still suits me just fine. Kyle is a sensitive, loving person, and Annie and I have always felt very close to him. He used to come and stay with us for a week or two, usually in the summers, and our closeness stems from that early connection. Michael has basically raised Kyle ever since he was about five years old. Kyle is a wonderful athlete, and when he was in high school was wrestling champion of the state of Nevada for two years. They live in the Lake Tahoe area, where Michael has had a successful flooring business for the last fifteen years. Michael splits his time between Nevada and a small village in Mexico, where George settled years ago.

My daughter Heidi's story is very different. After a rocky start, she realized that her childhood dream of becoming a veterinarian could become a reality. She went back to school after having left for a year, and became a brilliant student. She then went to the University of Victoria, and after just three years was accepted into the University of Saskatchewan's veterinary college. She graduated in 1987, spent two years in Newfoundland practising, and then, happily for me, settled in Victoria and has had a successful career as a veterinarian. She and her

Beth in 2010.

Me and my granddaughter Sonja,
about six months old, at one of my
openings in 1990.

husband, Doug, got together when we were still in Arbutus Bay. He's a carpenter and has been a wonderful support for me throughout my career. They had my second grandchild, Sonja, in 1990. What a beautiful baby she was—curly, reddish blonde hair, fair skin, and blue eyes. And they live here in Victoria!

In January 1994, my granddaughter Olivia Rose was born to Heidi and Doug. We call her Rosie, after my beloved aunt, and she continues that tradition of being a very loving person. Also a great athlete! The next year, another granddaughter, Megan, a dark-haired beauty, was born in Texas. She is Michael's second child and has always lived in the States. I wish I had more time with Megan, but it is difficult because of the distance. All my grandchildren are amazing athletes: it may be my father's genes. Michael has had one more adorable child, Chelsea, born in 2004. Michael and Tracy split up after a couple of years, and since then he has not been married. I'm proud of him for raising both Kyle and Megan since they were very young. I love all of the grandchildren so much and have tried to connect as often as I can: birthdays, holidays, and so on.

I guess I find it easier to write about the difficult times. Tolstoy said that "happy families are all alike," and perhaps the happy times are also alike and not very good copy. Annie and I had wonderful neighbours and wonderful friends in the 1990s and belonged to an ever-growing lesbian community. I also rejoined the Jewish community in Victoria. After having the Seder, I started to make small forays into the synagogue. Victoria's beautiful old synagogue is the oldest functioning synagogue in Canada and is a very inspiring building. I have enjoyed the Jewish community and felt that people there relate to each other on the highest levels. The synagogue itself is a very spiritual place: there's a lot of support. We share each other's happy times and, of course, the hard times.

I notice that with Judaism, as with most things in my life, I still have my rebellious side. I stay at the edge of things. Perhaps that's the artist's place, in order to examine, or just see, the whole picture. It's important to have that distance. I find I'm like that in all of my relationships, other than those with Annie and my kids.

My love affair with marijuana lasted for a very long time—too long. I eventually became addicted to marijuana, even though, towards the

end, I would smoke only a little bit, one or two puffs (tokes). I would sit back and smoke and see where my painting could go next. I was afraid that I needed it in order to paint, and I earned my living by painting. This went on until 2001, when I belonged to a group of women who met once a month to talk about creative aging. In September of that year the topic was addiction, and I talked about marijuana. I had been struggling with the feelings of addiction, including paranoia, for years, but I felt trapped and unable to stop. The women in the group asked me all kinds of questions about why I continued to smoke, but I could not justify my smoking to them and, finally, not even to myself. I knew that if there was anything to be learned from smoking dope, I had already learned it. So on September 14, 2001, I stopped.

For the last few years, our rabbi, Harry, has led "a call to artists," in which he gets artists, poets, sculptors, and writers together to talk about a particular piece of Torah or an idea. Both Annie and I have been a part of that. We meet once a month, and at the end of our discussions produce paintings or poems or whatever. Then there is a big exhibition, where we talk about our work and how we came to do it. Many people come to see it; it's a wonderful night. So being Jewish has become a joyous part of my life.

In 2007, Annie and I decided to leave our beautiful home and studio in James Bay and move to another part of town. The old neighbourhood was getting more and more noisy. Floatplanes were now flying over our house pretty much nonstop all day, and we were a block and a half from the heliport. Often, when we were sitting outside, we had to endure the sound of either an airplane or a helicopter. Finally, I just didn't want to live there anymore. James Bay is a very active neighbourhood, culturally and ethnically varied, and while I was sorry to leave it, I wanted a quieter place. We found a place in Oak Bay, a very quiet and beautiful town right beside Victoria. We now have a lovely 1940s house, extensively remodelled, with a studio in the basement for me and a nice big studio upstairs for Annie. We are very close to the ocean and one of our favourite places, a wild park. We live near a swimming beach with beautiful views of Mount Baker, visible across the strait in Washington State and always covered in snow. We can also see the Olympic Mountains to the south.

In 2010, I re-established the Valentine's Day studio show, and that

My daughter Heidi with her two girls, Sonja and Rosie, about 2007.

went very well. I had been showing in galleries for the previous five years and decided to try having a show in the new house. And we got a new puppy. His name is Benny.

Annie and I recently went down to Seattle, and I saw the musical *Hair* again. We enjoyed it tremendously. I had first seen it in 1970 in Chicago, with my brother, Bobby, and friend Linda. In the intervening years, after Bobby died, Linda became very ill with multiple sclerosis. At the end of *Hair*, the audience is free to go up onto the stage and dance with the cast. Both times I did that, but this time, I cried while dancing. I cried for all the years that have passed. I cried because I was dancing for Bobby and for Linda, who was a wonderful dancer but who hasn't been able to walk, let alone dance, for a very long time.

Growing older with Annie is poignant. To live with someone you love and to see her aging—her hair greying, her skin wrinkling, and her body showing the signs of the years we've spent together. All the loving, all the fights, all the shared experiences—it's something I never anticipated the beauty of. My only word for it is, again, poignant. And what a beautiful word it is.

EIGHT MOLLYS ON THE BEACH

My Aunt Molly was one of my best subjects. Approximately fifteen years after doing the painting in the *Family Series*, I decided to play around with her image and ended up with eight Mollys on the beach.

OIL ON CANVAS, 44" X 60", CIRCA 1993, PRIVATE COLLECTION.

OUR HOME

A night view of our James Bay home, which Annie and I shared for twenty-four years. We are visible in our living room. We loved that 1908 house and the wonderful studio we had built behind it.

OIL ON CANVAS, APPROX. 30" X 30", CIRCA 1997, PRIVATE COLLECTION.

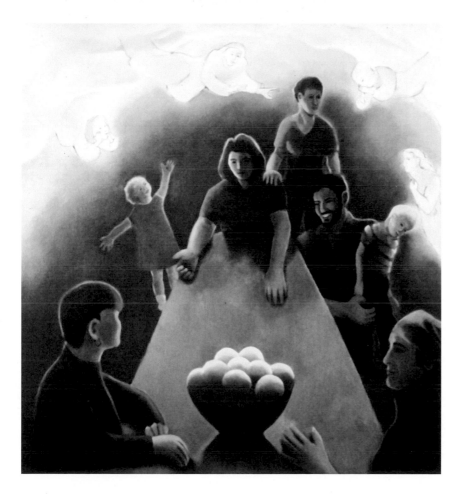

ANGELS AND ORANGES

In this painting, I am at the head of the table, Annie is standing behind me, Heidi and Beth are at the foot of the table, and Michael is beside me. My two oldest grandchildren, Kyle and Sonja, who were still young, are also in the painting. It's a large painting. I obviously felt something watching over us; perhaps I was feeling extremely fortunate at the time. It was one of those rare paintings that went well from the minute I started it and continued that way. I used it as the invitation for my annual show in 1994.

OIL ON CANVAS, APPROX. 50" X 45", CIRCA 1994, COLLECTION OF ERIN CALDWELL.

191

MOM AND DAD

On Friday nights, the women in a Jewish family light the Sabbath candles—historically, one of the only religious acts accorded to Jewish women. I have painted my father entering the room, about to say something, seeing my mother in the act of praying while she lights the Sabbath candles, and stopping himself from speaking. This would have been a rare occurrence.

On a formal level, the use of opposites, yellow-orange and blue-violet, gives the painting a monumental quality, and the candles gave me an opportunity to paint light, which I enjoy. This was the final painting in the *Family Series*. So much of this series has to do with these two qualities: the monumentality of the people and my obsession with light.

OIL ON CANVAS, 60" X 44", 1986, COLLECTION OF JEFF AND DONNA SMITH.

The last photo I took of my mother, 2002.

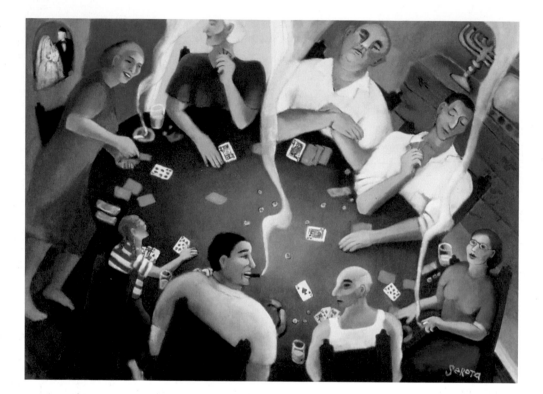

POKER

The whole family playing poker in Aunt Jenny's dining room. My mom and dad are on the right; she is smoking, and he is playing his cards close to his chest. I'm there too, in my usual outfit. My mother loved playing cards.

OIL ON CANVAS, 33" X 45", CIRCA 2003, PRIVATE COLLECTION.

Sarah's body changed as she aged. She grew smaller, weaker, and shakier. When she was in her seventies, her teeth were extracted and false ones took their place. Her beautiful, weak, blue-grey eyes developed macular degeneration and she couldn't read anymore. Eventually her thick, sturdy legs could not support her. Her heart attacked her, but she had a procedure done that was successful in taking out the plaque. But mostly her brain—her quick, alert brain—started to deteriorate. She had many small strokes and eventually couldn't remember her oldest friends or even her children's names. She forgot that she smoked. All that remained was the fear in her eyes. Finally that too went away, and she was like a child, helpless. Her old, tired, once almost-perfect body just gave up.

Sondra moved my mother down to Houston, where Sondra lived, in 1998. It was an assisted-living situation, which worked out well for a while. But Mom was still smoking, and her mind was going fast: senile dementia—just like her mother. One day she left a cigarette burning in the bathroom and started a fire. Luckily the staff caught it in time, but they became worried about what would happen in the future. They asked her to leave.

Sondra then found her a place in a Jewish home for the aged, where they could take more intensive care of her. While there, she fell in love with an old man. Once, while I was visiting her, he came into her room. I have never seen anyone change so rapidly. She went from barely listening to what we were saying to becoming very animated, smiling and flirting with him. But, little by

My mother in a very typical pose, about 1990.

195

little, she retreated again. All that remained of the old Sarah was apparent when we went into the dining room, where entertainers were singing. All of a sudden she was singing too—"Yankee Doodle Dandy"—and she knew all the words. Then she retreated once more. My mother was in the home with her dementia when Bobby died. We didn't tell her that her baby was gone.

In January 2002, she contracted pneumonia and was rushed to the hospital. She got better and was brought back to the home. I went down to see her in February, and she was like a baby, crying in her wheelchair and whimpering in bed. I had recently read that dementia is like living in a dream. So I asked her, "Mom, are you in a dream?" She said, "Yes."

Despite that, the last time I saw my mother, although she had senile dementia and didn't know my name, in her eyes I saw her love. I treasure our last day together.

Years before, when her mother had had severe dementia, my mother had said, "If I ever get like that, just kill me." So I had a conversation with Sondra and suggested, "Why don't we put a DNR [Do not resuscitate order] on Mom?" Sondra replied that she had wanted to do that but wasn't sure, so I said, "Let's talk to the doctors and nurses while I'm here. Both of us will be together and strong about it. It's what Mom wanted." So we talked with the staff.

Soon after, Mom got sick again. They wanted to take her to the hospital, but Sondra put her foot down and said, "We have decided that she's eighty-eight years old, that she never wanted to live this way, and that we should let her go naturally." So hospice was called in, and within a week Mom passed away quietly. The rabbi at the Jewish home was there that day, and Sondra called him in. While she was waiting for him, she told my mother that she would get to see Bobby on the other side—that he had died a year earlier. When the rabbi came, he read the prayer for dying to my mother. She listened all the way through, and when he finished, she died. It was March 31, 2002.

We had the funeral at the family cemetery in Chicago. There weren't many people present. I've noticed that the funerals of older people, unless those people are very well known or celebrities, are quite small. (If you die when you're young, crowds of people come.) It was very, very cold the day of Sarah's funeral, but I took the opportunity to visit all the family graves: my grandparents Philip and Sonia, my grandmother

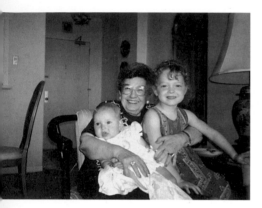

My mom with two of her great-granddaughters, Heidi's two little girls, Sonja and Rosie, about 1994.

Diana, lots of other aunts and uncles, and Aunt Rosie's daughter Edith, who died very young. My mother and father are buried next to each other, even though Mom had been married to another man for about ten years in the 1970s.

Because my mother had been sick for so long with dementia, it was much easier for me to deal with her death than with either my father's or my brother's. I had been prepared for it for a long time. And the death of the mind is also a kind of death, isn't it?

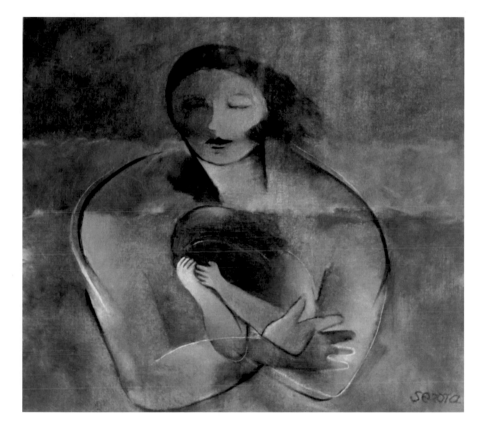

SOLSTICE

I was once at a Chanukah party which happened to fall on the winter solstice. My friend who was the host spoke before the candles were lit. She suggested to us that perhaps we could be in the dark for a while, since that was what the solstice was really about. We always rush to talk about the light—that night we stayed in the dark for a few moments. During that time, I saw this painting in my mind's eye, and painted it soon after.

OIL ON CANVAS, APPROX. 26" X 30", 1990, PRIVATE COLLECTION

THE BIRTHDAY LUNCH

I am invited to a young friend's birthday party. We are all eleven years old. She is one of the girls at the edge of our club, the Beau Esprits. She's tall, a bit heavy, has dark features and black hair. She's not very comfortable joking around and getting people to like her, but she's a good athlete and plays ball with us at the park. She's not a close friend of mine, and I'm surprised to be invited to her apartment.

We all are there, all of my friends, and we sit down at a large oval dining table covered with a clean white tablecloth, laid with beautiful silverware. I have not met her family before. Her mother comes out with a big white tureen filled with what looks like stew. All of this is doubly surprising, because we generally just have cake and ice cream for parties, but this is a whole lunch: bread, the stew, and later we will probably have cake and ice cream. Her mother begins to ladle the fragrant stew onto our plates, and while doing this begins to say mean things to her daughter. She speaks with a shrill voice, almost screaming. "You're too fat, you're ugly, you can't do anything right." On and on, all through our eating what is really wonderful food, she keeps on at her poor daughter, loudly cataloguing her deficiencies.

I don't know where to look, what to do. So I just shovel the food into my mouth with the big soup spoon, looking carefully at my plate, not at my friends, and definitely not at the birthday girl, who by this time is crying. Mucus and tears are running down her face. Her mother has a strong, what we call "Jewish," accent, meaning that she is from Europe. My aunts and uncles speak the way she does; many people in our neighbourhood do.

As I relive this scene—this tirade, this pitiful harassment—I wonder if the girl's mother could have been a Holocaust survivor. I'm curious about what would make a woman do that to her child, make a beautiful lunch for her friends and then proceed to tear it all down.

I think there are people for whom humiliation is love, perhaps the only form of love they've ever known. If your parents or people in authority over you treated you like this, it might stand for love, even intimacy.

I don't remember any more of the birthday party—not the cake, not the "pin the tail on the donkey," which we always played at the other parties. I don't even remember what happened to this young girl. Only the terrible sound of her mother's voice and the child's thick lips, trying to hold back the sobbing.

From time to time, I hear people say that suffering ennobles people, or that it should. They don't understand how the Jews, having gone through the Shoah, could do what they have done to the Palestinians. I know that violence breeds violence—I know it first-hand. I know that if one has been humiliated, one tries to do the same to others. Strangely, I can't recall any of my own birthday parties, only that young girl's. My father humiliated his children too, but only in private.

This is one of the things I have had to deal with throughout my life. I have made a conscious choice to stop both the violence and the humiliation within my own family. There are many times in life when we have these choices to make. Eventually some of us recognize that leading an honest life, choosing to treat people with respect, is what we want to do. This is not necessarily easy or familiar, but absolutely essential for me, and perhaps for our future.

BEFORE THE WAR

BEFORE THE WAR

I began the Holocaust series with this painting. At the time, I was dividing the canvas into vertical areas and experimenting with mixed media in an improvisational way. I started this canvas by attacking it with black gesso. I remember this vividly: I had my eyes closed and was painting furiously with the gesso and not thinking. I picked up some doilies and used them as stencils. When I stepped back, I saw the two pears in the right-hand panel. I immediately thought of Matisse's painting *La Desserte*, which depicts a young woman setting a table. Matisse's composition is quite similar to the right-hand panel of this painting. The whole painting came from that idea. The compote dish in the woman's hand is repeated in the centre panel, as are the pears. In the left-hand panel, I continued the vertical divisions and, without thinking about it, added shadow figures.

There's a lot of darkness in this painting. And there's a lot of light. I repeated the Matisse figure in the right-hand panel. I'm not sure why—perhaps re-establishing the individuality of the painting so that it is not a copy of the Matisse. The centre panel was painted in oil, whereas the other two are in both black and white gesso and acrylic paint. I was doing a lot of this at that time—trying to make the jump from painting in oils to painting in acrylics. It was eventually successful. I have worked in acrylics pretty much exclusively since 1998.

The techniques I employed in this painting were the same ones I used throughout the remainder of the Holocaust series, but there is no Holocaust in this painting. Perhaps the figures in the left-hand panel are a harbinger of what is to come. I had always been struck by how advanced, how civilized Europe was before the war. The doilies are a metaphor for that attention to detail, to manners, to the class system. In the window there is a willow tree, the kind I've seen in Europe many times. The way the willow trees were pruned was to chop off the tops of quite small trees, a very mannered kind of pruning. Who could have guessed what would happen in that place at that time?

MIXED MEDIA, OIL AND ACRYLIC AND PASTEL ON CANVAS, 44" X 60", 1997, COLLECTION OF THE ARTIST.

Since 1975, I've been keeping a journal, an exercise suggested to me by the then president of the Emily Carr College of Art in Vancouver. He thought it would help me in coming up with ideas for both my paintings and my life. That has been true. At the end of 1996, I wrote in my sketchbook: "I'm feeling the need to paint something about the Holocaust."

I'd been familiar with the terrible story of the Holocaust since I was thirteen and have read many books about it, such as *The Diary of Anne Frank*, André Schwarz-Bart's *The Last of the Just*, Leon Uris's *Exodus*, and Primo Levi's *If Not Now, When?* But, I continued in my sketchbook, "I've never really addressed the issue, even though it's been so important to me. I know that paintings about the Holocaust aren't going to sell, but everything doesn't have to sell. I need to do one or two paintings addressing this."

In 1997, I began the work. I had no plan. I still thought that I would do just a few paintings. I had recently learned how to use the Internet and found that it was very useful in getting information and photographs about anything. So I began my study of the Holocaust.

The first painting, which I eventually titled *Before the War*, was a large canvas divided into three parts representing Europe—the ground and climate in which the Holocaust took root—a culture that was so advanced, so civilized, so artistic, yet with corruption at its core. That first painting only hints at what followed. Matisse was there, as were beauty, darkness, pain, of course, and the doilies. I've often used doilies in my work. When I was a child, I collected them at restaurants and wherever else I found them. Sometimes I would colour them, and later I used them as stencils in my paintings. I even pasted doilies onto the

canvas, like a collage. In this painting, I stencilled the underpainting, the first coat, with them. To me, they have an old-fashioned feeling, a throwback to a time and place that has certainly passed.

I then worked on ten much smaller paintings, each twenty-eight inches by twenty-four inches. These paintings were far less oblique: in them, I explored themes of chimneys, women and children, stripes, stars, souls, trains, hands reaching out, numbers, Europe, and tombstones. What was new for me was that I worked on many paintings at the same time. I would put something onto one and then move over to another and paint something there. I had never worked in this way before. I was also beginning to work with texture, and was switching over from oil painting to working in acrylics. There was a lot of experimentation going on.

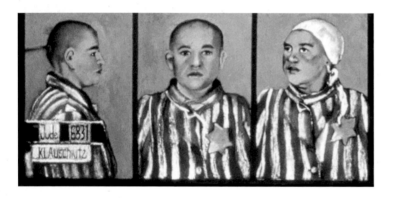

JUDE, 6831

The woman at Auschwitz that I felt so close to and eventually obsessed with.

PASTEL ON CANVAS, 21" X 40"
(DETAIL OF *ORDER AND CHAOS*), 1998,
COLLECTION OF THE ARTIST.

I did another big painting of a large group of naked women, presumably on their way to their deaths. The image was taken from a black-and-white photograph. I added the device of colourful people dancing in the sky; I was hoping that perhaps this was their end, that it all worked out for them. I share the hope that there is some salvation in death, that the other side will be better than what we know in this deeply flawed world.

After completing those small paintings, I embarked on the large triptych *Order and Chaos* (also the title for the entire series). It is, I think, among the best paintings I have ever done, perhaps because it came not only out of terrible sadness and intensive work over a long period of time, but also from a growing sense of guilt, the guilt of the survivor.

While doing this painting, I experienced something I had not previously understood. I realized for the first time that, because I was Jewish, if my family had stayed in Europe and had not emigrated to the United States in the early twentieth century, I might have shared the tragic fate of many European Jews: my end would have been similar to theirs.

Why was I spared? This was overwhelming for me. For nine months I had been utterly immersed in the series, and because it was so difficult, my defences were down. I was particularly vulnerable to experiencing

the devastation that the study of the Holocaust brings. To understand that human beings are able to treat each other with such disregard, inhumanity, and sadism is beyond every idea of being human that I had ever conceived.

In my journal, I wrote on May 24, 1997: "I wonder, this morning, if I could find out what happened to the young woman I've been drawing. How do I do that? I would like this to be a memorial to her. I think she was about eighteen years old. What about a memorial to my eighteen-year-old self—is that part of it? Your old self was on her own for the first time in her life, happy, interested in everything, alive. This young woman was in imminent danger of dying."

On May 25 I wrote: "Spent a lot of time on the Internet today, trying to find 'bodies in pits' and 'mass graves.' I did get one image that is the best one I have, but will still be extremely difficult to do. I am wondering why I'm doing it if it's so abhorrent to me and I'm so terrified to do it. It'll be so difficult on both an emotional and an artistic level, but at this point I think I should give it a try. I thought I was just working from no plan, but this feels like a plan—maybe that's part of my reluctance. I guess once I get started it'll just take over. I hope so.

"I guess this is at the centre," I continued. "The inhumanity of humans to each other, racism, and how dangerous and horrible the end results are. I've always been interested, moved and upset by racism, even as a child, and I've never really painted my feelings about it. This is my opportunity."

I recall that I also thought of it as my challenge. It was like a vision of hell, or perhaps my own fears. When I was younger I had painted a series of paintings of Orpheus and Eurydice's journey through the underworld. In that group of paintings, I portrayed the gods Hades and Persephone and the three-headed dog Cerberus, who guards the underworld. The Holocaust series was like that, but much darker. This series depicted humans, their bodies intertwined and almost indistinguishable. I also recalled *Tikkun Olam* (a Hebrew concept of repairing the world), and the idea that you can't heal a wound unless you clean it out by looking at it carefully. We need to understand our own capabilities for evil, then attempt to repair them.

After nine months, despite thinking I had no plan, I had completed thirteen paintings and shed many painful tears from a seemingly

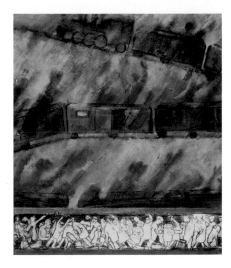

TRAINS

One of ten small paintings that were part of the Holocaust series, *Order and Chaos*.

The very first time I heard about the Holocaust was in a book written by a woman who had been transported on one of these trains to a concentration camp. I'll never forget how I felt reading that, the horror of those box cars crowded with dying and dead people. No room, no water, no toilet facilities, and certainly no pity!

In this painting I attempted to express some of this.

OIL ON CANVAS, 28" X 24", 1998, COLLECTION OF THE ARTIST.

bottomless pool of grief. But I did finally discover this, only this, about the young woman in the upper left-hand corner of my painting:

> *Female inmate with the number 6831: The Jewish woman was deported from Cracow to Auschwitz on April 27, 1942. Her name and her further life are unknown.*

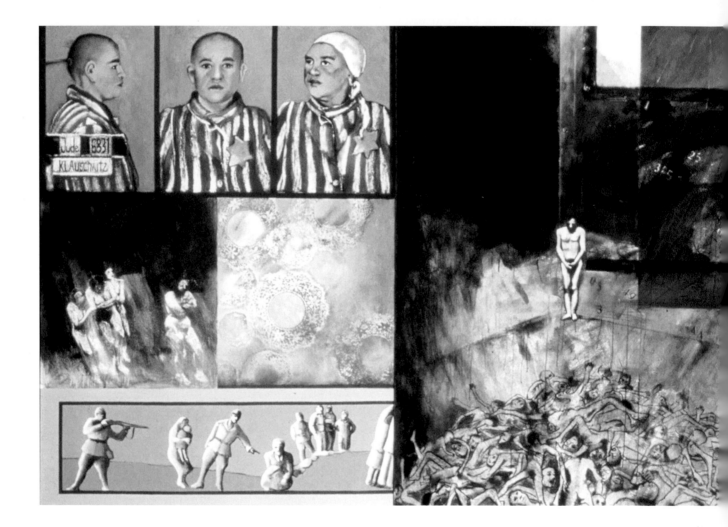

ORDER AND CHAOS (TRIPTYCH)

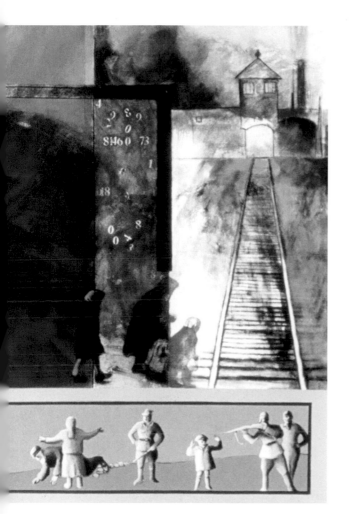

This triptych completes the Holocaust series. It comprises three canvases, each one forty-four inches across. The whole thing is sixty inches high and approximately eleven feet across. On the bottom of the painting, I painted black-and-white images of particular incidents that occurred during the Holocaust. A work done in one colour, usually greys, and imitating bas-relief is known as a grisaille. Many artists, notably Michelangelo and Diego Rivera, have used this technique.

In the panel on the right is a depiction of Auschwitz and its notorious train tracks. A small family is coming closer. The child on the left touched me greatly. She is coming to the concentration camp. What happened to her? I'll never know.

The most important pieces of this painting for me are the three faces of the prisoner in the upper left-hand corner. As I worked on her portraits in chalk pastel, I was obsessed by them. I became interested and curious about the woman's life and probable death in Auschwitz. After I finished the rest of the painting, I continued working on her portrait over and over again, as if I were somehow responsible for it.

In the centre panel, a man stands at the edge of the pit. He's naked, holding himself private. He is alone. His back is to the swastika. His family—possibly his mother, his father, his brothers and sisters—lies in the bottom of the pit. The red swastika behind him is filled with the horrible numbers, and there is darkness. What will he do? He is poised at the edge. Is he me? You?

OIL, ACRYLIC, CHALK PASTEL ON CANVAS, 60" X 132", 1997,
COLLECTION OF THE ARTIST.

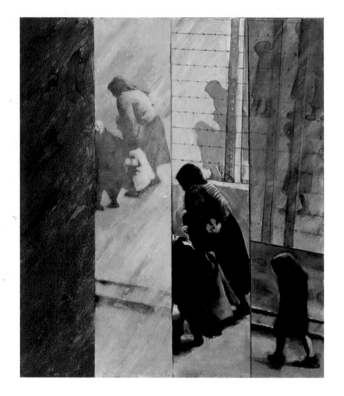

WOMEN AND CHILDREN

This is one of ten small paintings that were part of the Holocaust series entitled *Order and Chaos*. The figure of the little girl on the bottom right also appears in the right-hand panel of the triptych *Order and Chaos*. This child continues to speak to me.

ACRYLIC ON CANVAS, 28" X 24", 1998, COLLECTION OF THE ARTIST.

FAMILY PORTRAIT

FAMILY PORTRAIT

Here's our family, pretty much as we are now. We were down in Austin, Texas, for the bar mitzvah of my sister's grandson, Brian. My son, Michael, was not there, nor were his daughters, Megan and Chelsea, but everyone else in the family was. We posed for photographs in this configuration for various people's cameras. I received the photograph on which I based this painting from one of my relatives and was struck by the central figure in the top row: my eldest daughter, Beth. At the time she was still recovering from her addiction problems. I was struck by how she looked in that photo; this painting was born because of that. All of us were pleased to be together again. Everything had changed in our family after my brother died.

After I finished working on the whole family, there was something missing, so, on a whim, I put that fish in. It worked! So much of our family history is connected with that symbol. When everyone came to visit our home for my granddaughter Sonja's bat mitzvah, I had just finished it. I didn't know whether I should show the family this painting. I asked my niece Marcey what she thought. She said, "I love it." So I left it on my easel in my studio, and one of my relatives bought it. I was thrilled.

Standing in the back row (left to right): my nephew Marc, my nephew Scott, my niece Marcey, my nephew Richard, my daughter Beth, Marcey's partner Star, my daughter Heidi, my son-in-law Doug, and my nephew Larry. On the couch (left to right): my brother-in-law Bob, my sister-in-law Susan, my cousin Beverly (Aunt Rosie's daughter), me, my sister Sondra, and my partner Annie. On the floor: Brian, my grandson Kyle, my granddaughter Sonja, my granddaughter Rosie, my sister's granddaughter Michelle, and my niece Deborah.

ACRYLIC ON CANVAS, APPROX. 5' X 6', 2003, PRIVATE COLLECTION.

Sondra was four years old when I was born. I have a theory that the eldest child has experienced a heaven to which she always tries to return. We lived in a family that encouraged sibling rivalry, and, as a result, Sondra and I were very angry with each other for long periods of time. It's only since Bobby's death in 2000 that we've learned to get along, to enjoy each other and stop the war.

When we were young, Sondra used to take the tiniest little bit of my skin, pinch it, and turn it. She had the bed next to the window in our very hot, north-facing bedroom and would never let me change beds with her. She was one of my bosses, one of my mothers. She would say things like "What are you thinking of getting Mom and Dad for their anniversary?" Because I was very young at the time, I would ask,

Mother and daughter: Sarah and Sondra at my mother's apartment in Chicago, probably in 1978.

SONDRA, THE ELDEST CHILD

In 1998, my niece Deborah had her bat mitzvah. The next day there was a luncheon for my family, and Bobby, Sondra, and I sang together—a rare occurrence.

"What's an anniversary?" Then she'd explain it, but I was angry that I'd had to ask.

Sondra was so much ahead of me in everything. She often took care of me when my mother was busy, either with my brother, Bobby, or her work. Sondra hung around with friends that she had known all through school; her friends were very different from mine. If one child chooses a particular path, the next one often goes for the opposite. I was much more conservative in some ways. Now, I would probably be called preppy.

Sondra started dating Bob when she was fifteen. They married when she was eighteen, the same age at which my mother had married. As I write this, I'm sorry to say that Bob has just passed away. He and Sondra were together for fifty-eight years.

There were times over the years when Sondra and I were very close. We lived across the street from each other when I was in my very early twenties, when our children were young, and we walked together every day with our baby carriages. Sondra knew everything about taking care of babies and helped me so much with that. Then, for a while, we lived next door to each other. We sat together in the yard with our young children, sunning ourselves and smoking while our kids ran around and had fun. We played poker and mah-jongg together, painted together, and had shared friends. When she and her husband, Bob, moved to Houston in 1967, my children and I would go down and visit with them for two or three weeks. We were still really close in those early days.

But in my late twenties, we took very different paths. I moved to what Sondra called "another generation," and she stayed in the original one. My friends became younger, and our ideas often conflicted. Marijuana and other psychedelic drugs also separated us. Sex, drugs, and rock 'n' roll was my reality in the late 1960s.

When Annie and I came together, Sondra was supportive at first. I think what caused the change in our relationship was that her daughter, Marcey, became a lesbian. Sondra blamed me for that. I hadn't seen Marcey in thirteen years; nonetheless, I was the only lesbian she knew. When Marcey "came out" to Sondra and Bob, they broke off contact with her. That lasted for a couple of years. I was shocked by this: it was very painful for me. So years went by like that—every time Sondra and I saw each other, it was there.

With our brother Bobby's death in 2000 and my mother's death soon after, Sondra and I realized that just the two of us were left. Her husband, Bob, had been sick for a very long time with one thing after another. They both had diabetes. She has also had great difficulties with her health, especially with her legs.

Sondra and Bob did come to terms with Marcey's lesbianism, and they really loved her partner, Star. Marcey has been my greatest supporter, my greatest patron. She has collected more than forty paintings of mine over the years, and is also my very good friend. I appreciate her love and support all through these years.

Sondra and Bob's son Marc has two children, who Sondra is very close to. All of our children—my three and Sondra's three—were born quite close to each other, and throughout their childhoods they were the closest of friends. Their son Richard, who is the same age as Michael, met and married Flor, a young woman from the Philippines. Flor converted to Judaism, and she and Richard had a Jewish wedding. It was wonderful to have a wedding in our family that connected us with a totally different culture. They have since had a beautiful boy, Sean. Now Sondra has a lesbian daughter, a divorced son with two much-loved children, and a racially mixed grandchild. I believe that all of this has changed her mind and her heart.

When our mother was starting to show signs of dementia, Sondra went to Chicago, helped Mom pack up everything, and moved her to Houston. For the eight years our mother was in Houston, Sondra and Bob took care of her. When Mom needed to be moved to a home with a lot more care, they moved her again. I've always appreciated the huge assistance—the work, time, and energy—they gave Mom. So Sondra and I are friends again, and I hope we can continue to be friends for the rest of our lives.

At my niece Marcey's house with the painting of my mother in the fish store, about 1999.

Sondra and Bob at their fiftieth anniversary party.

MOUNT ROSE

This painting came from a visit to the San Francisco Museum of Modern Art, where I saw a very large exhibition of Anselm Kiefer's work. It was the most exciting show I've ever been privileged to see. We were there for the weekend and I could not look at any other art, even though there were some wonderful shows at other galleries. While I was there, I realized that putting objects at the bottom of the painting gave a new kind of perspective—there was a sense that the bottom of the canvas was closer to the viewer than the top was—an insight that led to this painting and many others. This is a view of Mount Rose from the highway going down from Lake Tahoe, where my son and his family live, to Reno, where I fly in and out.

ACRYLIC, TWIGS, BERRIES ON CANVAS, 54" X 72", 2008, COLLECTION OF RICHARD LEWIN AND JUDITH BELTON.

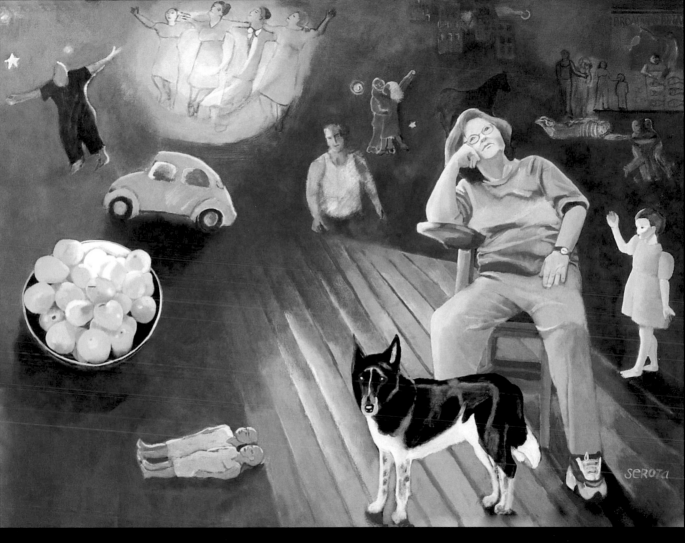

SELF-PORTRAIT WITH CHEEKA

BEING AN ARTIST: PHYLLIS STYLE

SELF-PORTRAIT WITH CHEEKA

I am in the beautiful studio that we built in our old house in James Bay, sitting in a chair that always reminds me of my school days. This is a very large painting, and I've included many of the images I've always worked with: my aunts, my old Volkswagen, my greanddaughter Sonja, my father, and, of course, our dog at that time, Cheeka. She was a beautiful, healthy, happy dog. We loved her.

ACRYLIC ON CANVAS, 53" X 72", CIRCA 2004, COLLECTION OF THE ARTIST.

SELF-PORTRAIT 2009

ACRYLIC ON CANVAS, 24" X 20", 2009,
COLLECTION OF THE ARTIST.

NEW SELF-PORTRAIT

ACRYLIC ON CANVAS, 40" X 30", 2009–10,
COLLECTION OF THE ARTIST.

I want to speak about my work, but not on a scholarly level. I won't talk about "deconstruction" or about my "practice", nor will I mention "marks."

This is my story: I am a working artist, living and painting in a town in which it has been historically difficult for artists to earn a living. Even though postmodern artists, whose works we "deconstruct" (sorry), don't think it's important or necessary to earn a living, some of us do. I have been earning my living from painting since 1979, and I hope to continue doing so until I keel over or my brain stops functioning, whatever comes first.

I have worked in series many times, and, contrary to public opinion, the conceptual artists do not have a monopoly on ideas. Much of my work has come from my own ideas, not the ideas of a mid-twentieth-century Frenchman or a professor with a coterie of student followers, to whom he expounds on what is wrong with everyone else's work.

My ideas: I once had a thought that I missed my family. I had left Chicago almost fifteen years before this and had been lucky to have a strong extended family. It was so large, so lively, we experienced so much *sturm und drang*—and now many of my aunts and uncles were dead. I believe it's important to get very specific about your life. Then it becomes universal; we all share so many experiences in just being human. So I thought of recreating them in order to see these people again, to have a visit with each of them in their most characteristic pose. Then I placed each of them in the gallery where I thought they would like to be in that space. This idea became the *Family Series*. It was thrilling to be able to have an exhibit at the Art Gallery of Greater Victoria and to have the chance to visit with all my family again.

WOUNDED

The rope climber who fell.

OIL ON UNSTRETCHED CANVAS,
88" X 51", 1988, PRIVATE COLLECTION.

Once, when I was on a massage table, the masseuse kept telling me "Just let go!" People always say this as if it's the easiest thing in the world to do. Well, I have trouble letting go, but I saw an image of a person on a horizontal rope letting go and falling. That incident led to a series of paintings I showed at Open Space gallery, called *Rope Climbers*. I thought, "We are all climbing, trying to get somewhere throughout our lives. We're moving towards what we think is up, and even though we don't know where we're going, we continue climbing." In one painting, I did let go: that figure is on the ground with a rope dangling above her.

Those twelve paintings were six, seven, or eight feet tall and four-to-five feet wide; I also did two rope climber sculptures. To prepare the series, I asked some friends to climb ropes. We went to a local gym to do this, and I took photographs of them there. Some brought their children, who were either on their backs or climbing alongside their mothers or fathers. Some people climbed the ropes easily, gracefully, while others struggled. For the show at the Open Space gallery, we hung thick hemp ropes so that the audience could climb them. At the show's opening, a modern dance group climbed and danced with and around the ropes. Annie, as the show's lighting designer, lit the gallery brilliantly for both the performance and the exhibit.

Now I want to talk about what I don't do. I don't have a set time to go down to the studio every day, nor do I have a certain number of hours that I work. I don't always work in series; in fact, I rarely do. I don't work from a particular theory or set of theories. If I feel like doing lemons, I do lemons. If I feel like painting my Aunt Rosie . . . I do.

I have to paint, and that's why I do it, but I also enjoy it. I get a certain kind of concentration that I don't get anywhere else. I put the music on and then, sometimes, especially if it's going well, I dance. I love dancing and painting at the same time!

What is my life like? I don't sleep that well, so I get up late. I watch a TV show in the morning (oh God, don't tell anyone). We take our dog, Benny, for long walks, otherwise he drives us crazy all day. Then I put on my old paint-stained clothes, get some clean water for my brushes, and either work on what I've already started or start something new. I often work on two, three, or four paintings at a time. I used to work on just one painting and paint it until it was finished. When I did that, I

got the feeling that I'd accomplished something. Now, because I work on so many things at a time, I can't expect that. The rest of my day is spent doing the things we all do: shopping, cooking, taking naps (now that I'm old), watching TV, talking on the phone, and emailing.

There's a certain way that I feel when I need to start something new—more energetic and somewhat brave. Mostly, I'm working on things that I've started at different times. I'm very impatient and want to be finished almost as soon as I begin. If I work for three hours at a stretch, that's a long time. When I was doing the *Esmeralda* series, I could work for eight hours a day, but I don't have that kind of energy anymore.

In late 1984, Michael Harding, curator of the Open Space gallery, asked if I would like to have a show there. I said I would think about it but hadn't really had a chance to think it over when, in December, there were suddenly ads announcing that the show would happen in May the

THE DEATH OF ESMERALDA

This is the final painting of *Esmeralda and the Fish*, a series that illustrates how one painting can lead to another and, by the last painting, tell a story. For the first time, I appropriated two figures from Picasso—a wonderful painting of large women running by the sea. They're in the clouds. This is one of my favourite paintings.

OIL ON CANVAS, APPROX. 5' X 6', 1985, COLLECTION OF DR. BRYAN AND VALERIE MURRAY.

next year. I was quite upset about it, but because the announcement had already gone out, I thought, Okay, I've just got to get going on this. Open Space is a very large space, and I could do really big paintings for the first time.

For some time, I had been interested in the way groups of people looked in silhouette. I'd been doing some work with that idea for a while, but all of a sudden a woman (I later called her Esmeralda) appeared in front of the group. This painting was about four feet by five feet. I madly began stretching great big canvases all over my studio walls. As soon as I finished the first one, which I later called *Esmeralda Appears*, I started on another, with attached figures. (I find that often two ideas come together to inspire a series.)

The other idea came from my realization that although I had painted so many fish in my life, I had never touched one in a painting. The fish had always been lying in the fish store or swimming. So the female figure, Esmeralda, first held a fish; in the next painting, she lifted up the fish; and in another, she kissed a fish underwater. All of that grew out of a little idea about never touching a fish. I ended up doing seven large paintings within three months. I've always loved those paintings, especially how they came so easily one after the other. It was an extremely successful series for me. I sold all of them right away.

Sometimes people ask me why I've painted so many fish. Because I am Jewish, the fish is not a Christian symbol for me. My family was in the fish business for as long as I can remember: my grandmother Sonia (who I never knew), my aunt and uncle, my father in the wholesale fish market, and finally my mother and later my father, who had their own store. And, not to be overlooked, I was born in the sign of the fish, Pisces.

In 1993, I showed a painting at Artropolis (a large show in Vancouver) originally titled *Nature Morte in Chicago*, now retitled *Primary Colours*. After that exhibition, a group from Edmonton planned to put on a show called The Works Project in Victoria. They were hanging works of art all over the city and asked me if I had anything very large that they could hang. I had a few things, including this painting. They hung it in the B.C. Ministry of Tourism and Culture offices in Victoria. After a while, one of the employees at the ministry complained about this painting, and as a result The Works Project

organizers took it down. I was very upset about this—I considered it to be censorship. Then one of our local patrons of the arts came forward and said I could hang it in his business establishment, Swans Hotel and Brewpub. All of this was reported on the front page of Victoria's daily newspaper, the *Times Colonist.*

Afterwards, I decided to call the ministry and said I would like to talk to the staff about art. I thought that perhaps I could raise some consciousness. The ministry agreed. I brought along a lot of slides and a projector and talked about other paintings I had done, both of my family and of other subjects. We had a lively conversation, but I wasn't sure that the woman who was so upset with my painting ever really got it. After that, many people came to me and said they had read about the controversy. They compared it to something that had happened in Toronto, when another artist had put a woman on a cross—I guess it's a pretty dangerous thing to do!

PRIMARY COLOURS

This painting features ritualized poses of my family—at least, how I saw them. My father always called my mother the martyr, and this painting emerged from that memory. The martyr is on the cross. I am reaching for my mother, as I always was. My brother has removed himself; he's not looking for anything or at anyone. My father is yelling at my mother, while my sister is starting to climb. There's a pile of dead, bleeding fish on the ground—it was always all about the fish. You can tell this is Chicago; the skyscrapers are my way of showing that. The bed on the left and the table on the right are other places where the family drama was played out.

OIL ON UNSTRETCHED CANVAS, 44" X 90", 1993,
COLLECTION OF THE ARTIST.

BEING AN ARTIST: PHYLLIS STYLE

Phyllis and Annie on the porch of our new home in Oak Bay, spring 2008. Photo courtesy Barry Herring

One of my major reasons for writing this book is to say that if you're a forty-year-old who is working just to earn a living but has been painting for a while, it is possible to do this for your living—to paint every day for as long as you want, and to earn enough money to get by. I have two bits of advice: look at as much art as you possibly can. This gives you permission to experiment, to play, to draw outside the lines. Most importantly, set up a permanent space where you can paint for even short periods of time, so that your easel and paints are at hand at a moment's notice. I can't promise that you'll be rich, but you will have the satisfaction of knowing that you've earned your living with your two hands, that you've made things that weren't in the world before you, and that they come from inside you. That's the satisfaction of being an artist.

I'm tired of people telling their children that they can't earn a living as artists, that they should become teachers or lawyers or doctors or engineers or whatever, when the child's heart is obviously in the arts. Our souls come alive in music, poetry, theatre, dance, and painting—if that's what ignites us, that's what we should go towards. As Joseph Campbell so importantly said, "Follow your bliss."

I thank whatever gods there are for my life. I feel so lucky to have been able to make art, to touch people in a special way. To have my work hanging in people's homes, where they see it often and may even think of me. To have been greatly moved by Chopin, by Tony Kushner in *Angels in America*, by T.S. Eliot, by Marc Chagall, by Betty Goodwin, and countless others.

Art touches me powerfully. I feel it strongly in my head and in my heart, simultaneously. Is this so only because art has been my life? Do you feel it too?

've been in British Columbia for forty-one years now. Annie and I have been together for thirty-eight years. We live in Victoria, and sometimes we drive up to Arbutus Bay. The Inn burnt down years ago; the only part of it still standing is the pub. Now when we go there, since our pub days are over, we sit on the beach and stare at the ocean.

Sometimes I see the ghost of a boat from Victoria that used to come to Arbutus Bay: we would all go aboard and smoke hashish with hot knives. I see Tom Thumb singing for a group of us who are drinking beer around a campfire. Tom would improvise brilliant songs—we would sit in wonder. I see myself tripping on the beach with Annie the first time we did acid together.

There are many ghosts in Arbutus Bay. My old self is still there—the one who thought she could sleep with everyone and would never hurt a child, let alone one of her own. The one who hoped that we would all live together peacefully, and that the world surely would change. We're all together there on that beach, all of us and Chris . . .

SHADOWS AND LIGHT

This is one of a small series of paintings with the same title. I was working with ideas of scale and thinking of the metaphors that light and shadow suggest.

OIL ON CANVAS, 30" X 56", 1995, PRIVATE COLLECTION.

GABRIEL'S DREAM

In this very large painting, I was exploring how long I could continue to paint without resolving the painting. When the figures came in, I realized it was about dance, all about different kinds of people being together, but I did not know that until it was nearly finished. That accomplished two things: it gave me a chance to experiment, and it kept the freshness of the final drawing. If I'd started out with the drawing, it never would have looked like this. I'm struck by the figures that are dancing alone: they seem happy. There is a part of me that wants to teach people about tolerance, about embracing differences, and that's one of the things I was thinking about in this painting. The angel Gabriel is playing the horn in the lower left-hand corner.

I was working in oils. Sometimes when I look at my oil paintings, I wish I still worked in oils, but when I've tried to go back I hate the smell, the extended drying time, and the inability to paint over things for days. I'm much happier working in acrylics now, but . . .

OIL ON CANVAS, 54" X 66", 1993, PRIVATE COLLECTION.

AFTERWORD

A Conversation with Phyllis Serota
Dr. Elizabeth Tumasonis, PhD IN ART HISTORY

Phyllis Serota has been a feature of the art scene in Victoria for more than thirty years. Her paintings appeal to viewers, collectors, and other artists alike because they manage to be both experimental and accessible at the same time. Colourful and expressive, her work conveys a wide range of moods. Among her most beloved images are joyful scenes of plump ladies dancing, based on her childhood memories of Jewish weddings and family celebrations. At the other end of the emotional spectrum are the tragic and haunting evocations of the Holocaust in a series exhibited at the Art Gallery of Greater Victoria in 1998.

One of her signature subjects is a fish, an image that has recurred in her work over many years. It shows up in various guises, swimming in the watery depths of a mysterious ocean or reclining on a platter

among other dishes on a laden banquet table. This image may be rooted in her recollections of her childhood in Chicago, where one of her aunts (who sometimes makes an appearance in her paintings as one of the dancing ladies) had a fish store and her entire extended family was involved in the fish business.

In recent years, Serota has continued to draw upon memory and imagination but has also alternated such works with far more naturalistic landscapes and still-life paintings. The latter include bowls of glowing fruit which appear intensely real but at the same time take on a kind of otherworldly significance. They seem to be infused with an almost mystical appreciation of the miraculous and fragile beauty of life.

I spoke with Phyllis Serota about her work in her sunny living room on an August afternoon in 2010.

ET *Where do you get the ideas for your paintings?*

PS From everywhere: TV shows, books, other people's work. Sometimes from memory or dreams. Recently many of my ideas have come from digital photographs I have taken of objects. For example, a bowl of yellow plums with light hitting them. So the ideas can come from many places.

ET *It seems to me that your work falls into two basic modes. Some of your pictures, as you say, are based upon memories or dreams, while others, like the still-life*

paintings of the yellow plums, depict scenes of the real world. Do you think these two ways of working are quite disparate? Or is there an underlying theme that unifies all your work?

PS I believe the underlying theme to all of my work is light. My first memories are of light. Even when I paint memories, dreams, fantasies, I'm always concerned with light. Recently I've been looking at the later work of Matisse, who didn't use shadows, and I've been working in a way similar to that. But even so, Matisse's work is all about light.

ET *The light that shines on those yellow plums makes them appear transcendent. Much of your work seems to me to be quite spiritual. Could you comment on the role of religion or of faith in your work?*

PS Well. I think that light *is* spiritual. It's hard for me to talk about my own spiritual beliefs, although I have often thought about them. It's not that I have so much "faith," but I have a sense that there is something positive in the universe and that's what I'm trying to connect with—I want to send out the message that this is a possibility.

ET *When you set out to make a painting, what do you do first? Do you make preliminary sketches?*

PS Sometimes I make little thumbnail sketches in my sketchbook, and then I usually draw on the canvas with charcoal or with paint. If I use charcoal I tend to get a little more perfectionistic about the

drawing. If I want to be really loose in the painting, then the first underdrawing will be in paint.

ET *You've already mentioned that you were inspired by the photographs of the plums. Do you use photography as the basis of your work?*

PS Often. I used to spend a lot of money on photographs, film, processing, but the digital camera has been a real boon.

ET *How long does it take you to make a painting? I know that Matisse would labour on a painting for many weeks, even though his work appears quick and spontaneous. Do you go back over the painting more than once? Do you repaint parts of it?*

PS Again and again and again and again! Every painting. It's very unusual for me to do any part of any painting only once. I could mention only two or three, in all these fifty years, where I didn't go over all the areas of the painting more than once.

ET *How do you know when a work is finished?*

PS I can't answer that because I never know when a painting is finished. Recently I was looking at a painting I did ten years ago and wondering what was wrong with it and what I could do to fix it up. When I was younger I thought a painting was like a time capsule. I would do one and then never touch it again. But now I regularly go back to paintings long after I first painted them.

PLUMS WITH SHADOWS

Another favourite plum painting.

ACRYLIC ON CANVAS, APPROX. 24" X 36", 2005, COLLECTION OF NICOLA CAVENDISH.

BRIGHT ANGEL PARK

Bright Angel Park is just outside of Duncan, about fifty kilometres north of Victoria. At the time I painted this, I was interested in adding sticks and other bits of texture that come from the area being painted, so all of the leaves and stones in this painting actually do come from Bright Angel Park.

ACRYLIC, TWIGS, STONES ON CANVAS, 44" X 60", 2008, COLLECTION OF THE ARTIST.

ET *You work with acrylic paints, although in the past you used oil paints. Why did you switch from one medium to another?*

PS I worked in oil paints for many years. I had a very nice blending technique that I used to use with oils. But then I started to wonder if I could get the same kind of results with acrylics. So I started playing with them around 1997 or '98. There was a transitional period of two or three years when I worked with both, often in the same painting. I would do an underpainting with acrylics and put oils on top of it.

Eventually I made the switch totally over to acrylics. I enjoyed the fact that they dried so quickly. It wasn't about the smell

or the danger to the lungs, all the things everybody talks about with oil paints. It was like Mount Everest—I climbed it because it was there. It's the same thing with acrylics—I thought, OK, I'll try this and see if I can do it. And then after a few years, when I tried oils again, I found it was such a struggle. I had to wait so long for the paint to dry before I could go over it again, and I thought, No, I'm not going to do this anymore. So around 2001 I gave all my oil paints away.

ET *What other media do you use?*

PS I like doing monotypes. When I don't know what to do next, sometimes that gets me going. I don't have to have some big, serious idea. I'll just start doing them. It's quite exciting because it's so immediate. I can just roll out some ink on a piece of glass and draw right into it. I can make a print from the glass onto a piece of paper and get something like a little sketch. Then I'll paint on the paper afterwards.

ET *Do your paintings ever actually resemble the first idea that you have of them?*

PS They're never as good as the first idea. It's always better in your mind's eye.

ET *Your pictures vary widely in mood. Some are dark and sombre while others are sunny and joyous or even humorous. Does the mood of your paintings reflect your own personal mood at the time that you made them?*

PS I don't know. I think when I start a painting it does, but my mood can change. I can often be in a terrible mood while I'm painting something very happy. I'm quite a moody person. Just because I act cheerful doesn't mean I'm really feeling that way. I sometimes think I understand how to reproduce joy on a canvas because I know the other side so well. I think that people who don't let themselves get really sad or depressed or angry, all the things that we try not to get into too much—those people don't really understand [the joy that is] the other side of that.

ET *What is your educational background? What kind of artistic training did you receive?*

PS I started going to art classes when I was a kid at the Art Institute in Chicago. That was a wonderful beginning for me. I didn't do any painting at all when I was in high school. I was just following along with the crowd in those days. After I got married, I went to night school classes in art. I started painting when I was twenty-one and I've been painting ever since. I took classes all the way through my twenties.

After I moved to Canada, I was painting very rarely. I was too busy getting stoned. It was the sixties, after all! Then I started teaching at Lake Cowichan in the Activity Centre. I had all these students who were good painters, but they kept painting the same subject over and over again. So I went back to school because I wanted to learn how to teach them better. I went to

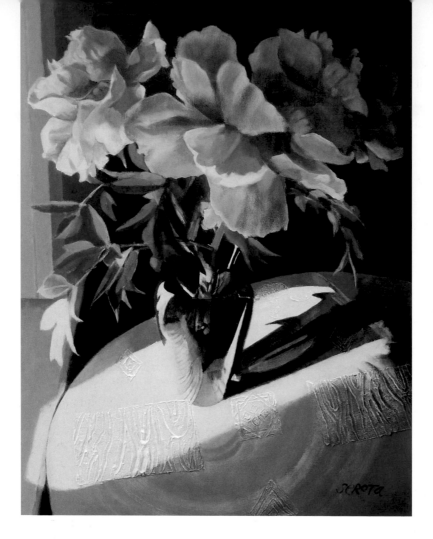

PEONIES

When Annie and I moved into our home in James Bay in 1983, we immediately planted two plum trees. They gave me much food for painting. The same holds true for the peony tree: Annie's mom, who is a wonderful gardener, has a beautiful peony tree in her yard. When I saw these huge flowers, I was immediately hooked. We planted a peony tree the next year.

This painting is of the blooms from our tree and was done in the second year of my peony paintings. It shows our French tablecloth (which I painted numerous times, with its raised areas) and a vase given to me by my late friend Jannit and her partner Lynn. I'm especially proud of this painting. I think it is beautiful.

ACRYLIC ON CANVAS, 40" X 30", 2007, COLLECTION OF CATHERINE PHOENIX.

Malaspina College and studied art there around 1974. Then I had about two more years left to get my degree in art so I transferred to the University of Victoria. I got my BFA in 1979.

ET *How else have you learned about art?*

PS I have hardly ever had a really good teacher. My first teacher at the high school was good, very experimental and fun. I had a couple of good ones at Malaspina, and then I had Freddie Douglas at UVic, who was a very good teacher and was very supportive of my work. But mostly I learned on my own, like everyone does.

Most of what I know about colour, I learned from [Johannes] Itten's book *The Art of Colour*. After I graduated I realized that there is a science of this. They never taught that at the university. So I borrowed Itten's book from the public library and studied it. For the next year I did experiments with colour.

In the last few years, I've studied texture, mainly by looking and trying things out. I've been experimenting with that intensively.

ET *What artists do you particularly admire? What artists besides Itten have had an influence on your work?*

PS There are so many I could name. As a child, my favourite artist was Renoir. I'm not a Renoir fan today, but he was my first favourite. Another artist who made a strong impression on me at that age was Van Gogh. The artists who have had the strongest influence on me are Matisse and Chagall.

I think Chagall is a very underrated artist. There's so much emotion in Chagall's work and so much love. It may be that I feel an affinity with him because of my Jewish background, but he was a fabulous artist. I admire Picasso and I love Botero. His work makes me laugh. I love humour in art. Also Max Bates, who lived here in Victoria, his work is sardonic and darkly funny. He was very influential for me. Other Canadian artists who have been important to me were Jean-Paul Lemieux and Betty Goodwin.

It was also important to me that Emily Carr came from Victoria. I appreciate her experimentation and her courage, and the fact that she was a woman. Also Frida Kahlo, after all the art therapy I did. Frida Kahlo is the QUEEN of art therapy! All the pain, the autobiographical quality of her work. Georgia O'Keeffe was also influential for me. She was a great artist and a pretty damn tough person. I saw a film of her working and she was blending her paint. That night I had a dream about her and when I woke up decided I was going to start blending. I blended for the next twenty years!

Of more recent art history, the artists I think are the most important are Anselm Kiefer, Lucian Freud, and David Hockney. I think Anselm Kiefer is the best painter in the world right now, and I love David Hockney's work. I love the humour in it and his fresh colours. But I think the most overwhelming show I've ever seen was an exhibition of Anselm Kiefer's work in San Francisco.

ET *The French literary critic and theoretician Jacques Derrida wrote of the "death of the author." In other words, he believed that the work of art should stand on its own and that we, the consumers and viewers of art, should not be concerned with the biography of the artist. Do you think that we need to know something of your life story in order to understand your work?*

PS Yes and no. Hopefully, the work will stand on its own. But if I tell a story about one of my paintings to people, they will see that painting in a very different way. Maybe they are people who have never looked at art and have never been touched by it. The story will give them a hook, and they may look at art a little differently in the future. I'm always interested in teaching and turning people on to art. I think teaching is my primary gift in life, even more than painting is. I think knowing the story behind a work really adds to an appreciation of it, and that's one of the reasons I wrote this book.

ET *You have lived and worked in Victoria for thirty-five years. What changes have you observed in the art scene here?*

PS In the early eighties, I was part of a group called Alley Art—everybody in the group loved everyone else—until the power struggles started and it all fell apart. There have been so many alliances and changes. I was part of the Open Space gallery for a long time. Then it became very narrow in its scope and nobody went to it anymore. So in 1996 Annie and I organized a show called *Opening Up, Open Space* in an attempt to overcome that. Also, about five years ago I organized a show of the work of Visual Art Department graduates at the university. I thought it was really weird that nobody had ever done that before.

There are a lot more artists here than there were in the old days. They're pouring out of the art schools. Years ago, most of the art produced in Victoria was very decorative, except for the work of the Limners. Today, there are more kinds of art to choose from.

ET *Of your many accomplishments, which make you the proudest?*

PS My children and my grandchildren, and of course I'm also proud of having had a long relationship. Annie and I have been together for thirty-eight years. It's a struggle to do that, as we all know. But the main thing that I am proud of is that I have earned a living with my hands since 1979. I have taught a little, but mainly I have supported myself by selling my paintings. I'm so tired of people telling their children to go to law school or business school in order to make a living. I think that you should do whatever it is that you love and that you can make a living doing that. I'm proof, aren't I?

ET *Do you think that painting can continue to exist in a digital world?*

PS Absolutely. People need to paint. They need to write, to dance. People need art.